Eileen Ramsay

by BARRY PICKTHALL

41/500

Eileen Ramsay

QUEEN OF YACHTING PHOTOGRAPHY

by BARRY PICKTHALL

ADLARD COLES NAUTICAL
LONDON

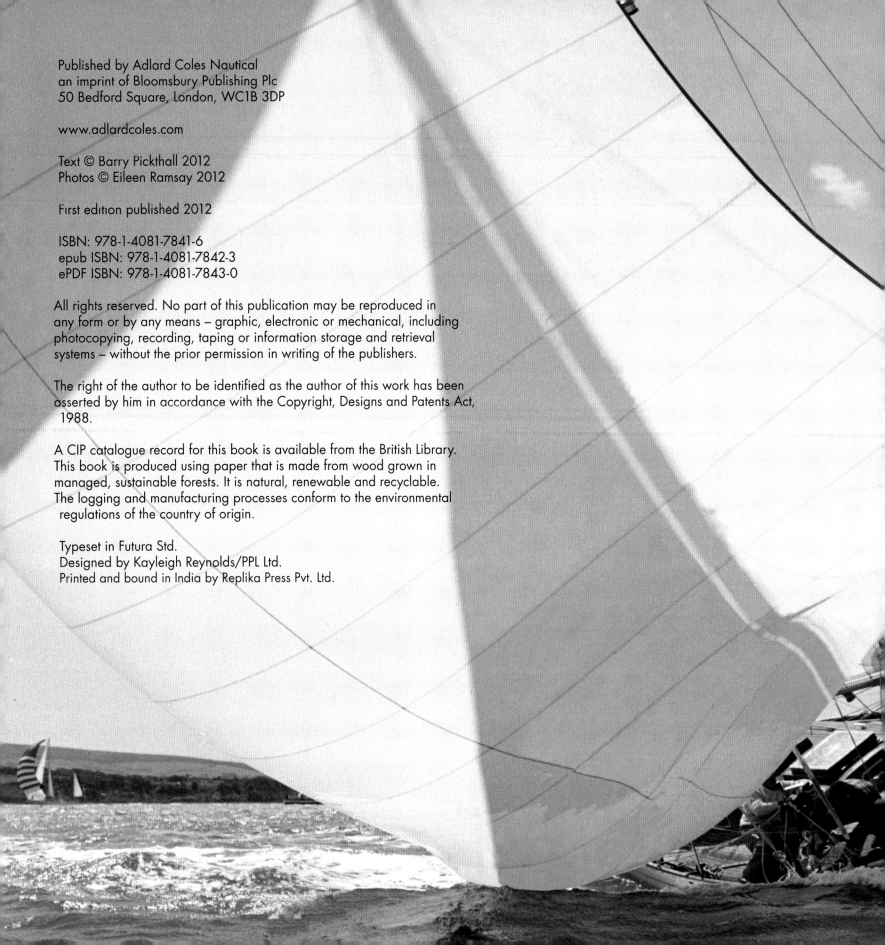

Published by Adlard Coles Nautical
an imprint of Bloomsbury Publishing Plc
50 Bedford Square, London, WC1B 3DP

www.adlardcoles.com

Text © Barry Pickthall 2012
Photos © Eileen Ramsay 2012

First edition published 2012

ISBN: 978-1-4081-7841-6
epub ISBN: 978-1-4081-7842-3
ePDF ISBN: 978-1-4081-7843-0

A CIP catalogue record for this book is available from the British Library.
This book is produced using paper that is made from wood grown in
managed, sustainable forests. It is natural, renewable and recyclable.
The logging and manufacturing processes conform to the environmental
regulations of the country of origin.

Typeset in Futura Std.
Designed by Kayleigh Reynolds/PPL Ltd.
Printed and bound in India by Replika Press Pvt. Ltd.

Contents

Foreword

BY NICK WARD
Author of *Left for Dead* – a personal account of the 1979 Fastnet Race

In the world of marine photography, there are few names or portfolios of work as special or classically outstanding as that created by Eileen Ramsay. This remarkable woman's mould-breaking techniques captured images over the course of three decades in a style that made intangible subjects tangible, a rare skill few photographers before her had been able to achieve.

From her South Coast base, she travelled the country bringing celluloid to life, from a Fairey Duckling becalmed on the Hamble River to an 'Admiral's Cupper' chinese gybing, or broaching with the foredeck crew thrown a-sunder in the Solent.

It was back in the 1950s, on Hamble Quay, that my father first made the acquaintance of George Spiers – Eileen's partner – which led to a life-long friendship with him driving and maintaining their launch *Snapdragon*. This was a 26ft clinker-built, Perkins powered, ex-RAF launch, painted navy blue with a smart white 'bumper' all around.

Eileen and George's first accommodation in Hamble was their grey van, parked inside their 'studio' – an outbuilding of the King & Queen pub on High Street. The studio had wonderful views of the river from its east–facing, red and white gingham-surrounded window. The smells of developing fluid and fixatives were all pervading. Strips of negatives hung from makeshift lines, the results of a long day's work on the water.

My eldest brother was roped in by my father to help paint and antifoul the launch up river at the Elephant Boatyard in Bursledon. Some years later, I was allowed to row everyone out to *Snapdragon*'s swinging mooring off the Royal Southern Yacht Club, where she was a member for many years. Often, on our return to 'base' – the two end cottages of Copperhill Terrace in Hamble Square, where Eileen and George lived for more than 20 years – we had tea together, my mum contributing homemade scones and shortbread.

OPPOSITE
A young Nick Ward playing in a dinghy on the Hamble foreshore during a Merlin Rocket open meeting.

BELOW
Yachts & Yachting *– one of many cover pictures that became Eileen Ramsay's stock in trade.*

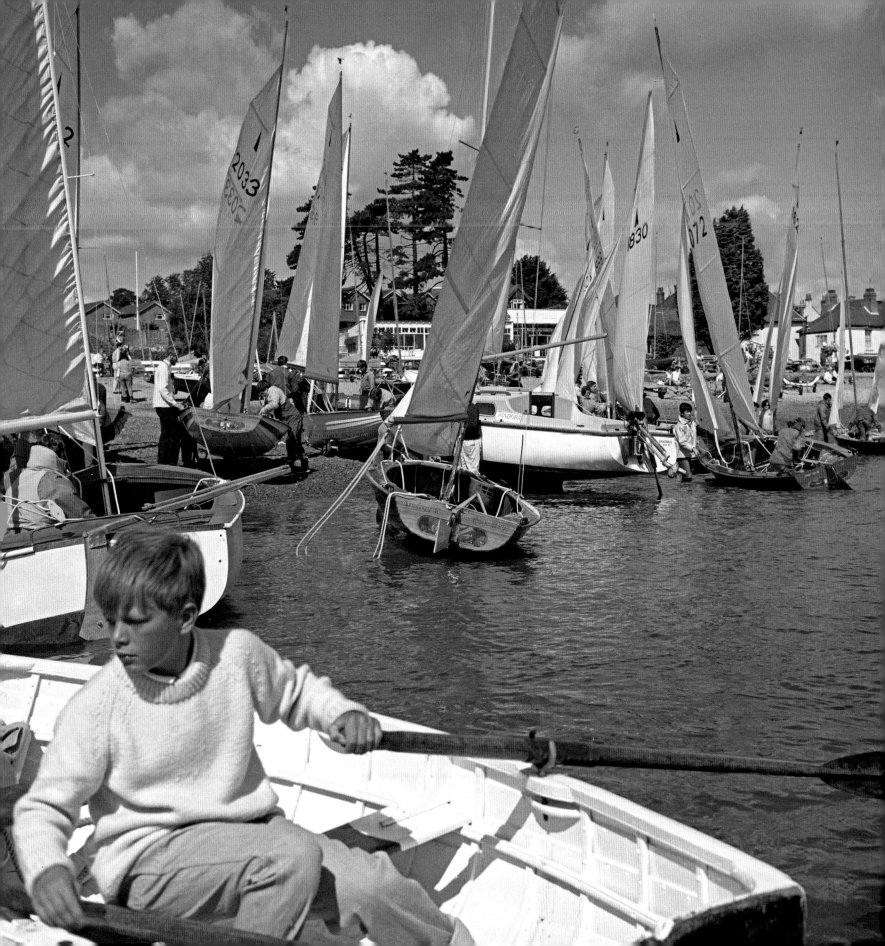

The smells ashore were as delicious to me as the ones my sister recalls at the boatyard, of fresh paint, antifoul, caulking, varnish and oil.

For us youngsters, it was a taste of a very different, wonderfully Bohemian world, where it was normal to hear the endearment 'Darling' used on a regular basis – very different from the 'Duckie' we were used to at home!

We lived opposite Eileen, in Satchell Lane, and on a sunny day in May 1968, when I was 13, my parents set me up with new jeans and shoes and, with very little persuasion, I was asked to row around the Quay in *Snapdragon*'s tender ...waiting to row out to the mooring. Little did I know that Eileen was not only photographing the Merlin Rockets on the Hamble foreshore and quay, but had me in her viewfinder as well. The following month the picture was used on the front cover of *Yachts & Yachting*.

Eileen's waterborne subjects are natural and rarely posed. Her flair and eye for detail are evident in every frame and are a reflection of her personal elegance and poise.

I am delighted to be part of this tribute – a fanfare to one of our most influential marine photographers, Eileen Ramsay.

OPPOSITE
The 12 Metre **Evaine** *racing in the Solent. She was campaigned by Owen Aisher during the 1958 trials to select Britain's first Post-War America's Cup challenge.*

BELOW
Eileen Ramsay's faithful photo boat **Snapdragon** *being given a fresh coat of paint by the Ward family.*

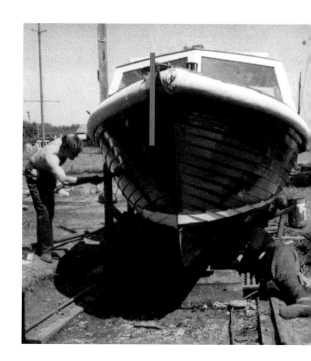

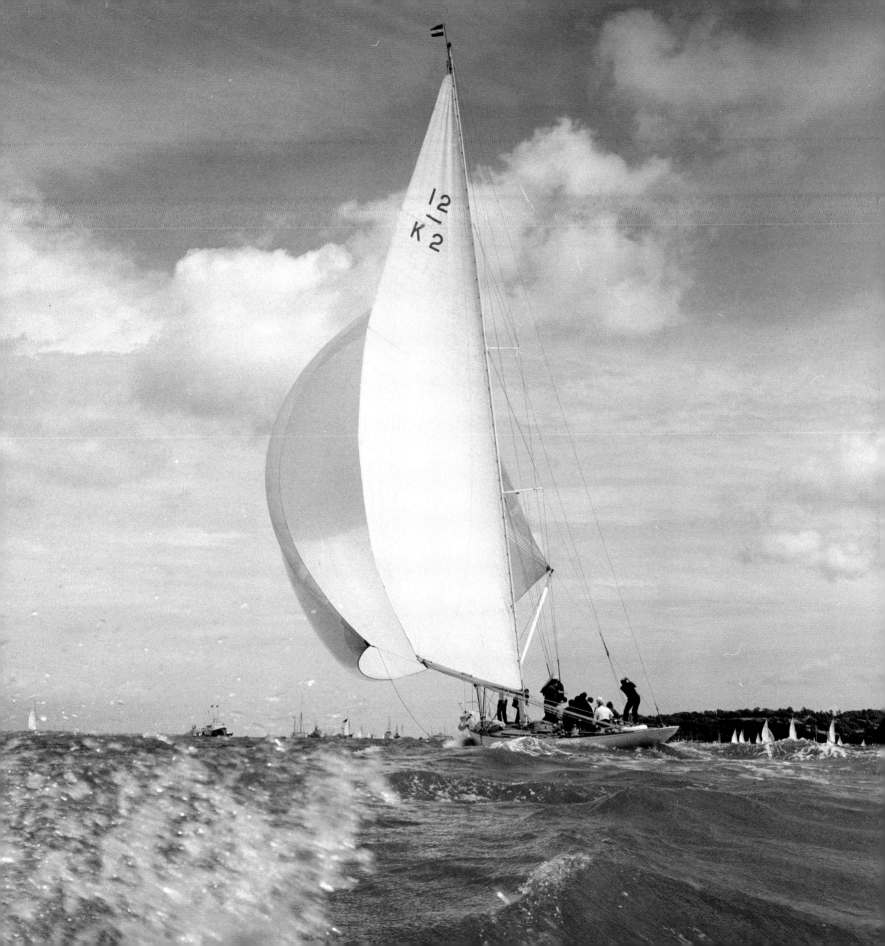

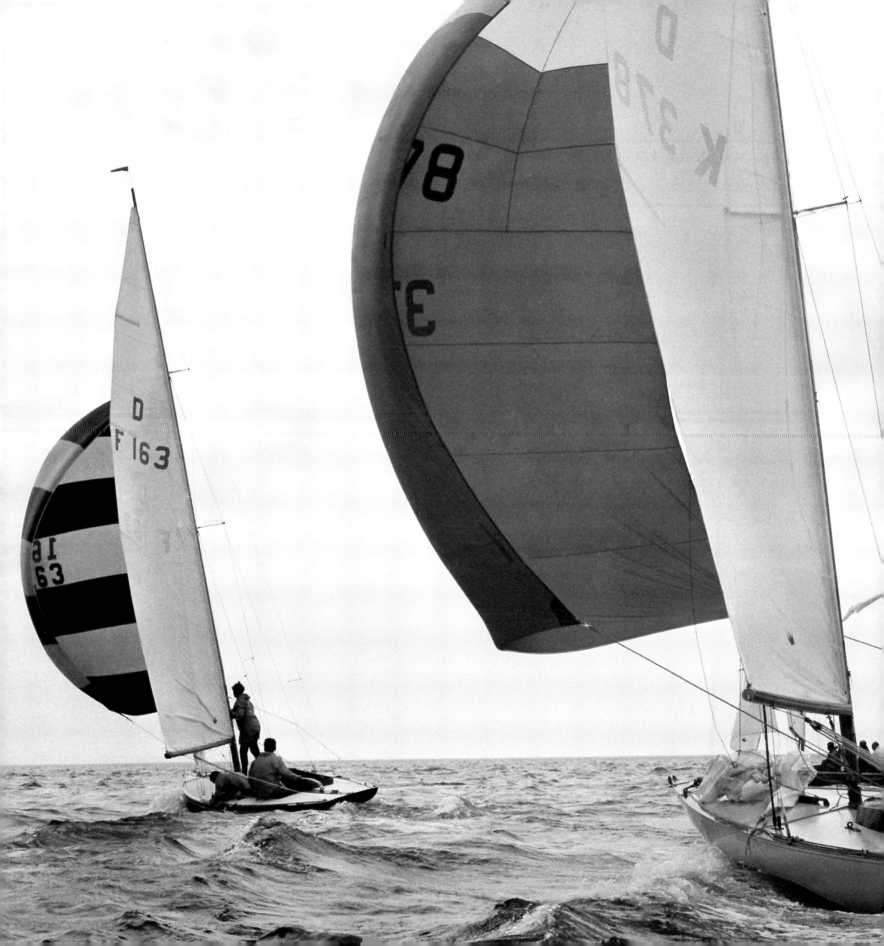

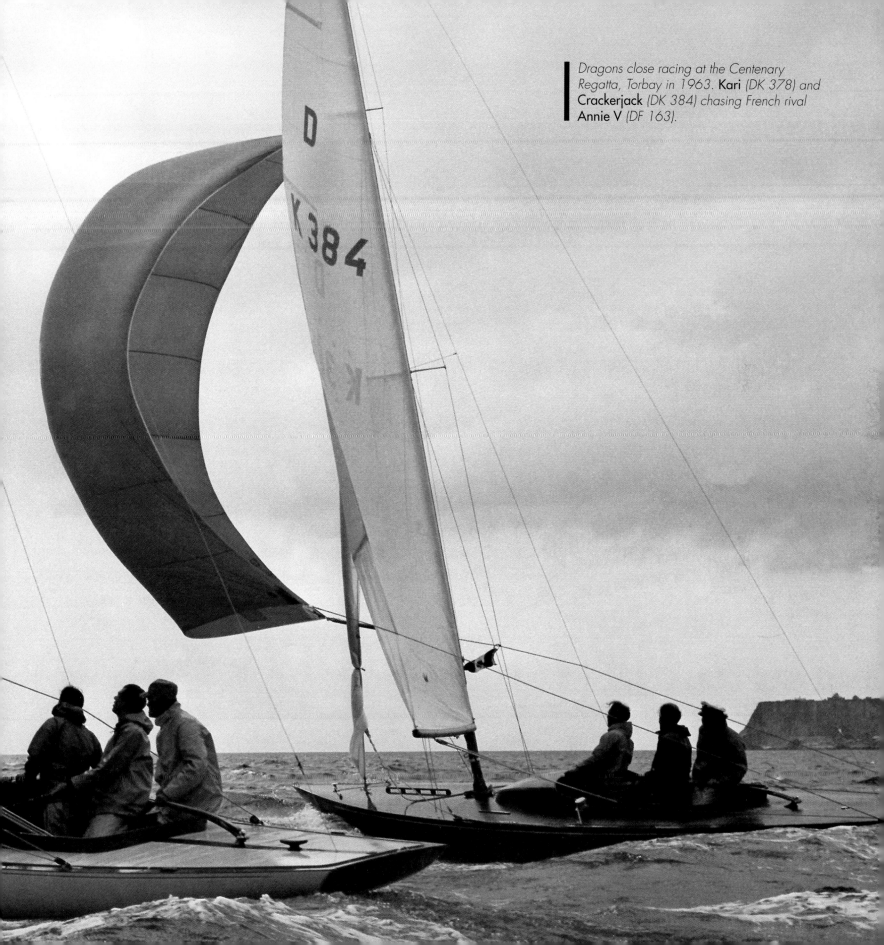

Dragons close racing at the Centenary Regatta, Torbay in 1963. **Kari** *(DK 378) and* **Crackerjack** *(DK 384) chasing French rival* **Annie V** *(DF 163).*

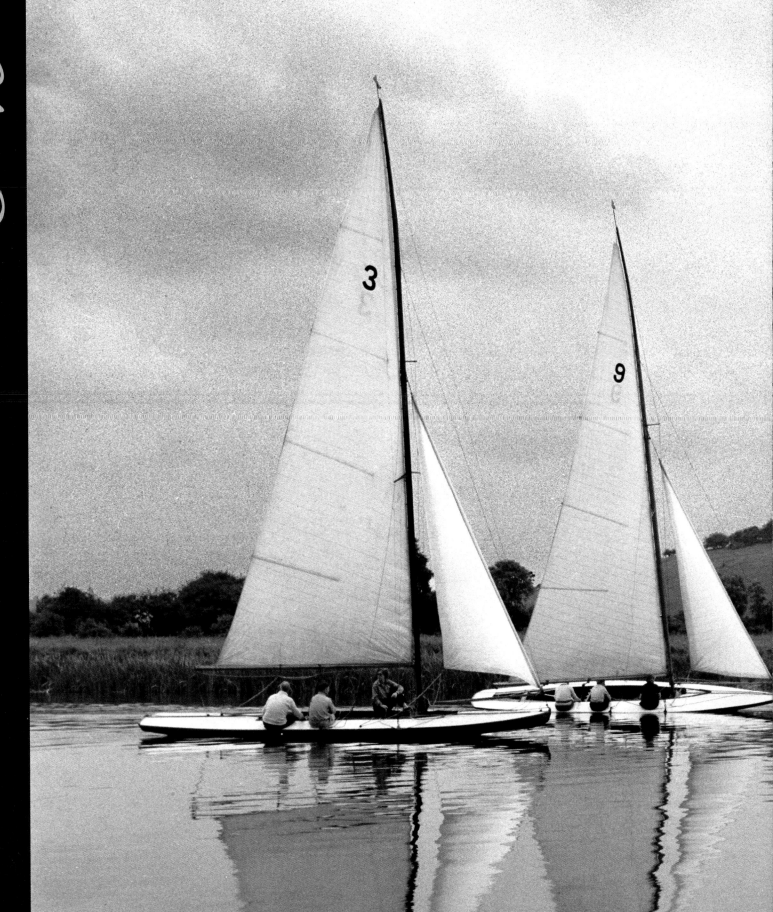

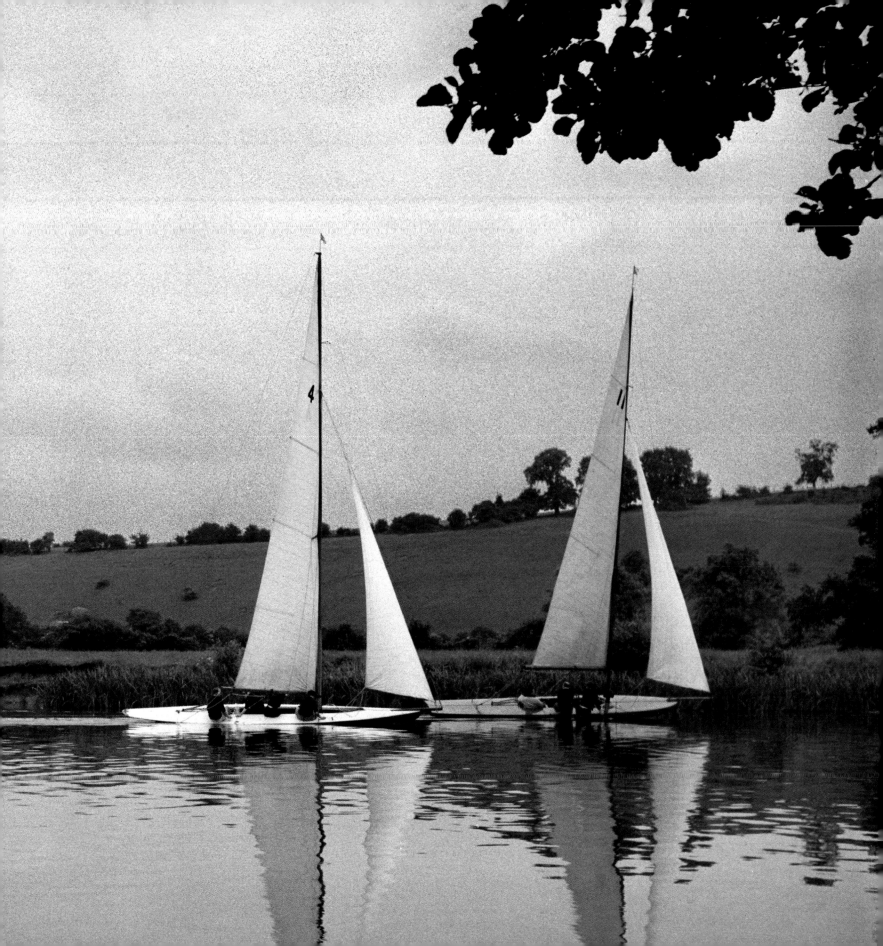

Eileen Ramsay

Eileen Ramsay made her mark as the queen of yachting photography during the 1950s and '60s when the sport in Britain enjoyed a post-war explosion in both dinghy and offshore sailing.

Her archive of photographs includes iconic pictures of 12 Metre racing off Cowes, historic pictures of sailing pioneers from the first *Observer* Singlehanded Transatlantic Races (OSTAR) and the solo voyages of Francis Chichester, Alec Rose, Robin Knox-Johnston and Chay Blyth.

Also in the archive are long forgotten images of Olympic sailors Keith Musto and Tony Morgan, Silver medallists at the 1964 Games in Tokyo, and Rodney Pattisson and Iain MacDonald-Smith, who won Gold for Britain in the same Flying Dutchman class at the Mexico Games in 1968. She also recorded the career of Charles Currey, who won silver at the Helsinki Games in 1952 and did much to satisfy demand for both dinghies and powerboats as a director of Fairey Marine. Then there was Sir Owen Aisher, a patriarch of British yachting with his many *Yeoman* yachts, and his son Robin Aisher, who represented Britain in the 5.5 Metre keelboat class at the 1960 and '64 Games before finally winning Bronze at the Acapulco Regatta in '68.

Although she only photographed him once, the colourful Uffa Fox's dinghy and keelboat designs from early National 12s and International 14s to his Firefly, Albacore and Flying Fifteen class boats were often reflected in her focus screen. So too was Sir Max Aitken, the head of Beaverbrook Newspapers and a stalwart of the Cowes yachting and motorboat racing scene.

Other noted sailors to have fallen within Eileen Ramsay's focus have been Stewart Morris, Gold Medal winner at the 1948 Games in Torquay, fellow International 14 champion and Olympic representative Bruce Banks, and Sir John Oakeley, the son of wrestling champion Sir Attle Oakeley, who became one of Britain's most successful dinghy champions in the '60s and '70s,

PREVIOUS PAGE
Thames A Raters, racing during Upper Thames YC Bourne End Week in 1952. These tall rigged scows are one of the oldest class of race boats on The Thames and inspired Ramsay to take up sailing photography.

OPPOSITE
Eileen Ramsay with her Rolleiflex camera. She was the queen of yachting photography between the 1950s and early 1970s.

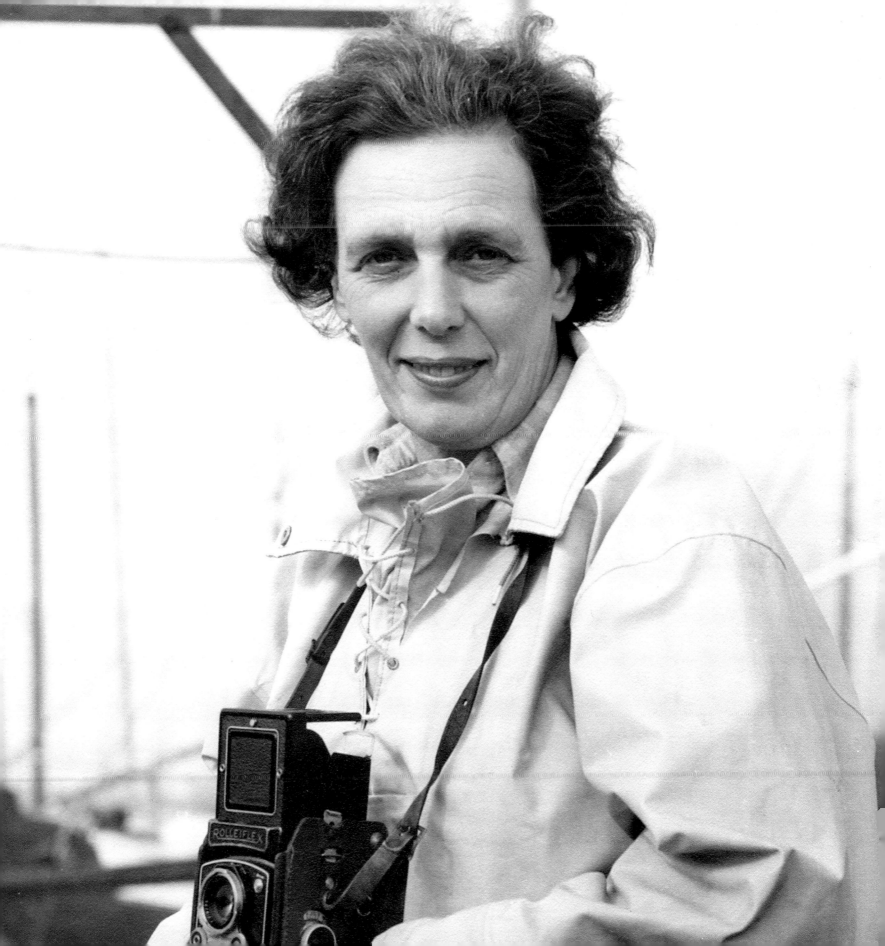

winning the Merlin Rocket crown three times in succession before going on to win the Flying Dutchman world championship.

Eileen, who was born in 1914 at Sanderstead, Surrey, began her career in 1937 as a 22-year-old receptionist to her friend Gilbert, son of the Reading based Royal photographer Marcus Adams. As war clouds gathered across Europe and the call to arms began, Adams knew that his services would be required to record the impending conflict. Rather than close the studio down, he gave each of his staff a camera and told them to go out and take some 'interesting' photographs. The one to come back with the best pictures would take over the studio during the War.

'I didn't know anything about cameras then, but my pictures were judged the best and I got the job.' Eileen remembers, adding 'Photographic materials were very difficult to get, but I had great success taking pictures of wives and people in uniform, which taught me a lot about portrait photography.'

It was also during this period that she met George Spiers. "I first met him when he was the head technician to the Royal photographer, Marcus Adams, who photographed the Princesses Elizabeth and Margaret throughout their childhood. He joined me just after the War as a partner."

Once the war clouds had cleared, they decided to start up on their own from a studio in Chelsea, with Eileen taking on any commissions that came her way, from magazines to newspapers. In 1955, she and her partner George Spiers decided to move south to live on the Hamble after purchasing the 28ft clinker-built ex- RAF launch *Snapdragon*. They moored her at the end of their garden and Eileen Ramsay set out to make her mark on the marine world.

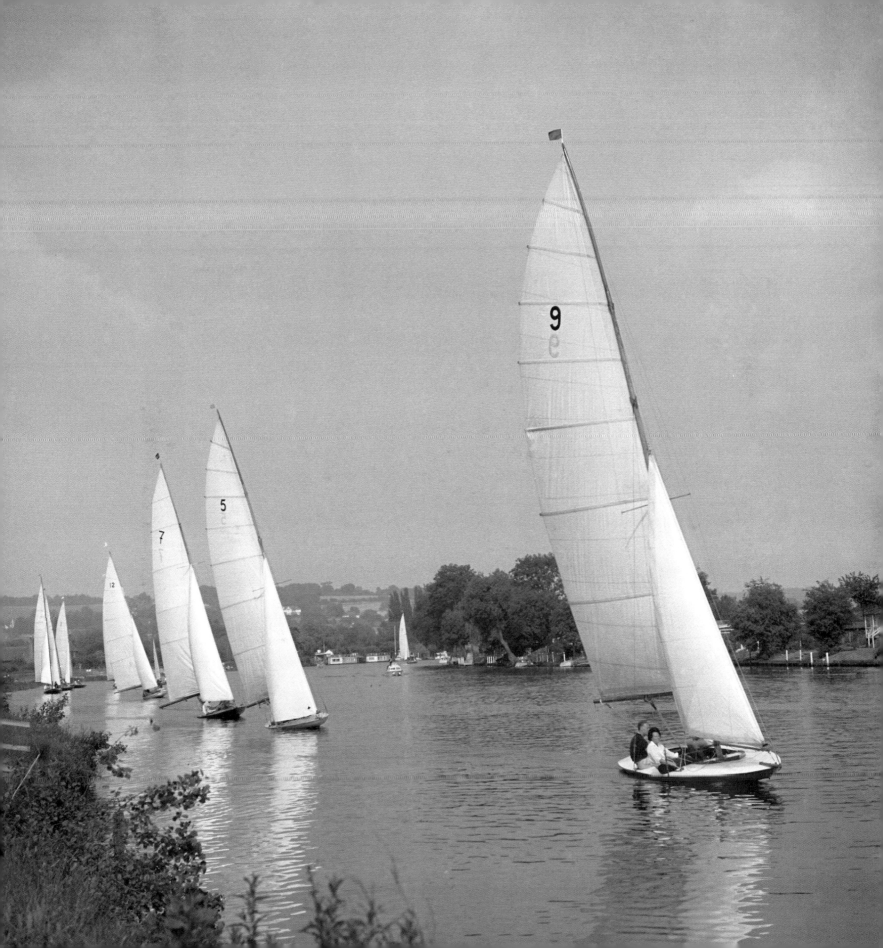

One of Eileen's first pictures published was of a scene on the Menai Straits, taken in 1945 when holidaying with friends on Anglesey. The picture, titled 'Black Sails', was selected for the 50th edition of *Photograms of the Year*, an annual review of the world's best photographic art.

Using similarly plum toned terminology to Brian Sewell, the BBC's latter-day art critic, ET Holding, a luminary from the London Salon of Photography, wrote of Eileen's picture:

'Much of the effectiveness of this well-balanced picture is due to the skilfully selected proportions of the three elements of which it is composed – sky, land and water. The flat tones of land and water, showing no recession – also have their decorative value in a picture the crowning feature of which is the pageant of clouds drifting across the sunlit sky.'

No mention here of the gaff rigged yacht centre-stage within the portrait. He must have missed it amongst the eloquence of reflected clouds. Eileen didn't. To her, the yacht made this picture what it is – an award-winning portrait. 'The whole point of the picture was the contrast between the mountains and clouds reducing the boat to a tiny feature,' she recalls now. It remains one of her favourite photographs.

OPPOSITE
'Black Sails', the award-winning portrait of the Menai Straits taken by Eileen in 1945.

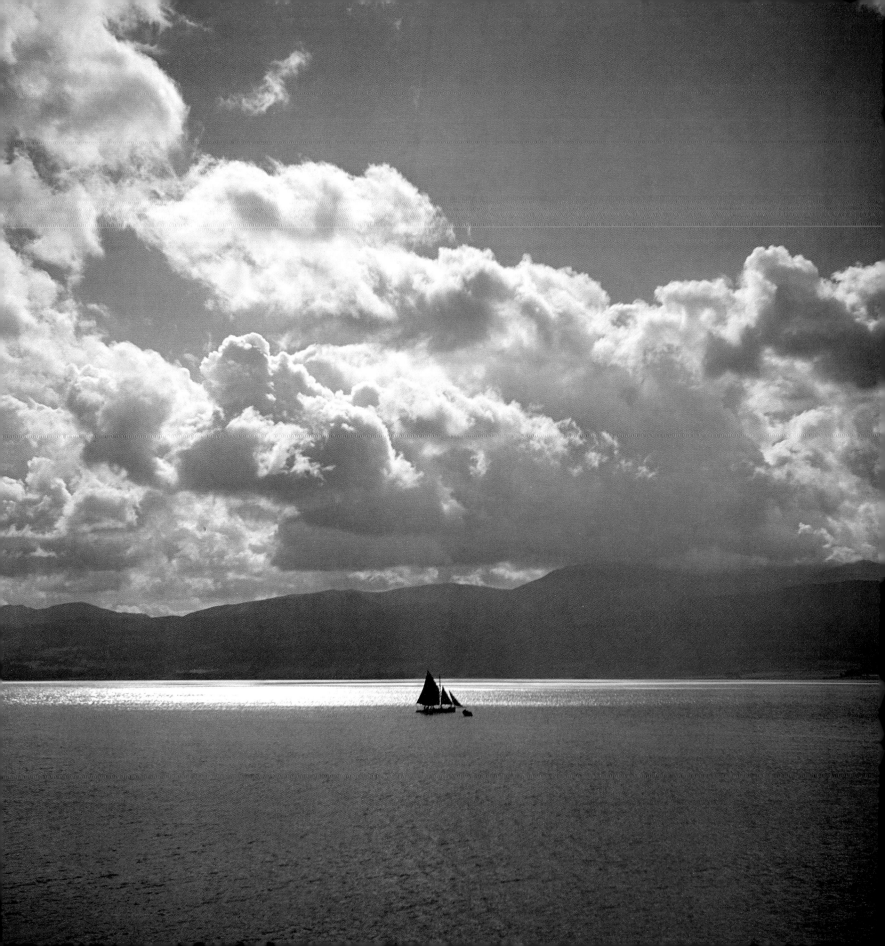

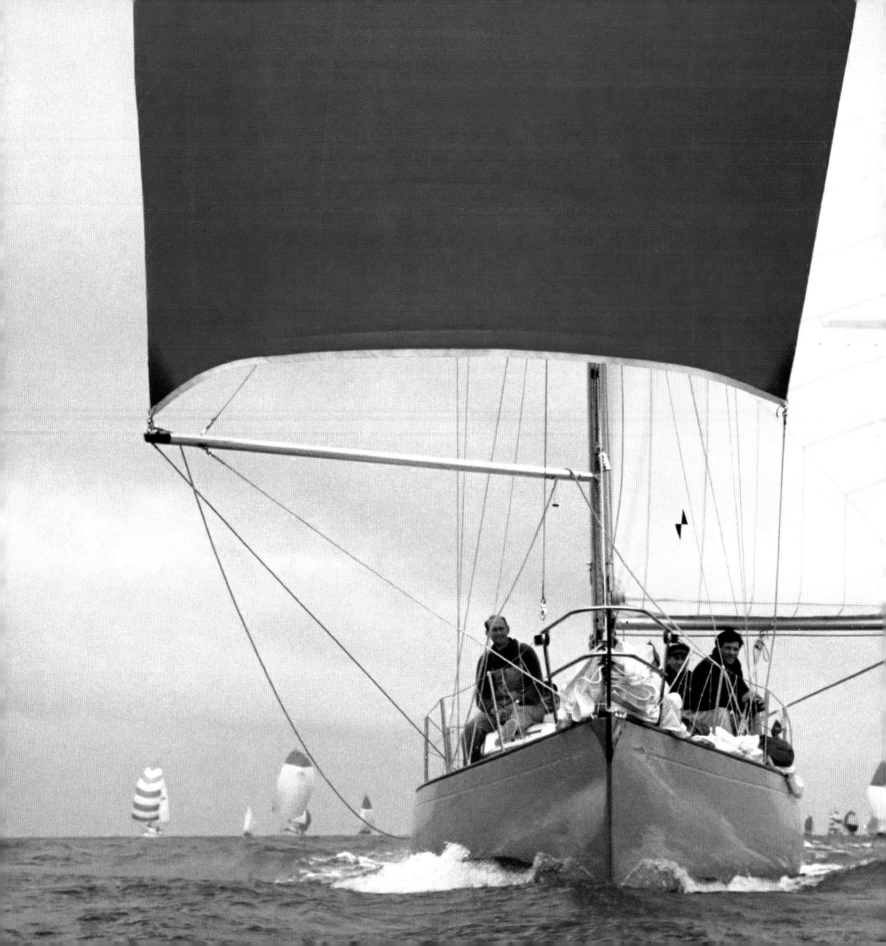

ROUND THE ISLAND RACE
The Royal Air Force Association's yacht
Slipstream of Cowley competing in the
1969 annual Round the Island Race with
a colourful pack of chasing yachts astern.

Eileen began taking colour pictures
in 1962 and set up her own colour
developing process two years later, but it
took several more years before magazines
and newspapers could print in colour.

BELOW
Hamble, as it was after the Second World War.

OPPOSITE
The first stage of Port Hamble Marina in 1960 when the first pontoons had been laid – and quickly filled with boats.

Eileen was happiest working at water level. She did get airborne in a helicopter once to cover the development of the first British marina which was completed on the Hamble River during the 1960s. 'Having experimented with aerial photography from a bosun's chair at the top of Peter Green's yacht *Firebird X*, then the tallest rig in Port Hamble Marina, I was persuaded to fly just the once, and that was enough,' she readily recalls.

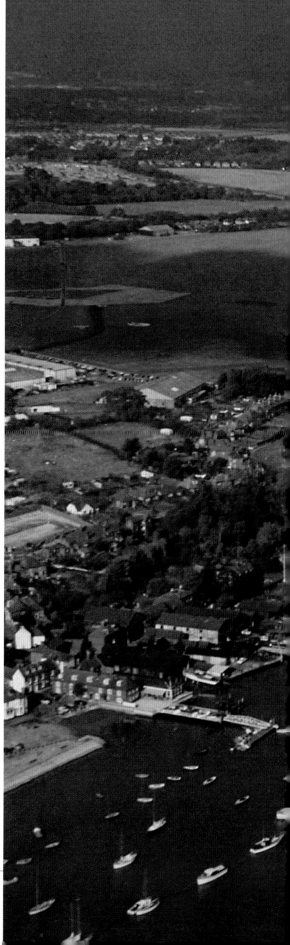

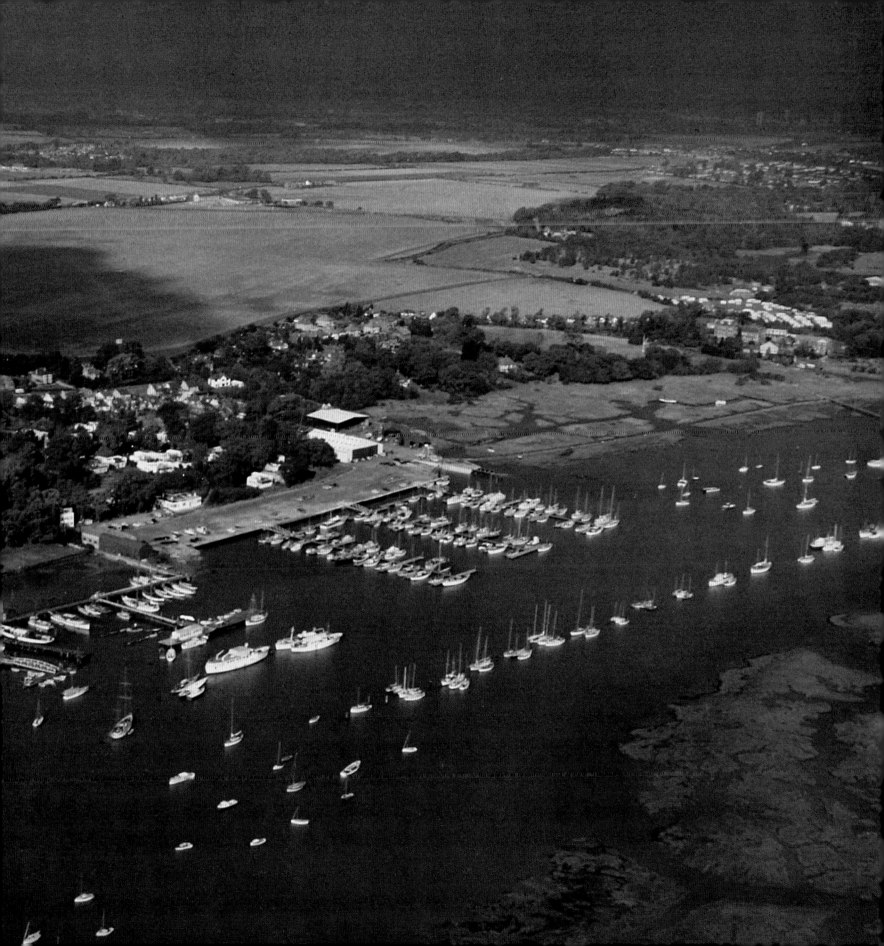

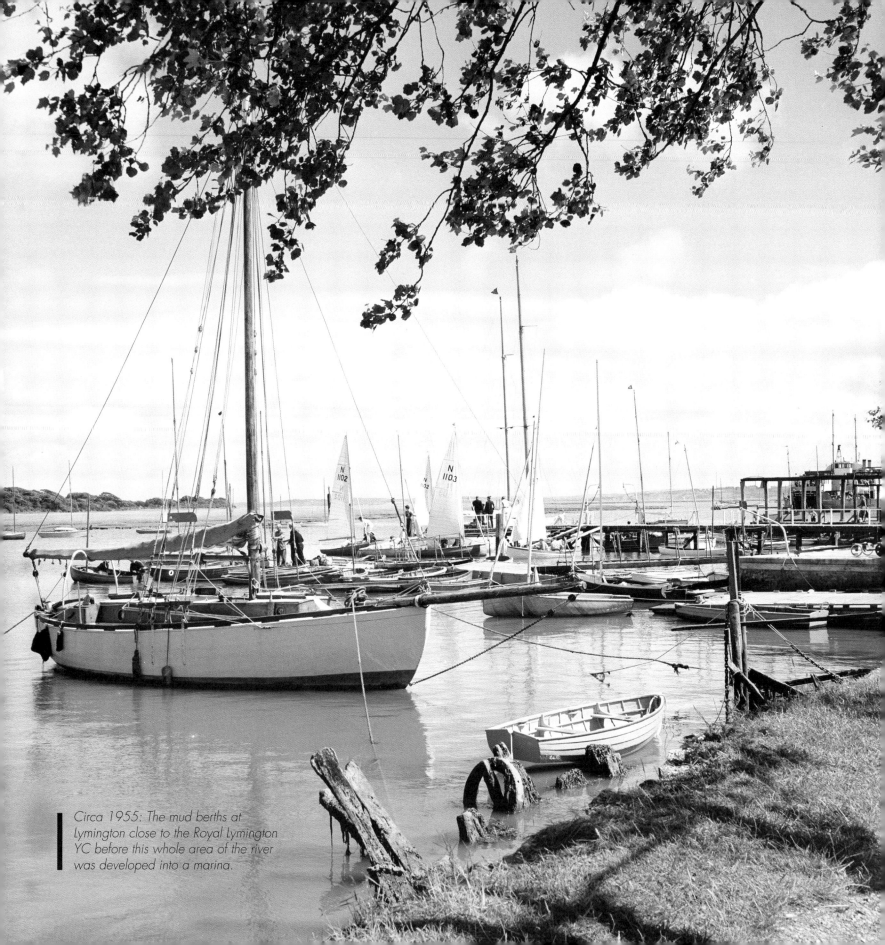

Circa 1955: The mud berths at Lymington close to the Royal Lymington YC before this whole area of the river was developed into a marina.

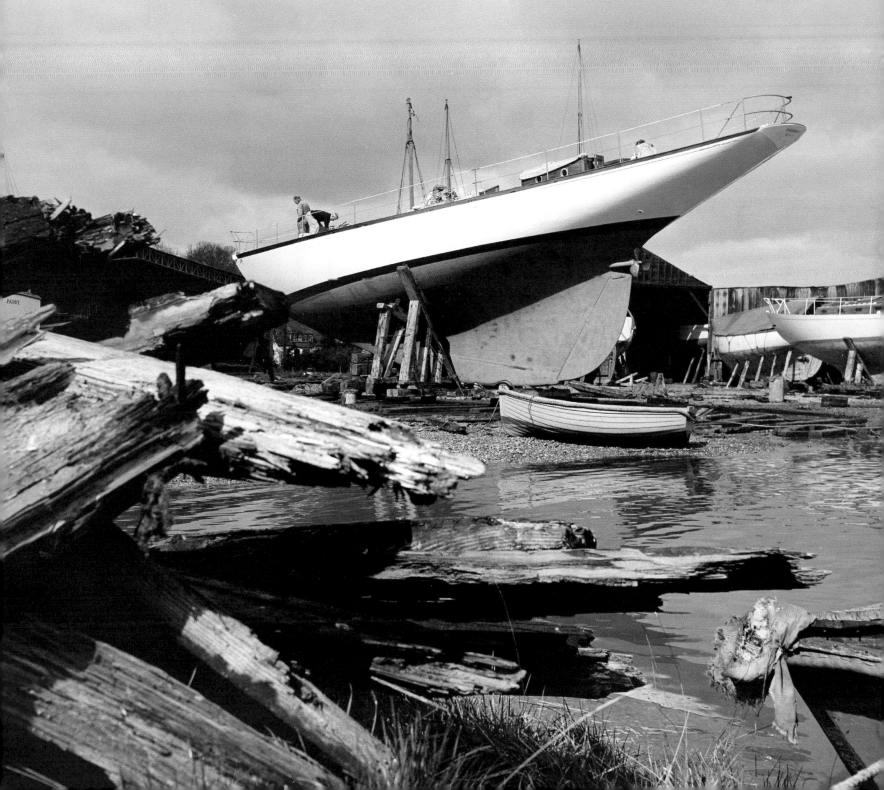

Circa 1955: **Firebird X**, *the 68ft schooner built by Camper & Nicholsons in 1937, undergoing a refit on the Hamble. At the time, hers was the tallest rig on the river, and Eileen used it to take aerial photographs of the river.*

Kenneth Beken

A mixture of photographic chemicals and salt water must be running through my veins since, like Eileen, I have no desire to pick up a camera if out of sight of the sea! From an early age I would trawl through the yachting magazines, and having started my professional career in the early 1970s, was well aware of who was taking the best pictures of the day; those that stood out as being creative rather than simple 'reportage' style.

At the turn of the 20th Century the pre-eminent maritime photographers were – alongside my grandfather, Frank Beken – George West, Arthur Debenham and William Kirk. They were followed by Edwin Levick and Maurice Rosenfeld in New York, who were both to become contemporaries of my father, Keith Beken.

Between the '50s and '70s when photography became popular, Eileen Ramsay carved a name for herself, with creative skills shouting out from her studies printed in nautical books and magazines. Her style was unique and innovative, and just as you can spot a 'Beken', an 'Eileen Ramsay' is easy to discern.

Finding her niche mainly in dinghies, dayboats, larger cruisers and racing yachts, she developed an emphasis on action, taken mostly by hanging precariously over the side of her photo-boat with her camera at sea level.

She came from an era that was taught to conserve film; not shoot it off like a machine gunner. She carefully framed each picture before firing the shutter – a totally different style to that of today when chips are cheap and everyone is now a 'photographer' following the premise that if you take enough pictures, one will surely come out right!

Eileen certainly had the 'eye' for a good photo and the sailing world was all the poorer for her early retirement. Fortunately her archive has been secured for posterity and given a new lease of life. I for one look forward to the release of more of her wonderful work.

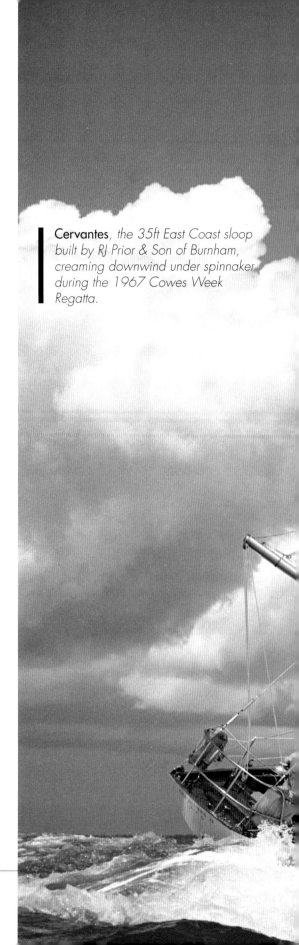

Cervantes, *the 35ft East Coast sloop built by RJ Prior & Son of Burnham, creaming downwind under spinnaker during the 1967 Cowes Week Regatta.*

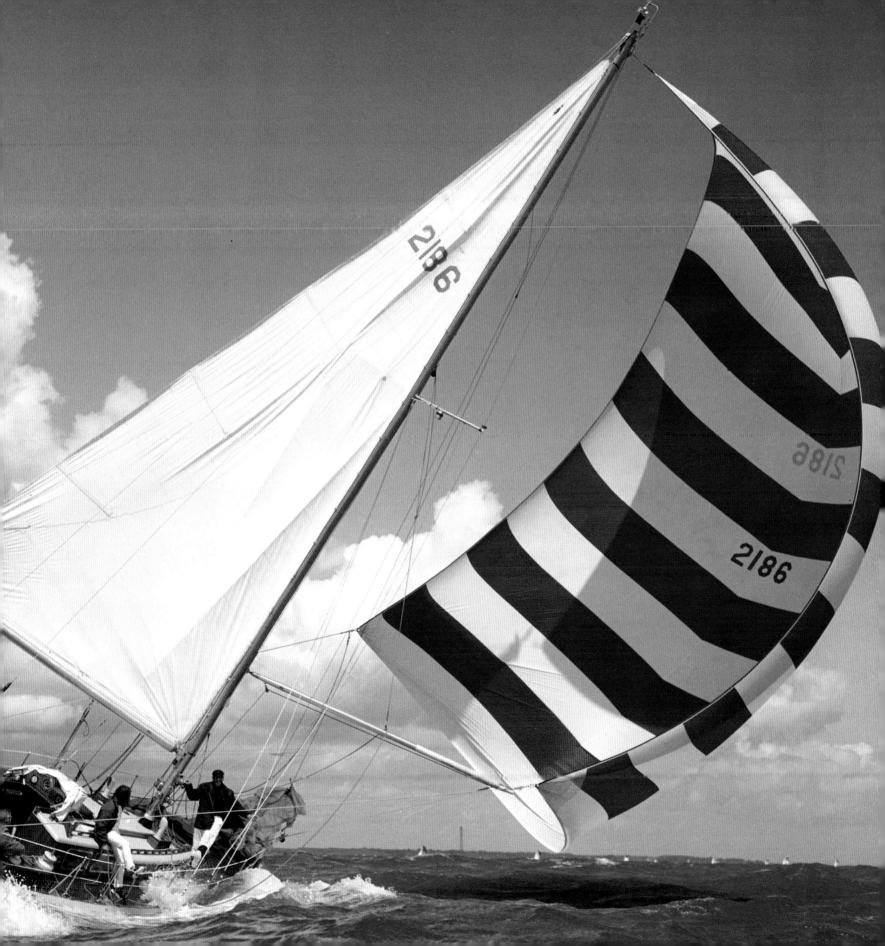

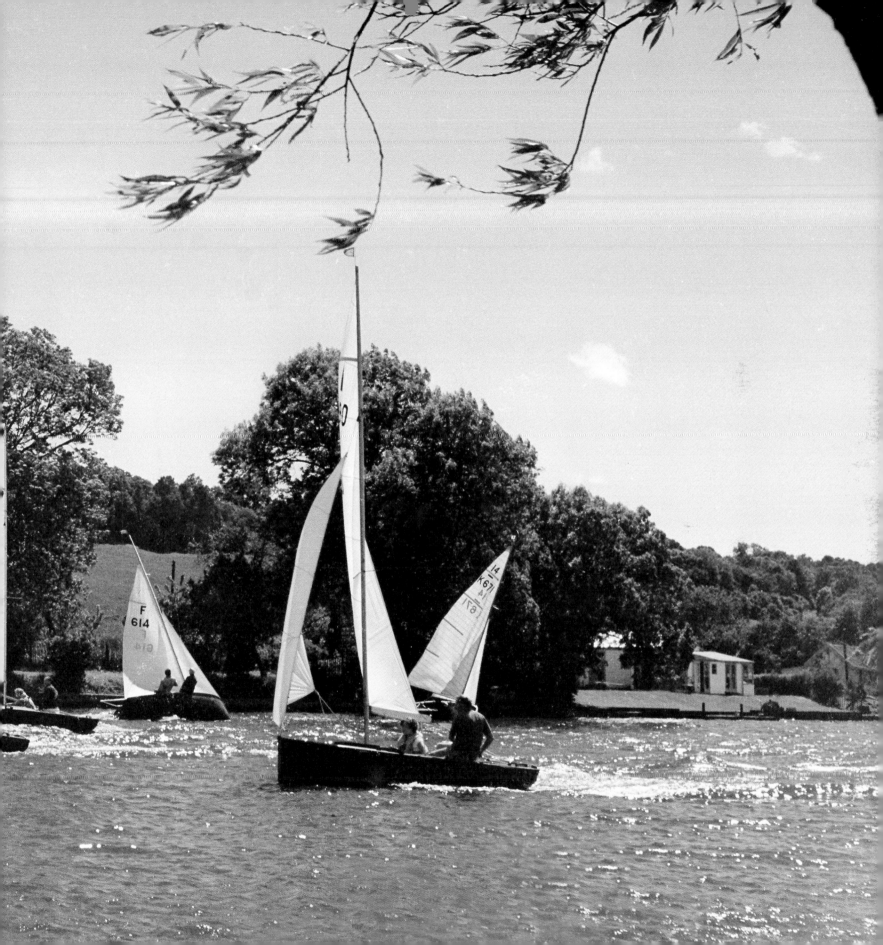

Dinghy Days

Eileen started photographing dinghies in 1947. It was while walking with her partner George along the towpath at Henley-on-Thames on a glorious sunny day, that she found what pictorial subjects these dinghies were, with ever-changing light on the sails, the many different angles, and the great variety of framework afforded by trees and rushes along the riverbank.

Soon afterwards, she began photographing all types of dinghies in every kind of setting – sea, estuary, river and reservoir. She and George were sunk at Whitstable, they were stranded on sand banks and even had engine trouble in the middle of a championship race – the most embarrassing of all. But they gradually learned by experience the best ways to make their pictures.

In her first book *Dinghy Days*, published by Adlard Coles in 1959, she wrote, 'On the towpath it is a very simple matter to find the right setting – a piece of overhanging willow, a clump of irises, or a fallen log – and then await the coming of a boat into this chosen frame, but at sea, the man at the helm of our launch plays a most important part in getting us into the correct positions at the right time without interfering with the racing.'

At Hamble, Eileen had her own launch *Snapdragon*, which had a top speed of 15 knots. The boat was also sturdy enough to go out in most weathers, had a large open cockpit and a small cabin for shelter when it was too rough or wet to photograph. It also kept the driver dry. *Snapdragon* was too big and heavy to trail behind a car, and Eileen and George had a second 19ft launch they would tow to events behind their Land Rover.

Eileen's Rolleiflex camera recorded the post-war explosion in dinghy sailing. She witnessed the development of many dinghy classes and also charted the careers of designers Uffa Fox, Ian Proctor, Jack Holt, John Westall and Peter Milne.

(continued on page 42)

PREVIOUS PAGE
A menagerie of Merlin Rockets, Fireflys and International 14s racing on the Thames during the 1959 Bourne End Week.

OPPOSITE
Yum-Tum II *steals a march to leeward of the National 12 fleet during the 1951 Bourne End Week.*

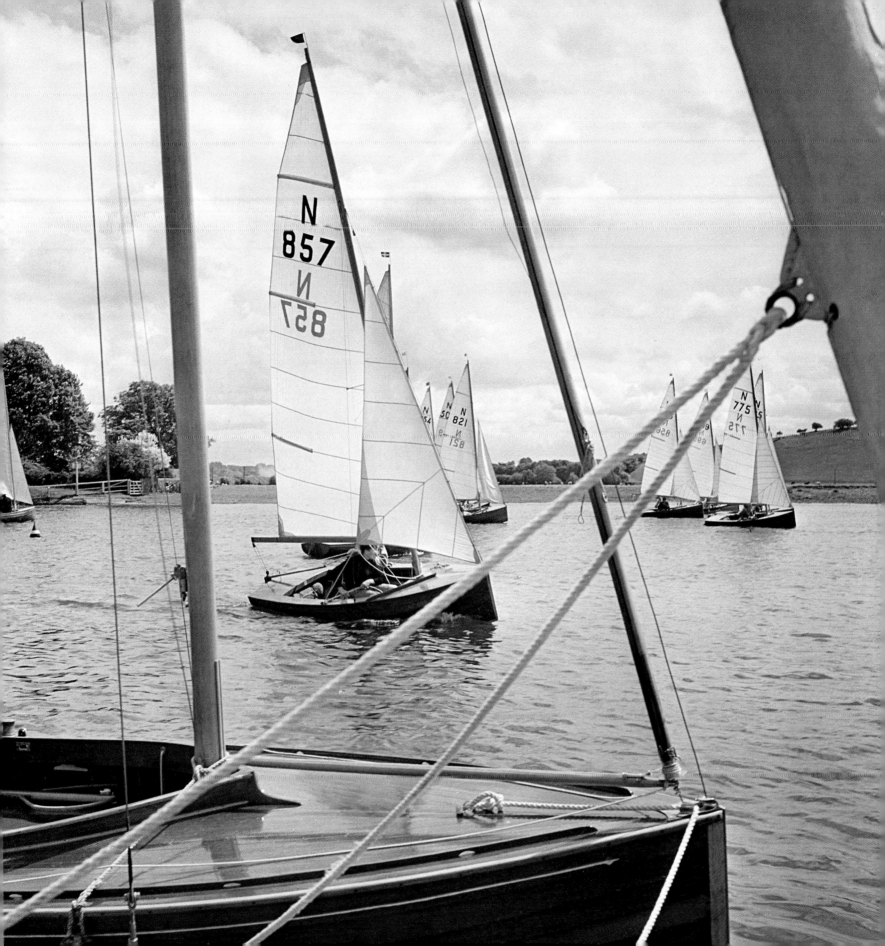

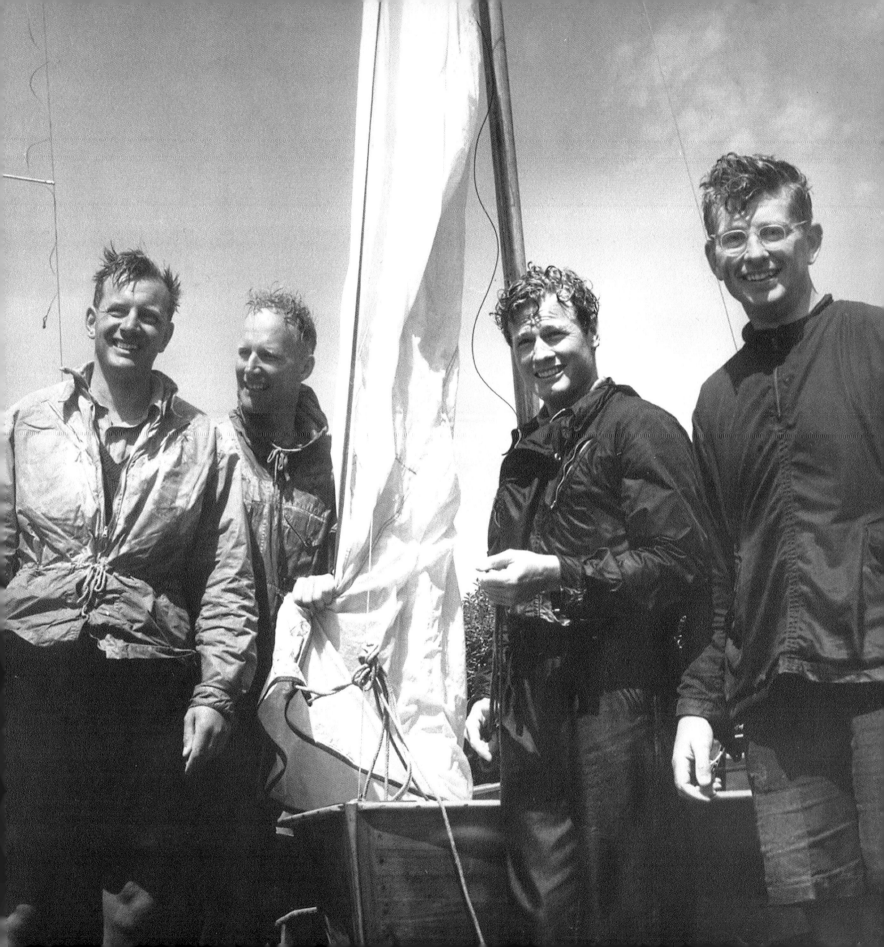

DINGHY LEGENDS

LEFT: Britain's elite sailors during the 1950s and '60s. Left to right: Charles Currey, Austin Farrar, Keith Shackleton and Bruce Banks.

BELOW: John Oakeley, pictured in 1958, won a hat trick of championships in the Merlin Rocket class between 1956 and 1958, and also won the National 12 Burton Trophy in 1957. In later years he went on to win the Flying Dutchman class world championship and represented Britain in two America's Cup campaigns.

TOP RIGHT: Designer Peter Milne sailing the prototype Fireball, built by Chippendale Boats at Fareham.

BOTTOM RIGHT: Designer Ian Proctor with his crewman Cliff Norbury. Proctor, along with Jack Holt, was one of Britain's most prolific dinghy designers, producing a series of Merlin Rocket and National 12 designs, the Wayfarer, Wanderer, Osprey and Tempest Olympic keelboat. He and Norbury also founded Ian Proctor Metal Masts, one of the first companies to introduce extruded aluminium masts.

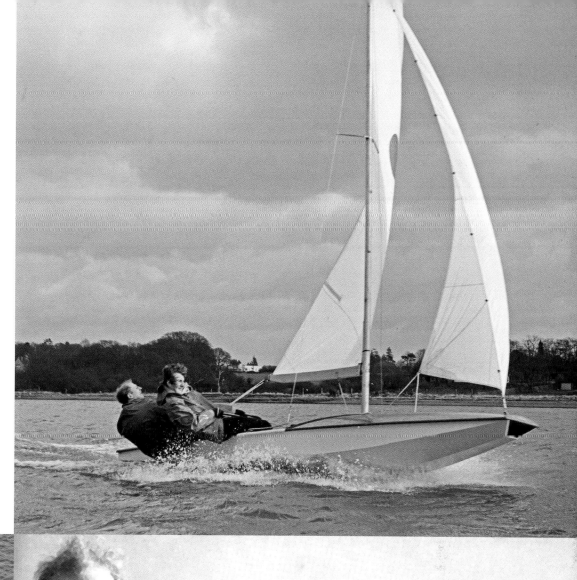

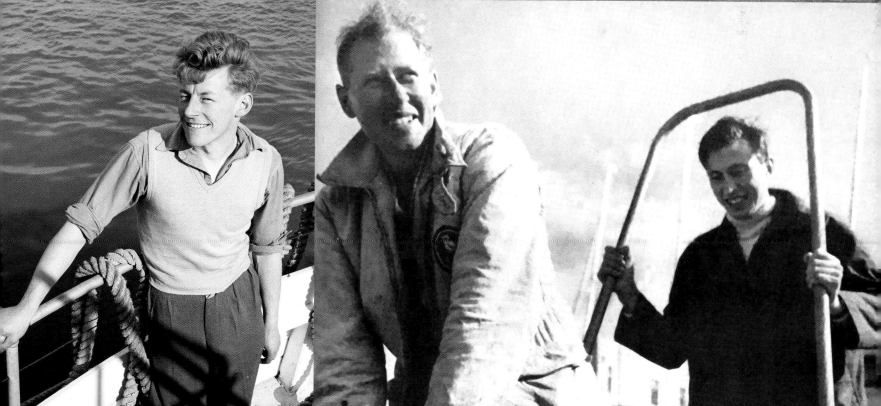

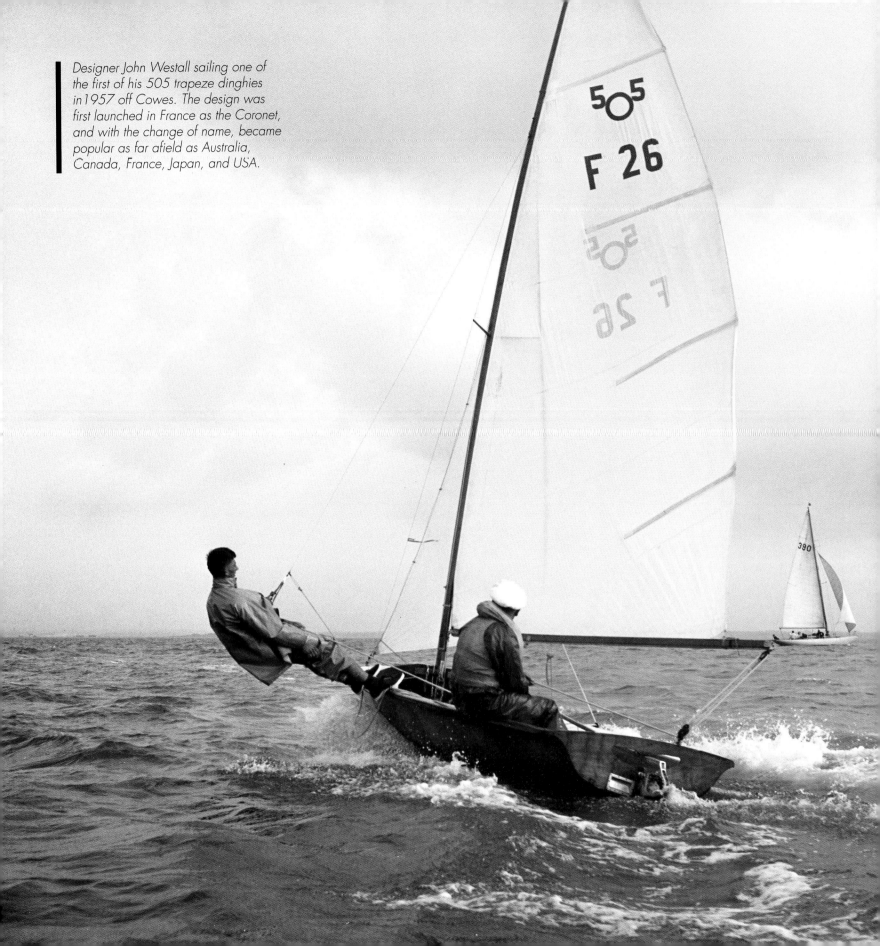

Designer John Westall sailing one of the first of his 505 trapeze dinghies in 1957 off Cowes. The design was first launched in France as the Coronet, and with the change of name, became popular as far afield as Australia, Canada, France, Japan, and USA.

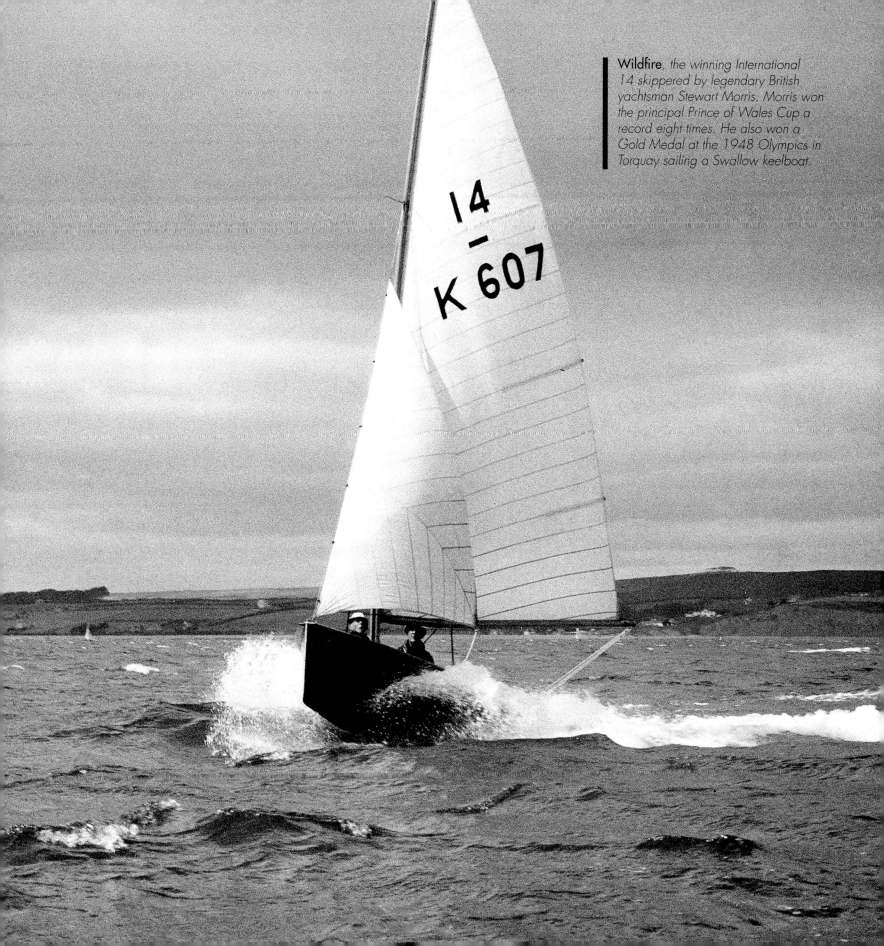

Wildfire, *the winning International 14 skippered by legendary British yachtsman Stewart Morris. Morris won the principal Prince of Wales Cup a record eight times. He also won a Gold Medal at the 1948 Olympics in Torquay sailing a Swallow keelboat.*

14
K 607

BELOW LEFT
Noggin's *crew leaning out hard during the 1959 GP14 Class championship.*

BELOW RIGHT
Vernon Stratton, the British Olympic representative in the Finn singlehander dinghy class preparing for the 1960 Olympic Regatta in Rome. Stratton finished 12th overall. He went on to manage the British Olympic yachting team from 1968 to 1980.

OPPOSITE
International 14 crews competing in the 1956 Luster Regatta at Tamesis Sailing Club on The Thames.

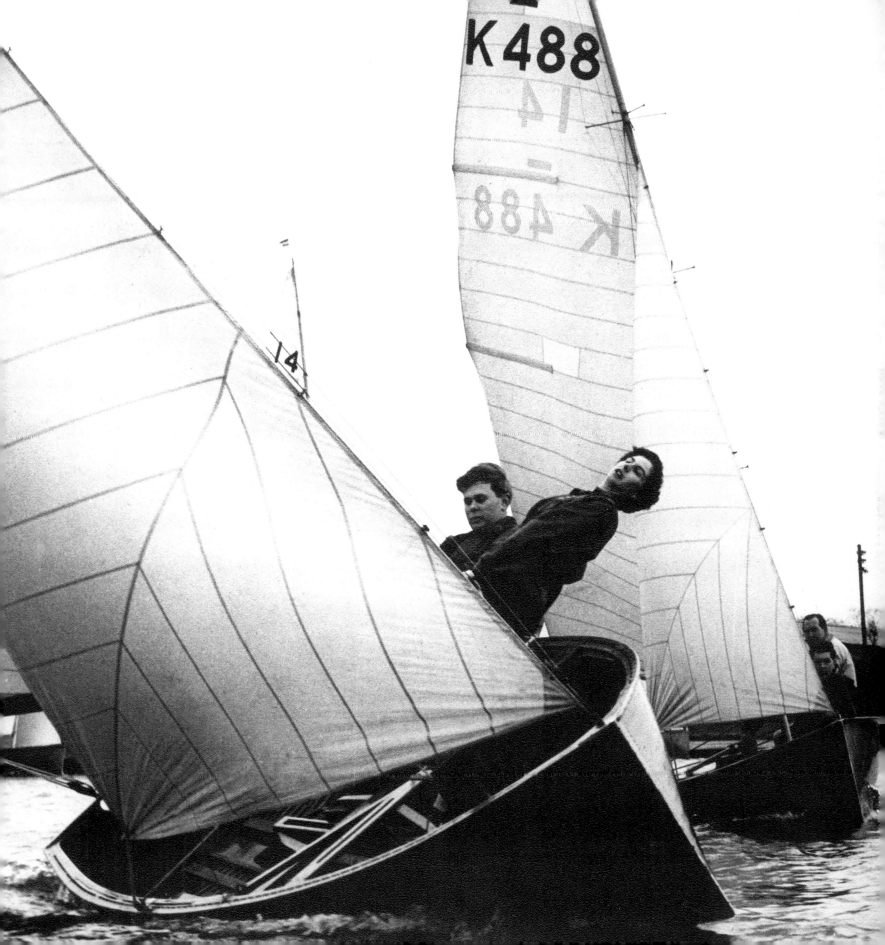

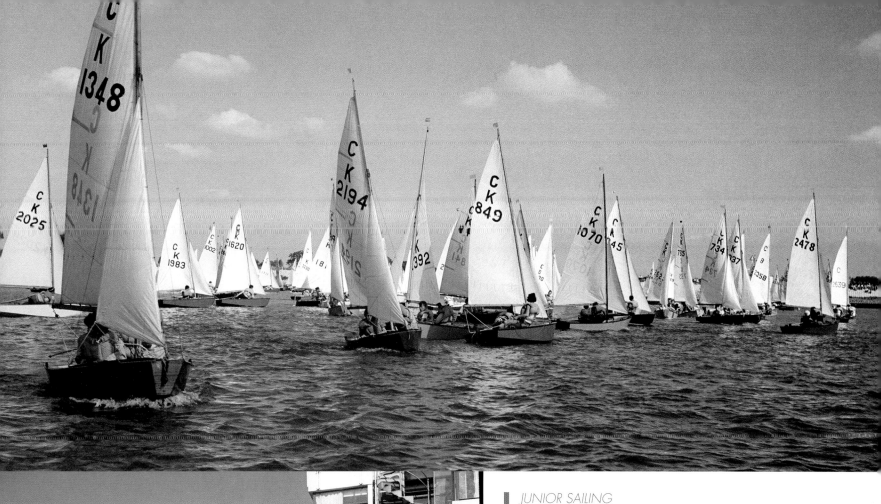

JUNIOR SAILING
Both the Optimist (opposite) and the Cadet (above) junior training dinghies were designed around an 8ft x 4ft sheet of plywood for home completion. The two classes developed ferocious competition. 'If ever we got in the way, it led to some appalling language,' Eileen recalls.

OPPOSITE
A study in concentration on the face of one young Optimist sailor during Optimist Week on The Hamble in 1962.

ABOVE
Junior crews competing in 1959 Cadet Week at Burnham-on-Crouch.

LEFT
The Royal Corinthian YC at Burnham-on-Crouch was a breeding ground for young sailing talent. Among those to have graduated through the Jack Holt-designed Cadet is triple Olympic medallist Rodney Pattisson.

First photographs of the ubiquitous Mirror dinghy.
Do-It-Yourself TV presenter Barry Bucknell came
up with the concept for this 11ft car-topper
utilising the stitch and glue method of plywood
construction pioneered within the canoe world.
The Daily Mirror, which decided to adopt the
class – hence the red sails – called in Jack Holt to
refine the design.

The Mirror was launched in 1962 as a
simple DIY project and Eileen Ramsay was
commissioned to take the first promotional
pictures. The first kits were priced at £69
including sails, and Bell Woodworking marketed
a complete version ready to sail for £149. The
boat was an immediate success. Five decades
later there are now close to 80,000 of these
dinghies worldwide.

(continued from page 30)

Eileen spent each season covering the major dinghy championships and selling the pictures to competitors, magazines and newspapers. She also devoted the first week of each August to photographing Cowes Week and travelled as far as the Menai Straits to cover more regional regattas. At one event, the press boat she was working from hit a wreck and sank. 'It was not a question of women and children first – it was cameras first,' she laughs now.

During a recent gathering of Yachtsman of the Year award winners, Iain MacDonald-Smith recalled Eileen approaching him and Rodney Pattisson on a lay-day during a Flying Dutchman championship they were competing in at Poole, prior to them winning the Gold Medal at the 1968 Olympics. 'I don't think anyone had asked us to do a shoot before, but we went out as far as Old Harry Rocks and sailed around her launch. The pictures she took of us were not only the best we had ever seen, but probably the most widely published pictures she had ever taken. They appeared everywhere.'

Former International 14 sailor the Rev David Brecknell also had the opportunity to reminisce when tracing two pictures that Eileen had taken of himself competing in the 1959 Bourne End Week, and at the Prince of Wales Cup off Falmouth the following year. On finding that her pictures were still available, Brecknell wrote to Eileen: 'I remember being fascinated by your technique of taking pictures with the camera slung from your neck and bending down over the side of the launch to press the shutter. The results have rarely been matched.'

Keith Musto, another of Eileen's famous subjects, has just as strong memories of another picture she took of him and his wife Jill sailing their National 12 *Crewcut* to victory at the 1956 Burton Cup off Weymouth. 'It was a remarkable shot that we still have on my wall at home. It has us sitting out hard with a splash of sunlight reflecting off a field in the distance that had the effect of giving me a halo around my head.'

'Eileen is one of those quiet, talented, determined people who you could easily miss in a crowded club house but whose ability behind the camera was outstanding in so many ways. Her skillful positioning to get not only the action shot of the boat but also the reflection of the water and the effect of the sky was absolutely brilliant. This is particularly relevant when we consider the limited equipment she used and compare it with today's state-of-the-art cameras. I have nothing but admiration for Eileen.'

Eileen continued to follow Musto's career, and when he and Tony Morgan were selected to represent Britain with their Flying Dutchman *Lady C* at the Tokyo Olympics in 1964, she was at the Whitstable Regatta to record their victory in the trials. The pictures were published extensively when the pair went on to win the Silver Medal.

With the exception of Kos, perhaps, very few women have managed to turn themselves into quite the household name that Eileen Ramsay became within the world of yachting photography. 'I don't know why. Perhaps it was because I wore the right shoes and didn't interfere,' she says delicately, before showing a more steely side to her character by adding, 'Don't let anyone tell you that a woman can't make their way in business. I always did, and got to places that male photographers would have given their right arm to have been.'

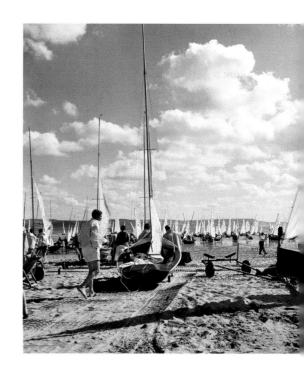

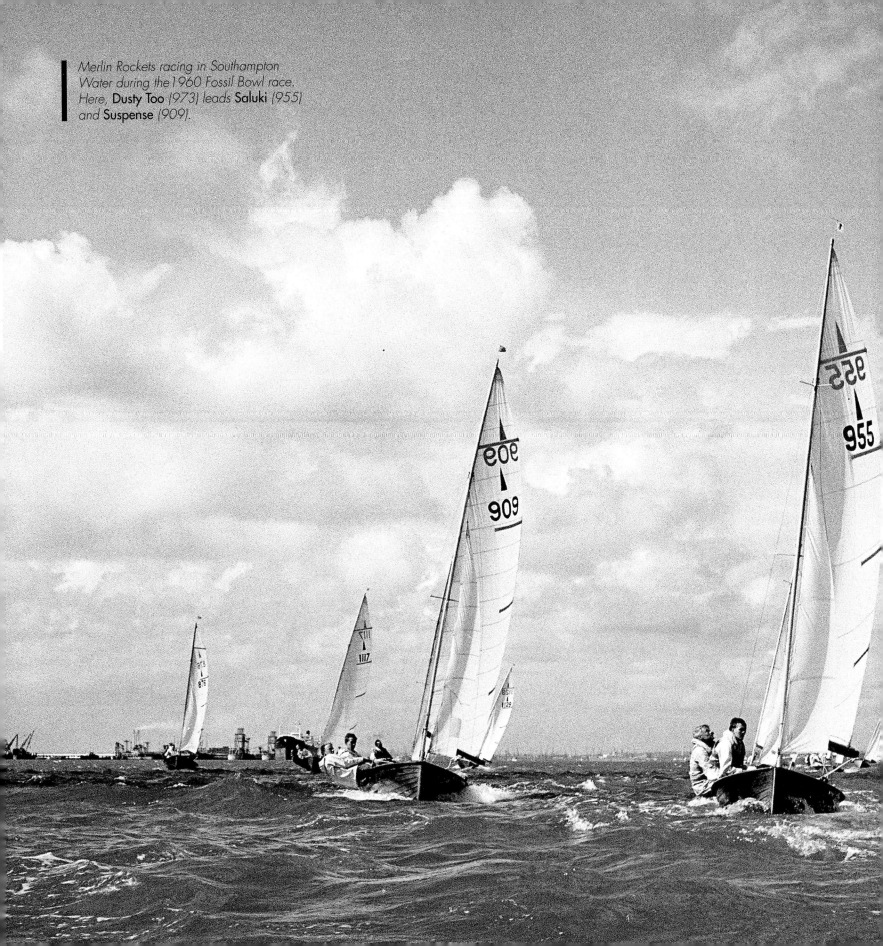

Merlin Rockets racing in Southampton Water during the 1960 Fossil Bowl race. Here, **Dusty Too** (973) leads **Saluki** (955) and **Suspense** (909).

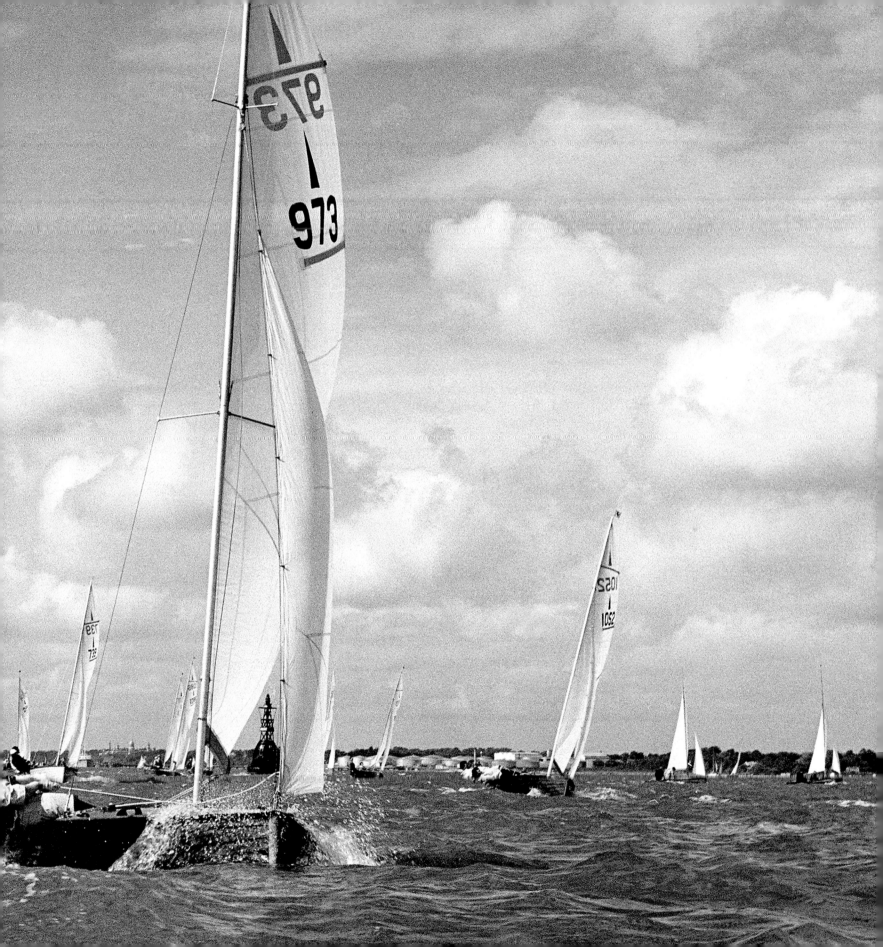

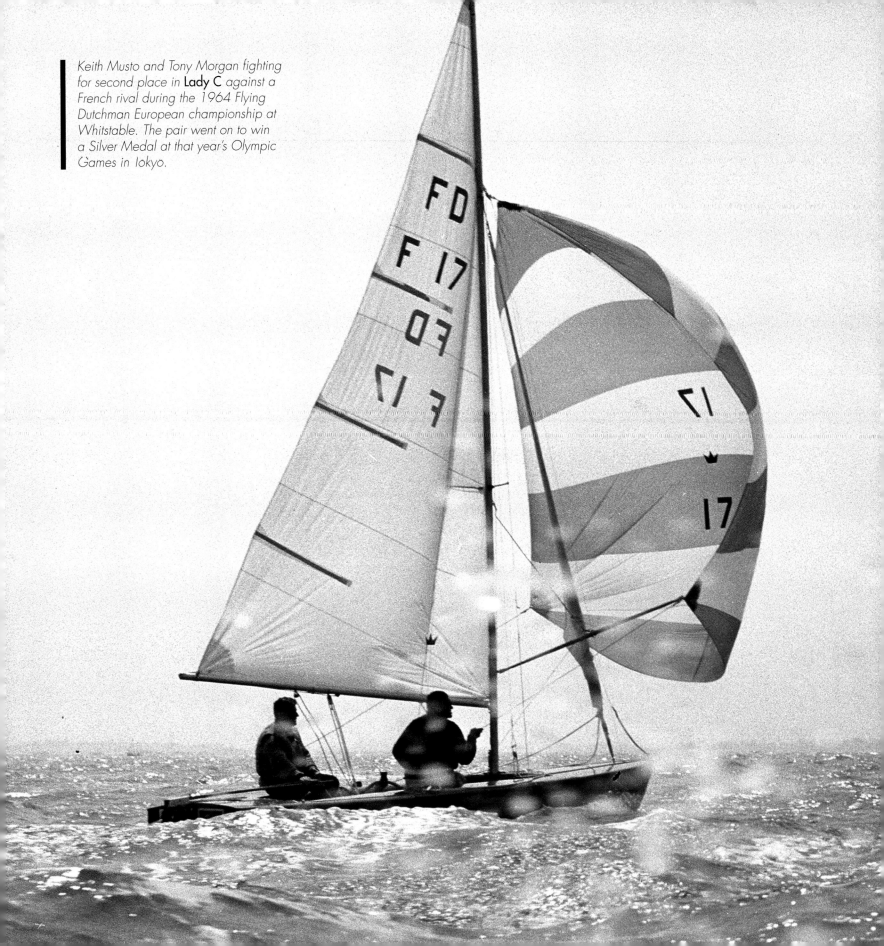

Keith Musto and Tony Morgan fighting for second place in **Lady C** against a French rival during the 1964 Flying Dutchman European championship at Whitstable. The pair went on to win a Silver Medal at that year's Olympic Games in Tokyo.

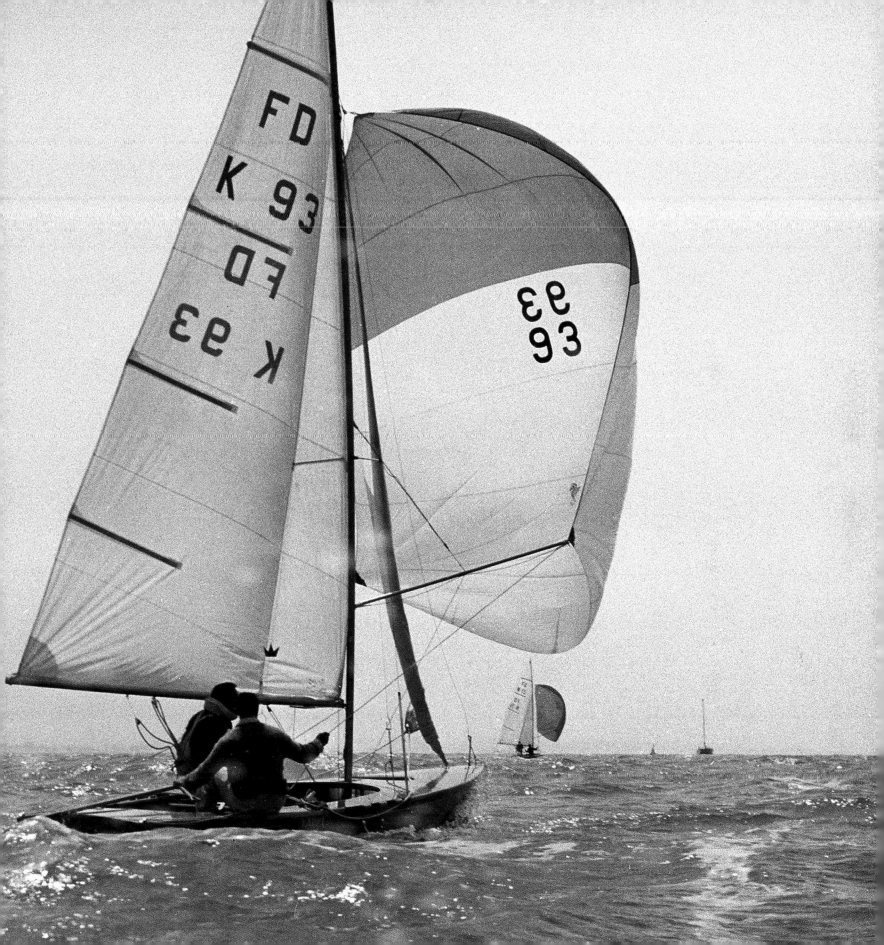

LEFT
Iain MacDonald-Smith and Rodney Pattisson photographed at Poole, prior to going out to Mexico and winning Gold at the 1968 Olympic Regatta in Acapulco.

OPPOSITE
Supercalifragilisticexpialidocious (Superdocious) *in perfect balance. This photoshoot was the first undertaken by any Olympic aspirants and the pictures were published widely after the pair won their Gold medals. Eileen wasn't allowed to photograph the inside of the boat. 'They were much faster than everyone else and didn't want to give any ideas away to the competition. We gave the pictures to the newspapers and magazines to hold and only publish after the Games.'*

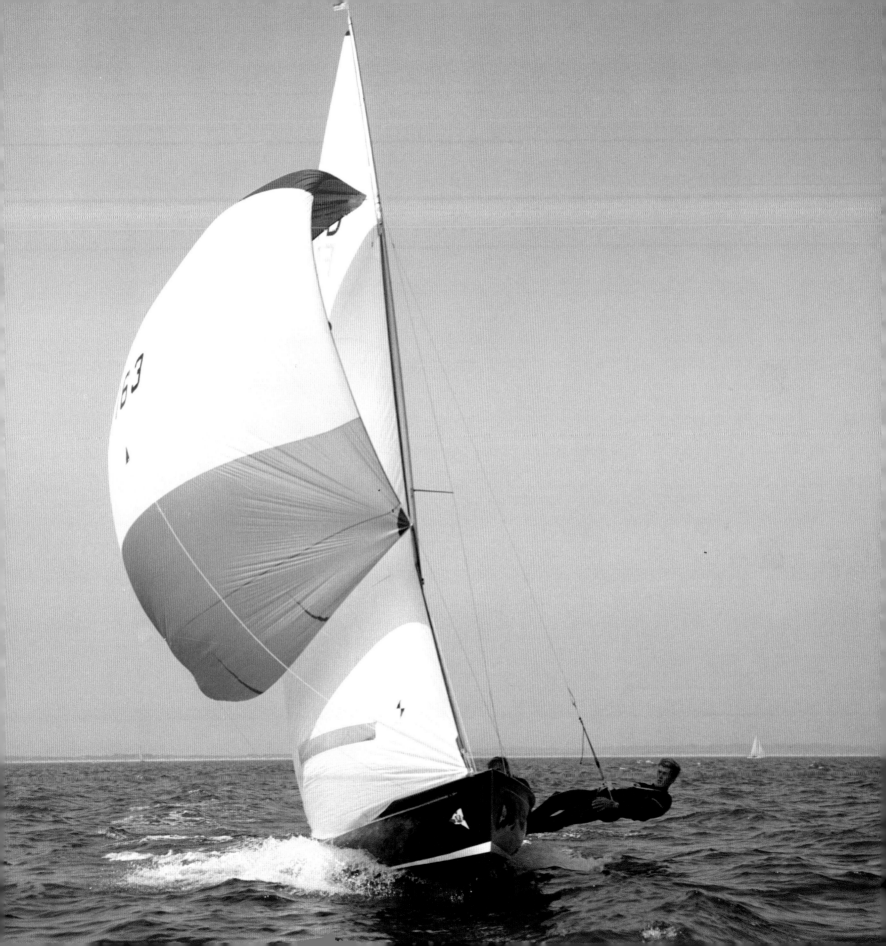

OPPOSITE
The first Putney to Tower Bridge dinghy race was held on the river in 1956.

OPPOSITE
The first Putney to Tower Bridge dinghy race was held on the river in 1956.

BELOW
The race was won by Jack Holt and Beecher Moore, pictured here from London Bridge in their Enterprise dinghy.

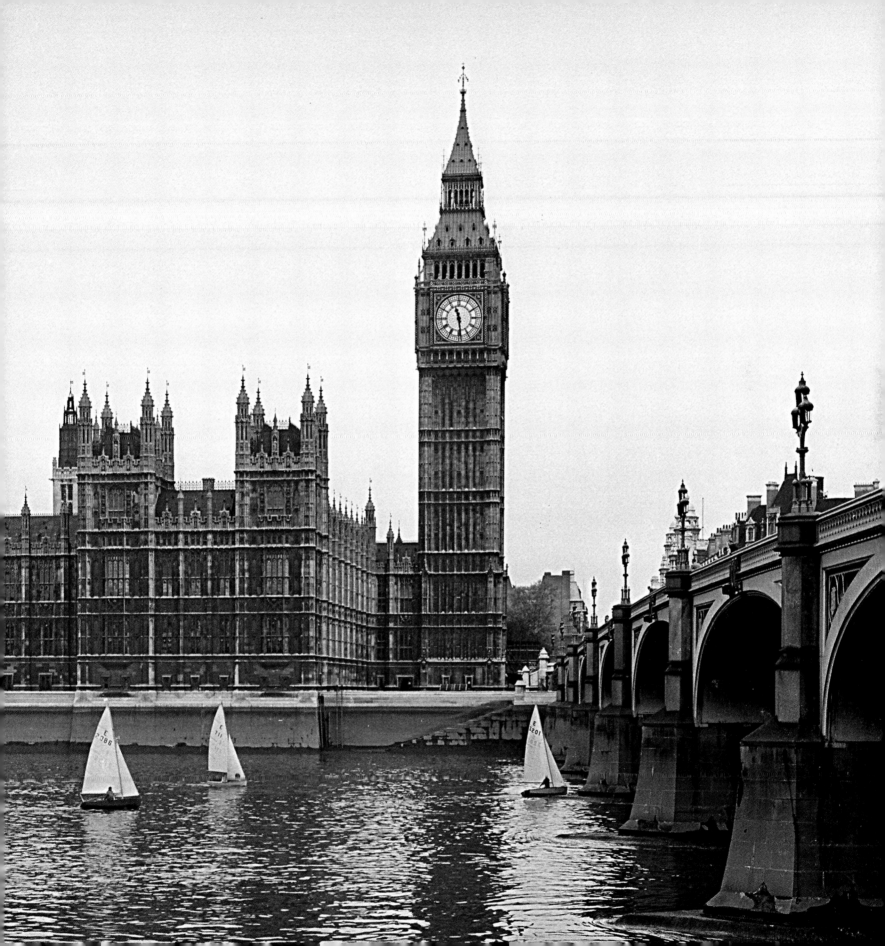

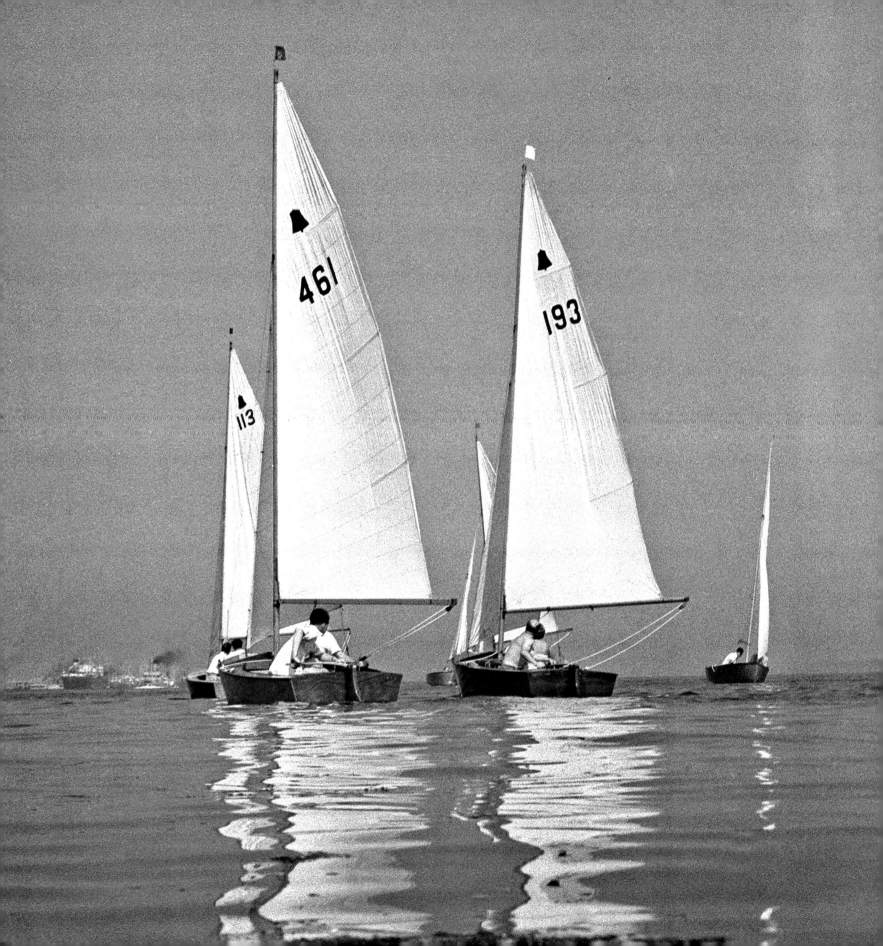

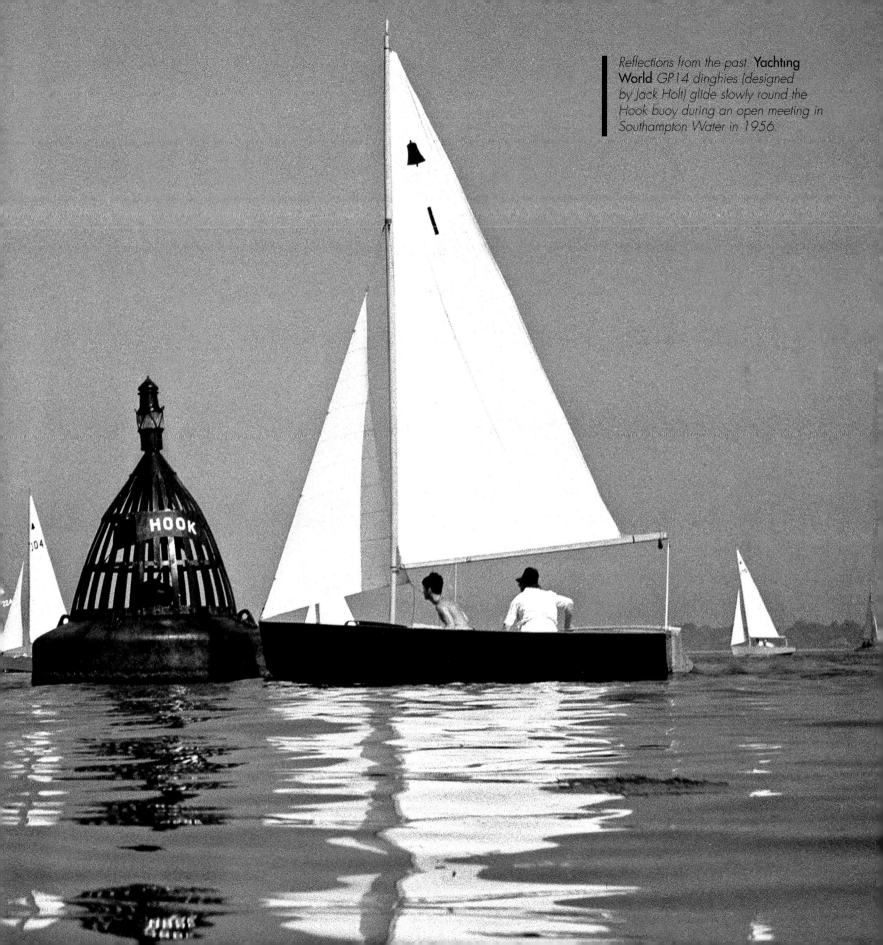

Reflections from the past. **Yachting World** *GP14 dinghies (designed by Jack Holt) glide slowly round the Hook buoy during an open meeting in Southampton Water in 1956.*

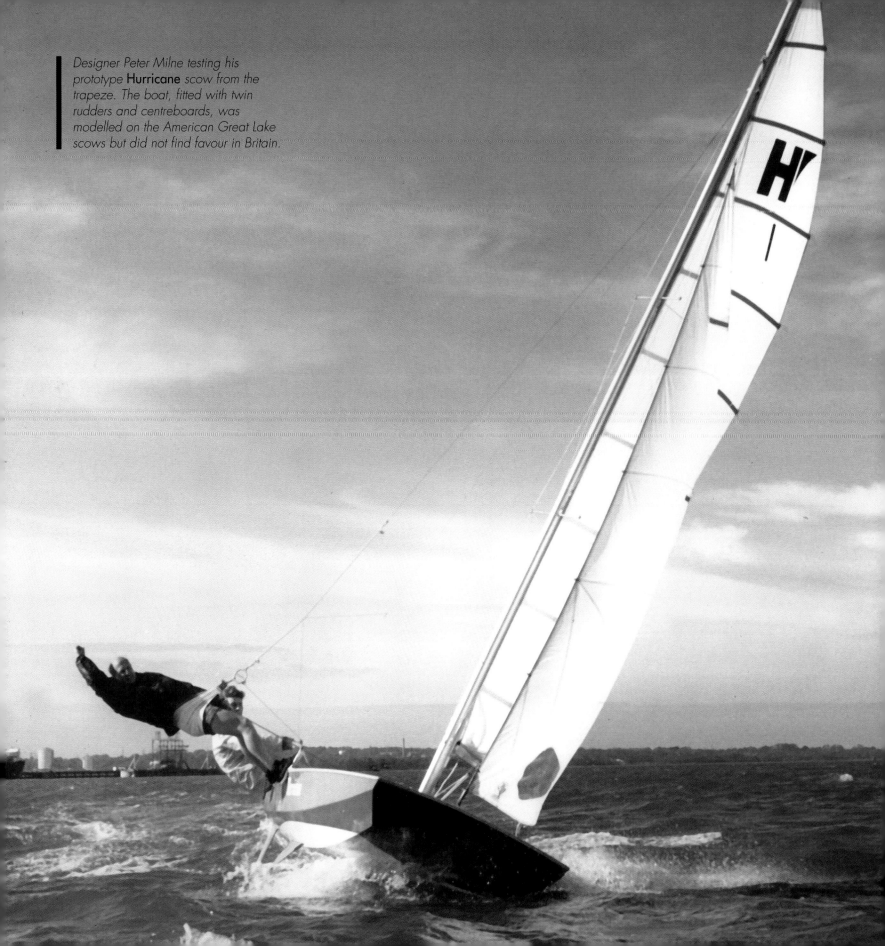

Designer Peter Milne testing his prototype **Hurricane** scow from the trapeze. The boat, fitted with twin rudders and centreboards, was modelled on the American Great Lake scows but did not find favour in Britain.

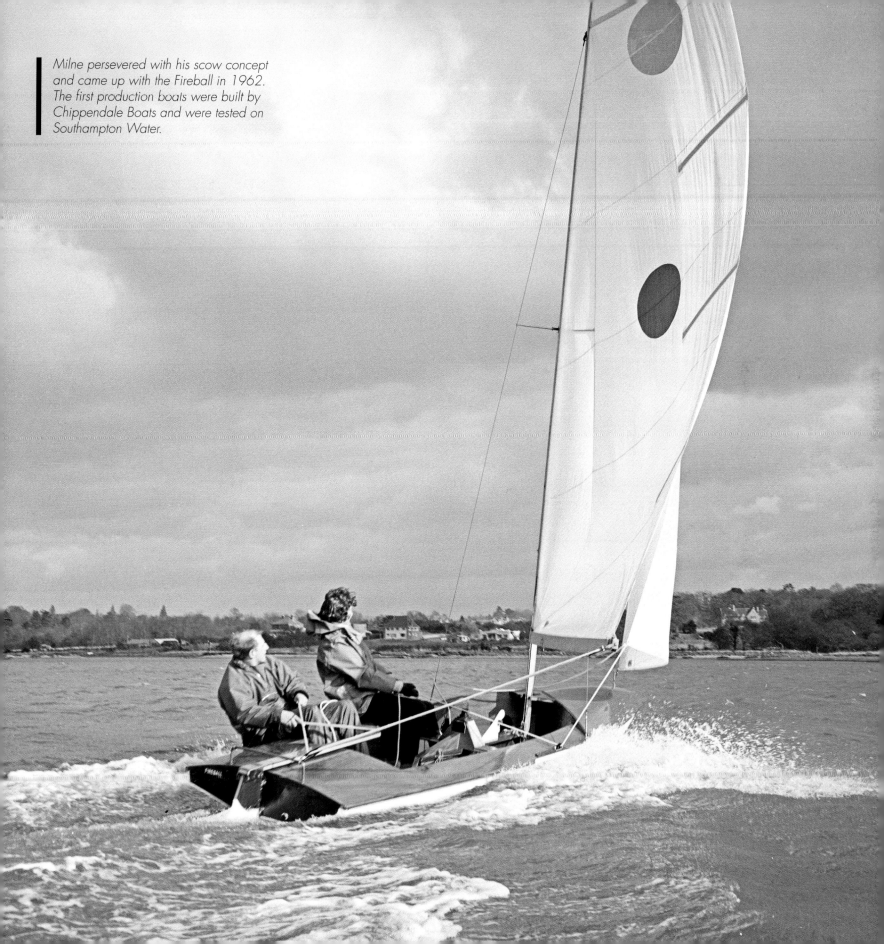

Milne persevered with his scow concept and came up with the Fireball in 1962. The first production boats were built by Chippendale Boats and were tested on Southampton Water.

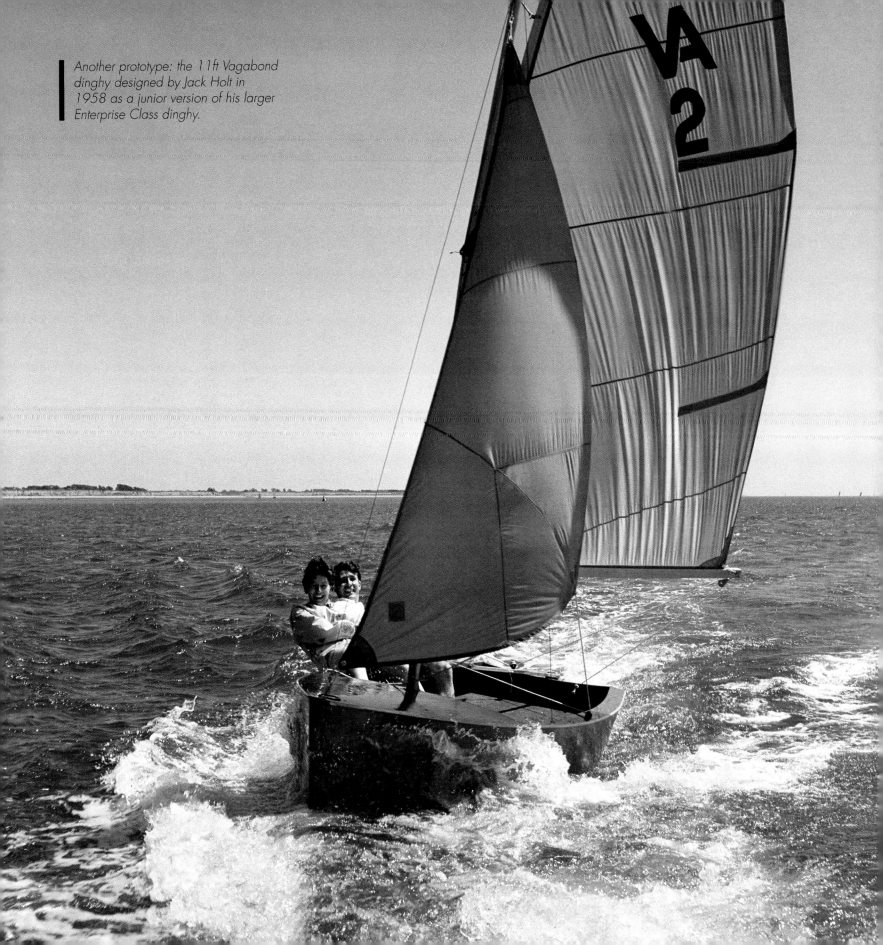

Another prototype: the 11ft Vagabond dinghy designed by Jack Holt in 1958 as a junior version of his larger Enterprise Class dinghy.

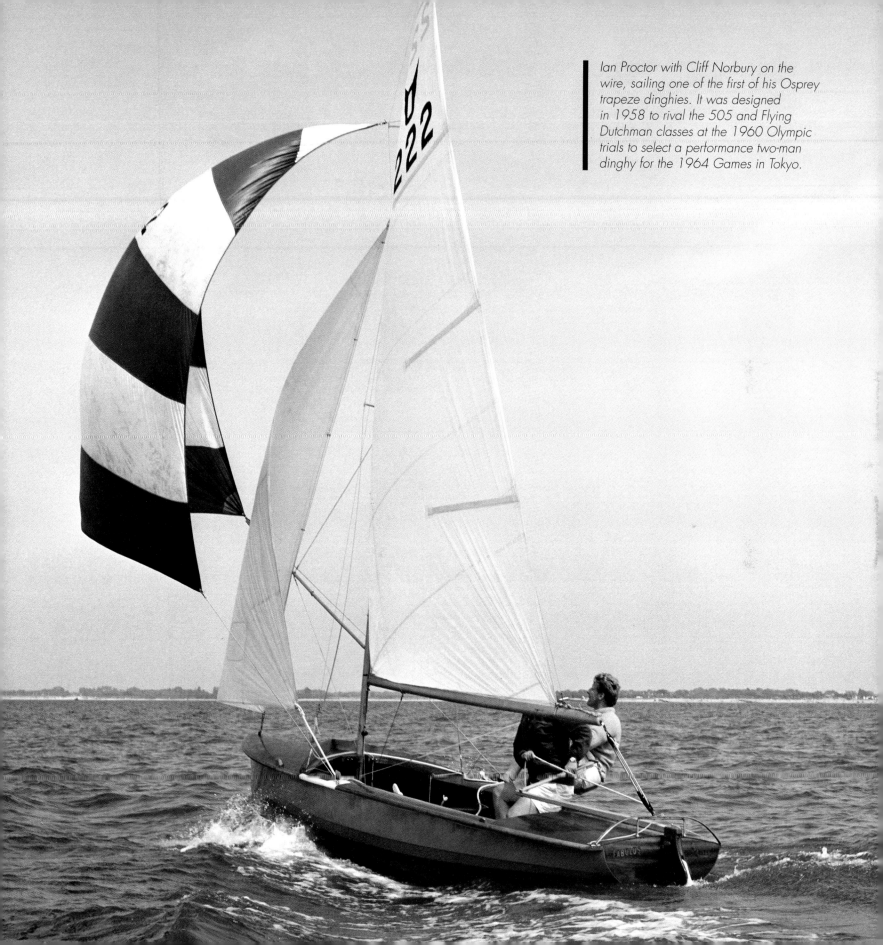

Ian Proctor with Cliff Norbury on the wire, sailing one of the first of his Osprey trapeze dinghies. It was designed in 1958 to rival the 505 and Flying Dutchman classes at the 1960 Olympic trials to select a performance two-man dinghy for the 1964 Games in Tokyo.

OPPOSITE
Firefly crews launching from Plymouth Hoe during their 1958 Class championship. The Firefly was the first mass-produced dinghy, manufactured by Fairey Marine using an autoclave system developed during the Second World War to produce airframes for the wooden Mosquito fighter/bomber.

BELOW
Peter Cook sailing his National 12 at an open meeting on the Hamble in 1956.

My first memories of Eileen were in the early 1950s when I was sailing in National 12s at Hamble River Sailing Club and on the open meeting circuit. In those days it was normal at open meetings for a practice race to be held on the Saturday and for the open meeting itself to take place on the Sunday.

Eileen then lived in London but would be on the water on the Saturday afternoon taking pictures. She returned to her darkroom in Edmonton, processed the pictures that night and returned the following day to photograph the open meeting itself and offer an array of pictures on view in the clubhouse and available to order.

In those days Eileen would hire a local motorboat for her photography. Later she moved to Hamble and used her own launch which was always handled expertly by her partner, George. She always used a Rolleiflex camera which had a viewfinder in the top and she specialised in shots taken over the side of the boat with the camera held low over the water.

Eileen was one of the first to supply colour pictures for the covers of yachting magazines and during my time as Editor of *Yachts & Yachting*, we featured many of her shots. She was also in great demand by boatbuilders to take shots for their brochures. She was used by Small Craft of Southampton for their Wayfarer, Gull, Graduate, Leader and GP14 publicity, by Camper & Nicholsons for their range of yachts and also by Fairey Marine for their sailing and power boats.

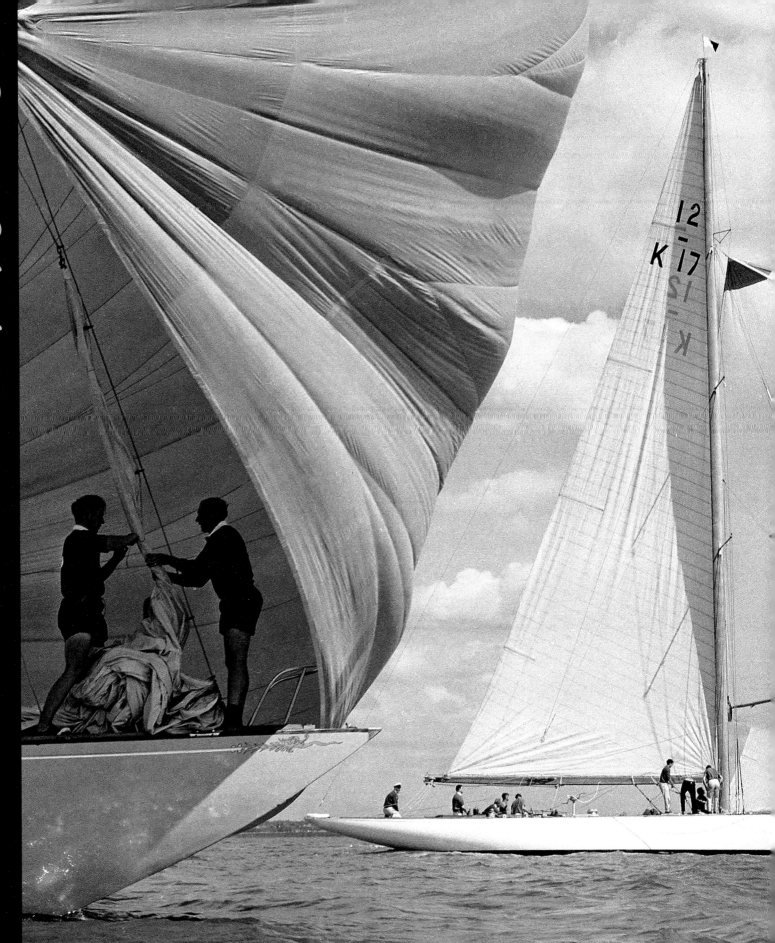

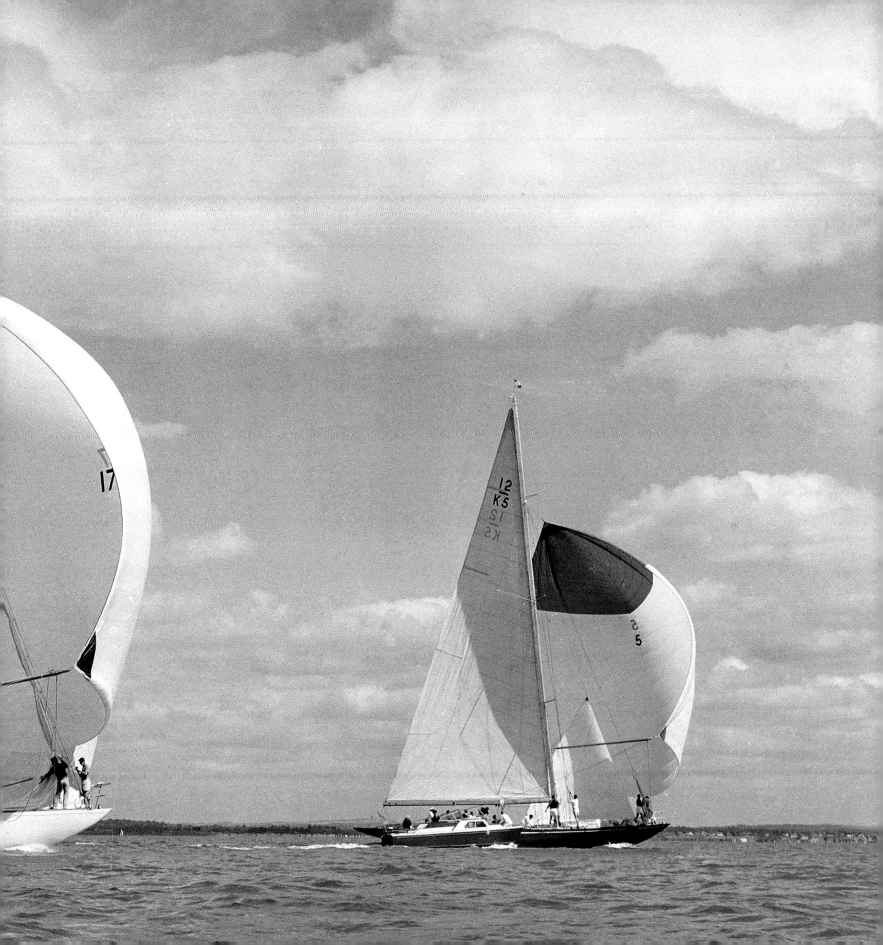

Cowes Week

Cowes has been the centre of yachting in Britain since the 1800s, and the annual Cowes Week Regatta, held during the first week of August, squeezed into the social calendar between Glorious Goodwood and the Glorious 12th – the start of the grouse shooting season – remains one of the largest in the world. Living at Hamble, just across the water, the cloud of coloured sailcloth was a natural attraction for Eileen's Rolleiflex to focus on.

Her first Cowes Week was in 1957 and she didn't miss a year until finally bagging up her camera gear in 1971. 'I photographed Prince Philip sailing with Uffa Fox on his Dragon class keelboat *Bluebottle* and the Uffa Fox – designed Flying Fifteen *Coweslip*, both given as wedding presents to him and Princess Elizabeth.' She also photographed *Bloodhound*, the 1930s Camper & Nicholson's ocean racer bought by the Royal Family in 1962 as a private yacht to compete at Cowes and accompany *Britannia* and the Royal Family on their annual Scottish cruise through the Hebrides.

Photographing royalty in the '50s and '60s was never as pushy as with the paparazzi today. 'I was always far more interested in making good pictures rather than the subjects within them, so I was never one to go chasing royalty.'

The Royal yacht *Britannia*, however, provided a great backdrop for photographing other yachts, and Eileen would work the angles to picture yachts crossing her bows whenever she could. During the 1950s, the kingpins within the sailing world were 12 metre crews gearing up for the first post-war America's Cup challenge against the New York YC in 1958. The Royal Yacht Squadron formed a challenge syndicate in September 1956 and after a series of trials in the Solent between *Evaine*, *Norsaga*, *Flica II*, and *Vanity V*, David Boyd's second design *Sceptre* (launched from Alexander Robertson's yard on the Clyde early in 1958) was selected for the match off Newport,

(continued on page 70)

PREVIOUS PAGE
12 Metre action: **Flica II, Sceptre** *and* **Vanity V** *provided a main focus during the 1962 Cowes Week Regatta.*

OPPOSITE
The 44ft Robert Clarke designed sloop **Naseby,** *built at Itchenor Shipyard, crosses* **Britannia's** *bows ahead of* **Swanilda,** *a 42ft sloop designed by Charles Nicholson and built by The Berthon Boat Company during the 1960 Cowes Week Regatta. Both yachts had been launched that year.*

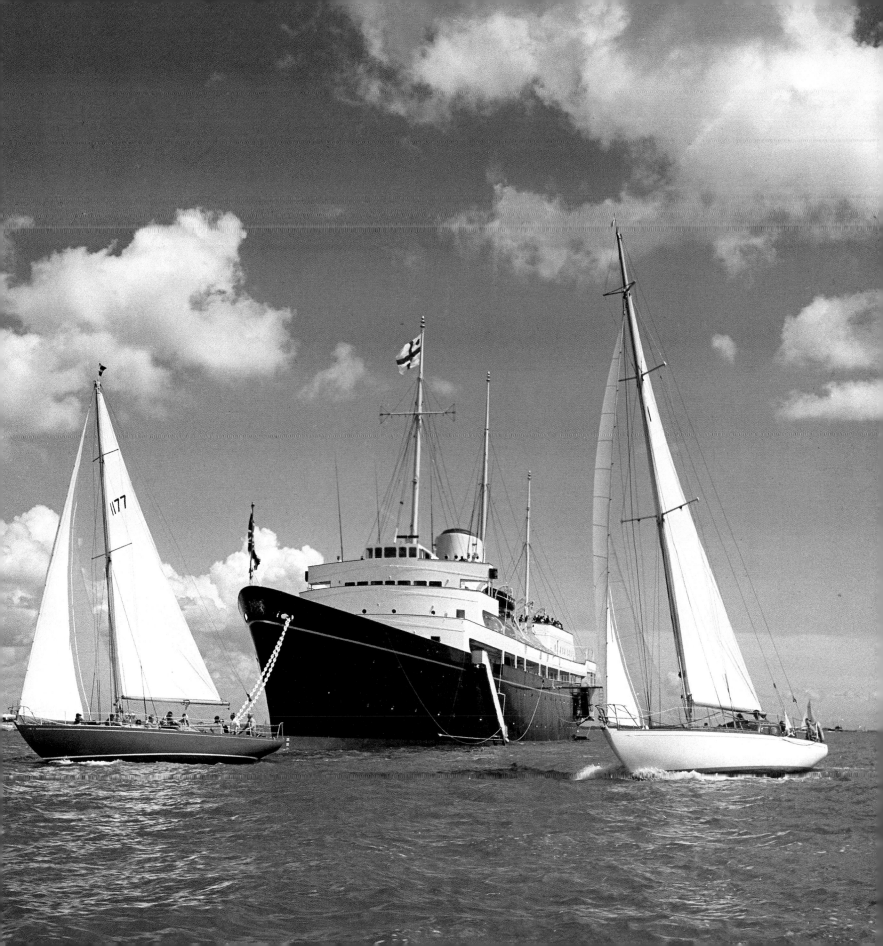

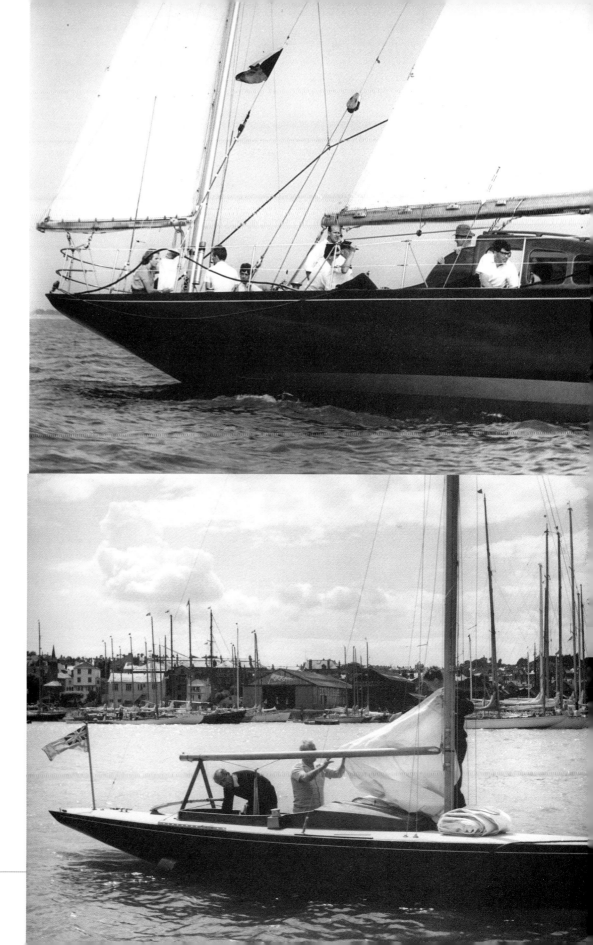

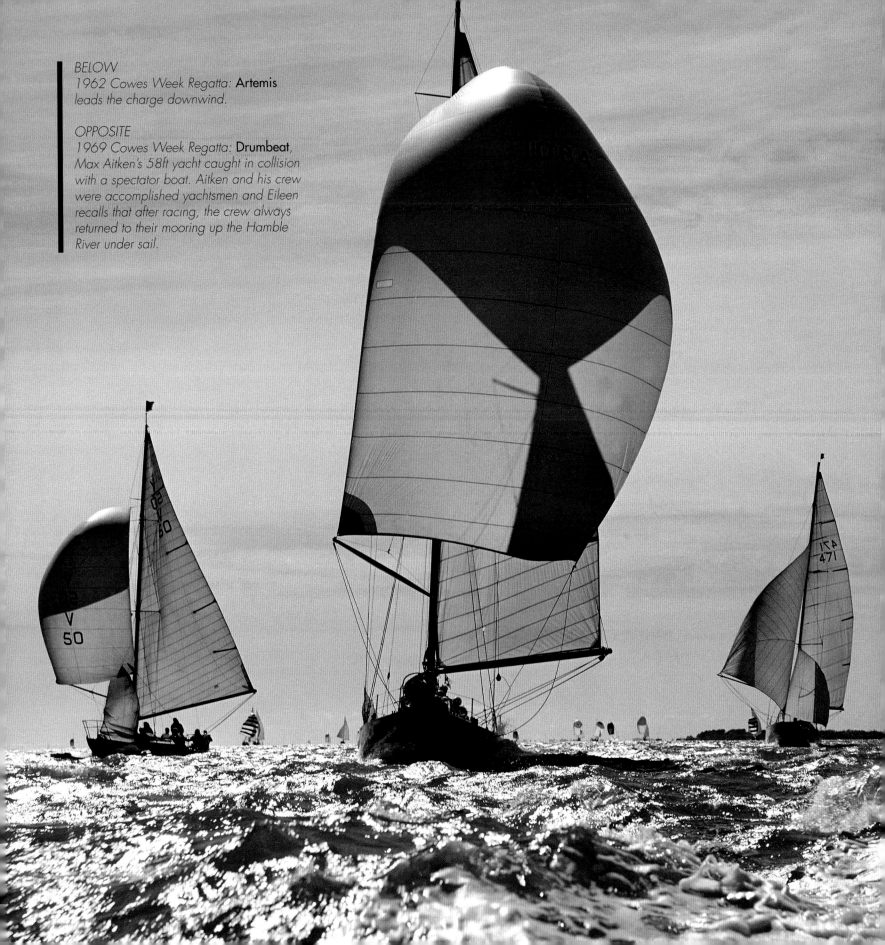

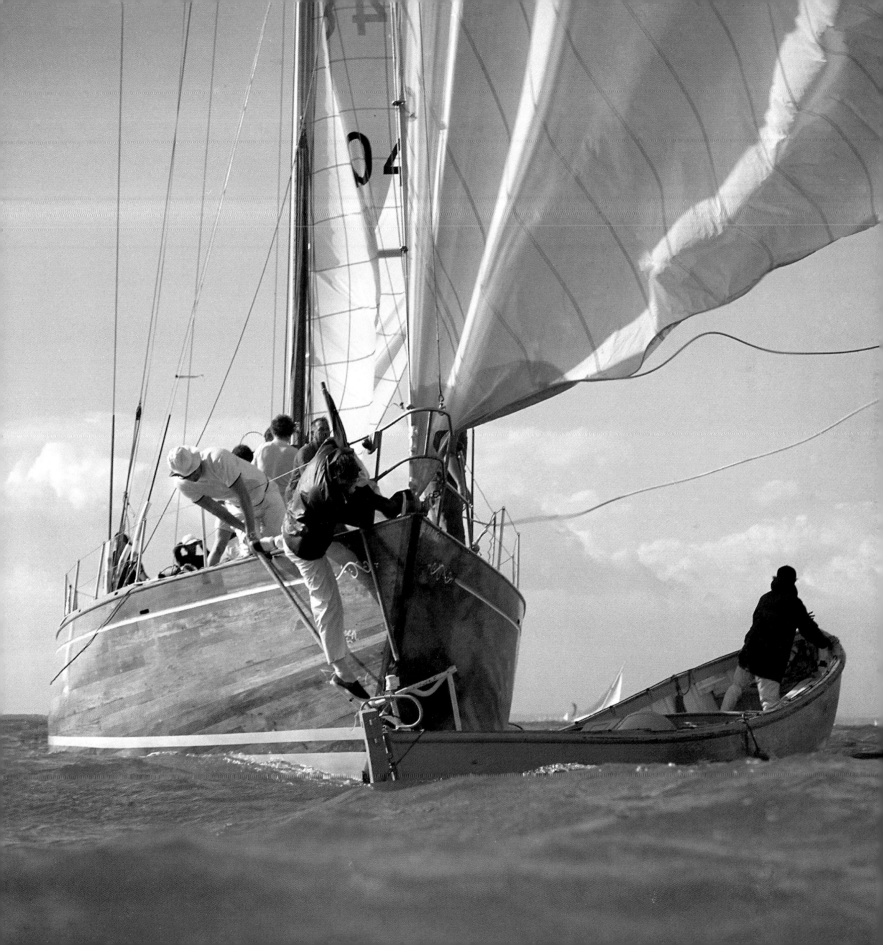

OPPOSITE
1967 Cowes Week Regatta. **Firebrand**, *Dennis Miller's successful British Admiral's Cup yacht reaching under spinnaker.* **Firebrand** *and her crew had also been a member of Britain's winning Admiral's Cup team two years before, but this year they finished second to Australia.*

(continued from page 64)

Rhode Island, in September that year. Great expectations rode on her wake, but the yacht was soundly beaten by the American 12 Metre *Columbia*. The same fate awaited *Sovereign*, Britain's next challenger in 1964, but these yachts nevertheless made for great pictures during racing at Cowes Week each year.

Another initiative led by the Royal Yacht Squadron was the introduction of the Admiral's Cup, a gold trophy put up in 1957 to encourage foreign teams to compete at Cowes Week. Initially, the USA was the only country to take up the challenge, but interest eventually spread, first to the Antipodes and then across Europe. When Edward Heath won the Sydney Hobart Race with his first *Morning Cloud* yacht in 1969, and later, when Prime Minister, he captained Britain's Admiral's Cup team to victory in 1971, coverage of the sport grew considerably. But while the media boats chased the big names, Eileen continued to focus on what made pictures good rather than the celebrities within them. The Dragon, Folkboat, South Coast One Design (SCOD) and X-Boat classes provided far better pictures, and with the media cameras pointing elsewhere, opportunities were all the easier to come by for Eileen.

Eileen's skilled portraiture became just as sought after as her sailing pictures. One of her most famous is of Uffa Fox, taken on the roof terrace of the sailing raconteur's house overlooking Cowes Roads. 'He was terrible,' she says now. 'I don't remember how many bedrooms there are in that house, but he tried to push me into each and every one of them. In the end, I had to tell him very firmly, "I am here to take a portrait photograph of you, and I think we should get on with it!" He and Max Aitken, who lived close by, were notorious friends, and between them, got up to all sorts of mischief.'

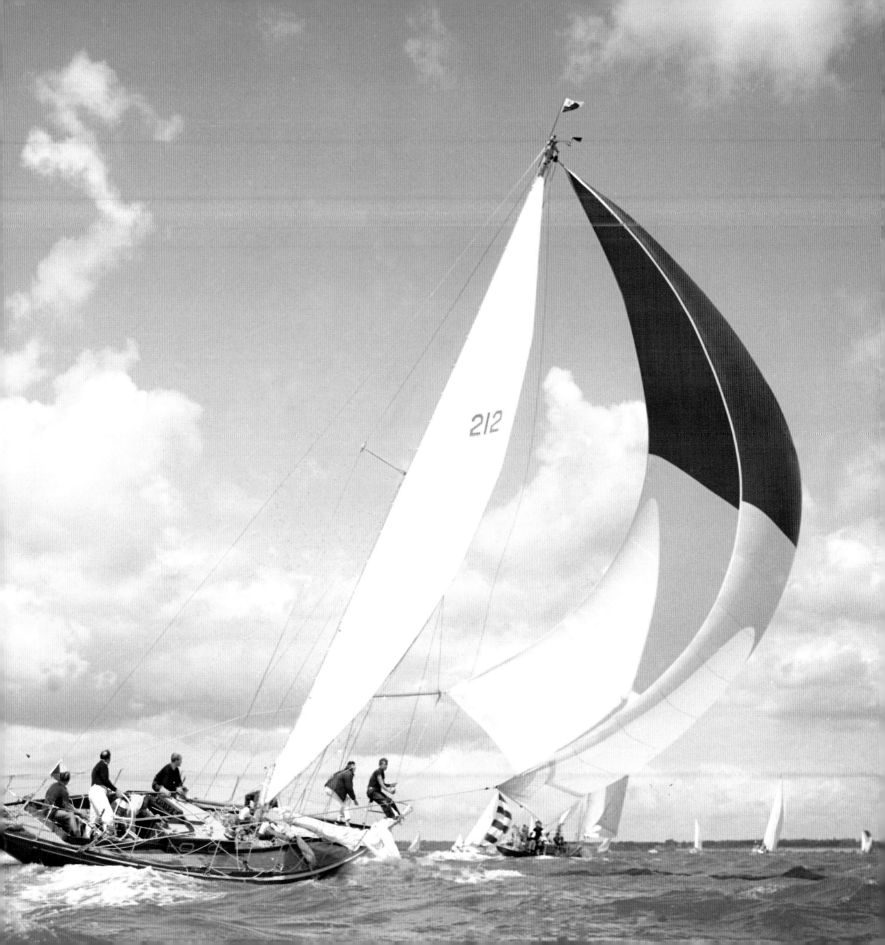

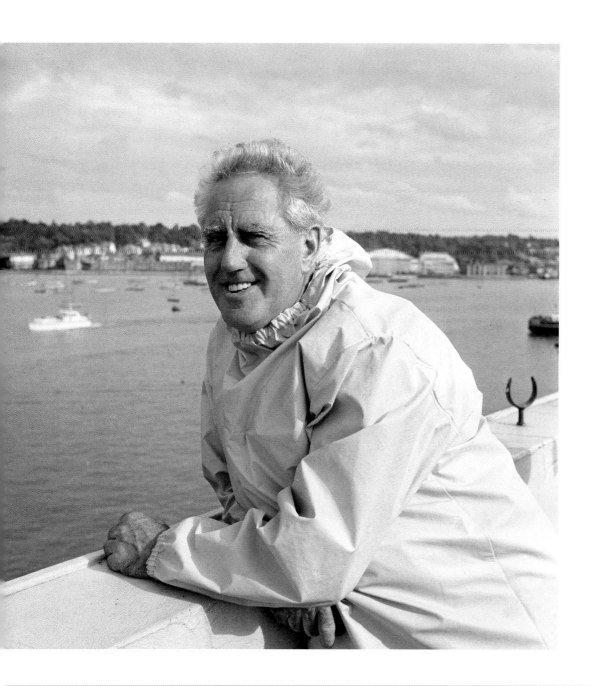

LEFT
The face of Cowes: Uffa Fox posing for Eileen's camera on the rooftop terrace of his house.

OPPOSITE
Max Aitken at the helm of his famous One-tonner **Roundabout** *during the 1966 Cowes Week Regatta.*

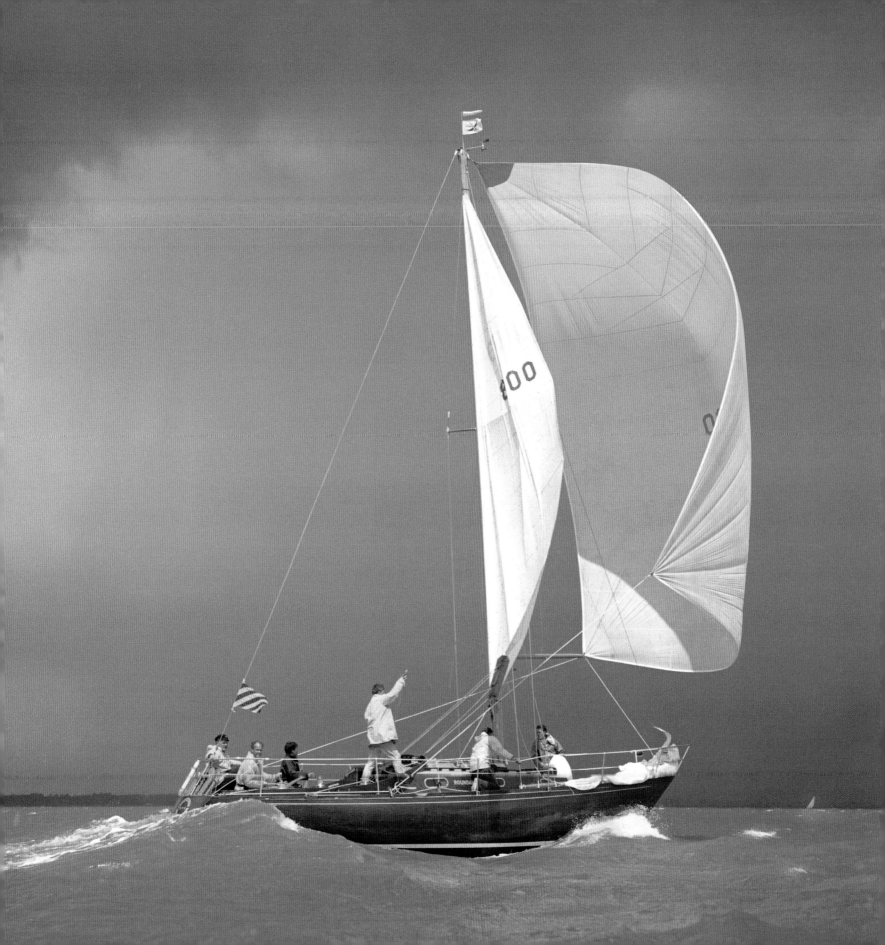

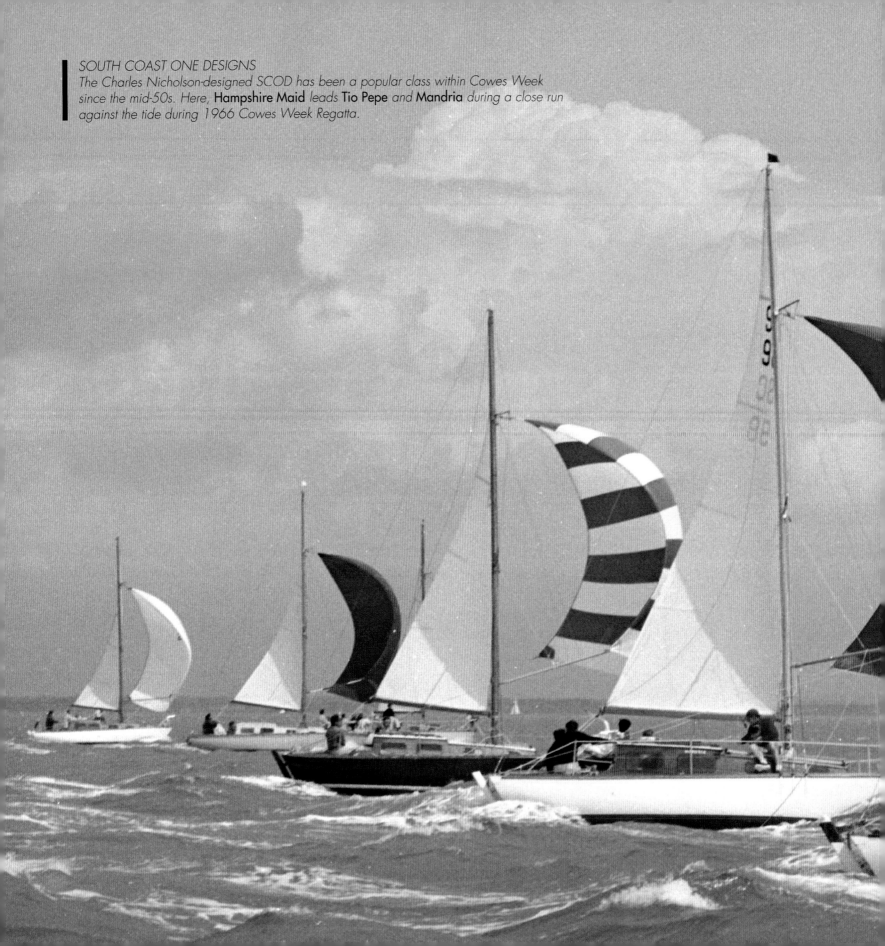

SOUTH COAST ONE DESIGNS
The Charles Nicholson-designed SCOD has been a popular class within Cowes Week since the mid-50s. Here, **Hampshire Maid** leads **Tio Pepe** and **Mandria** during a close run against the tide during 1966 Cowes Week Regatta.

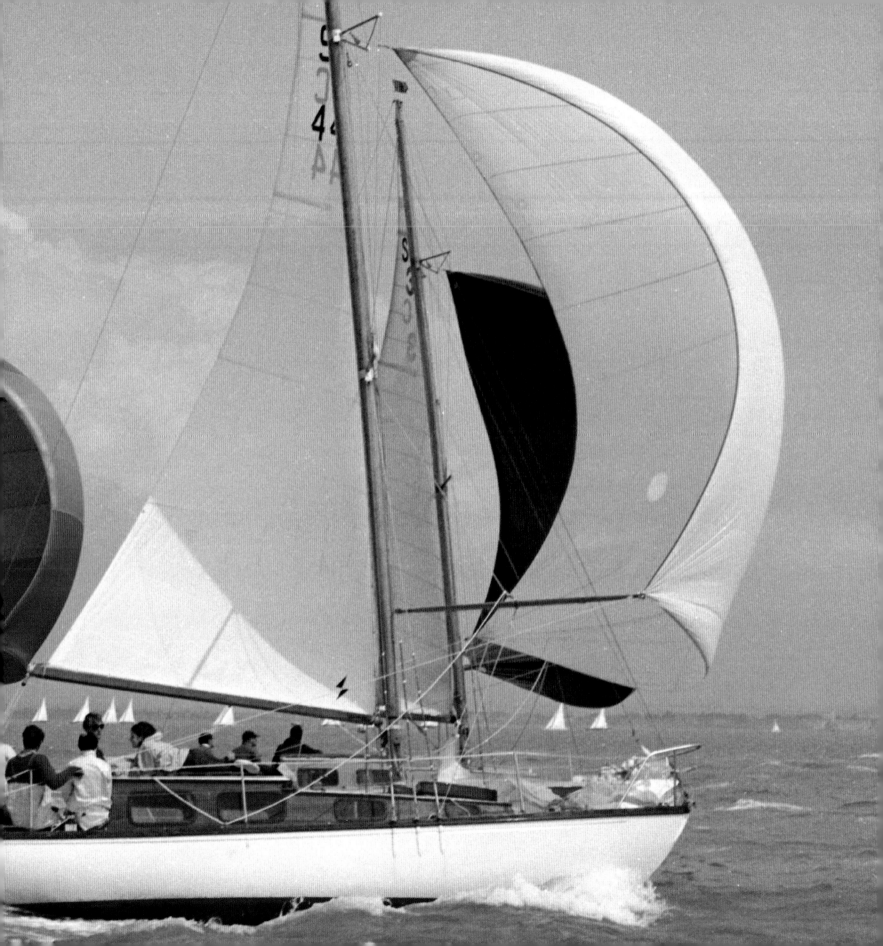

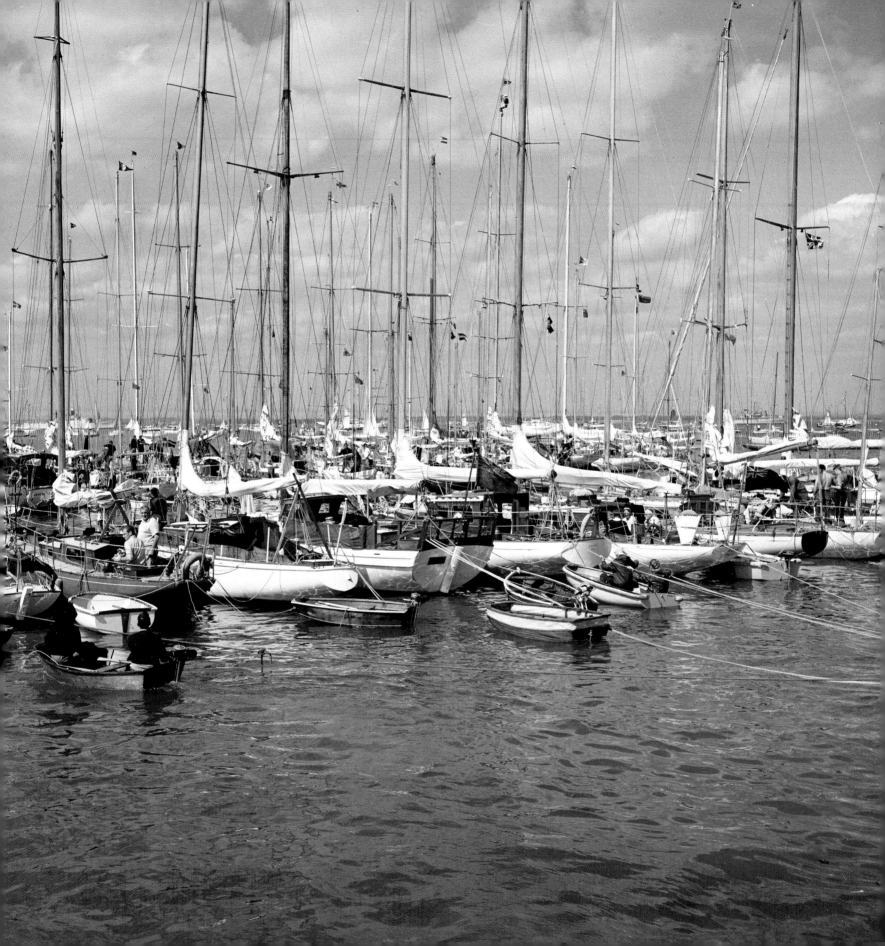

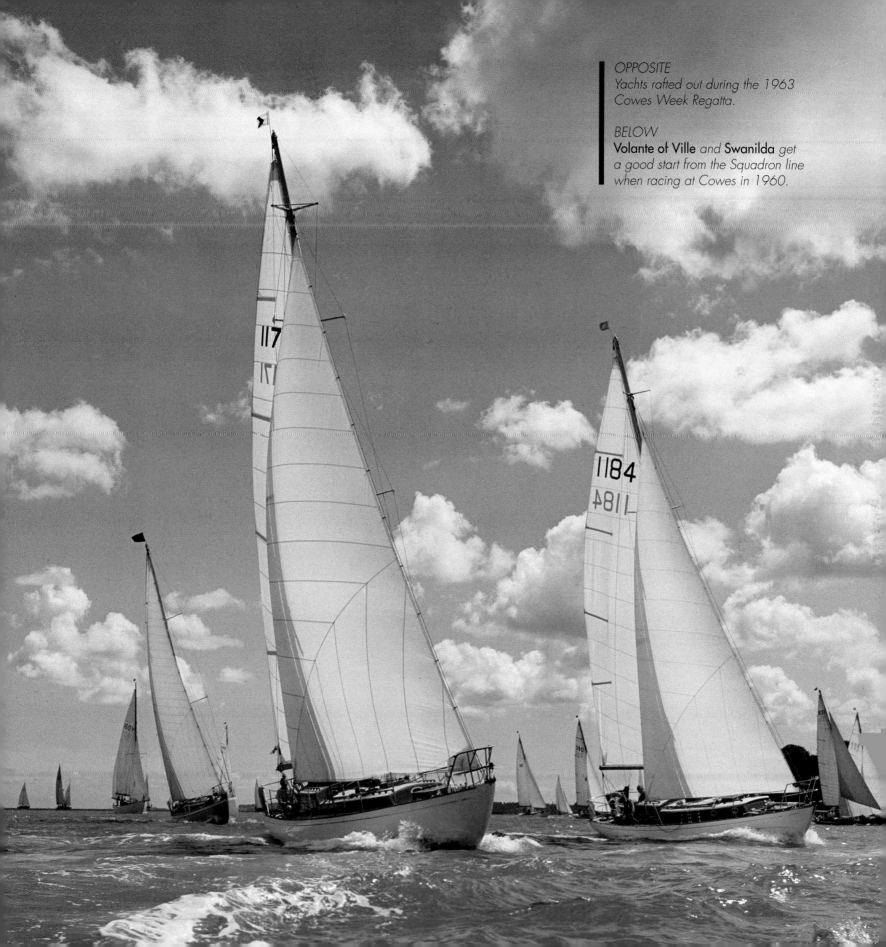

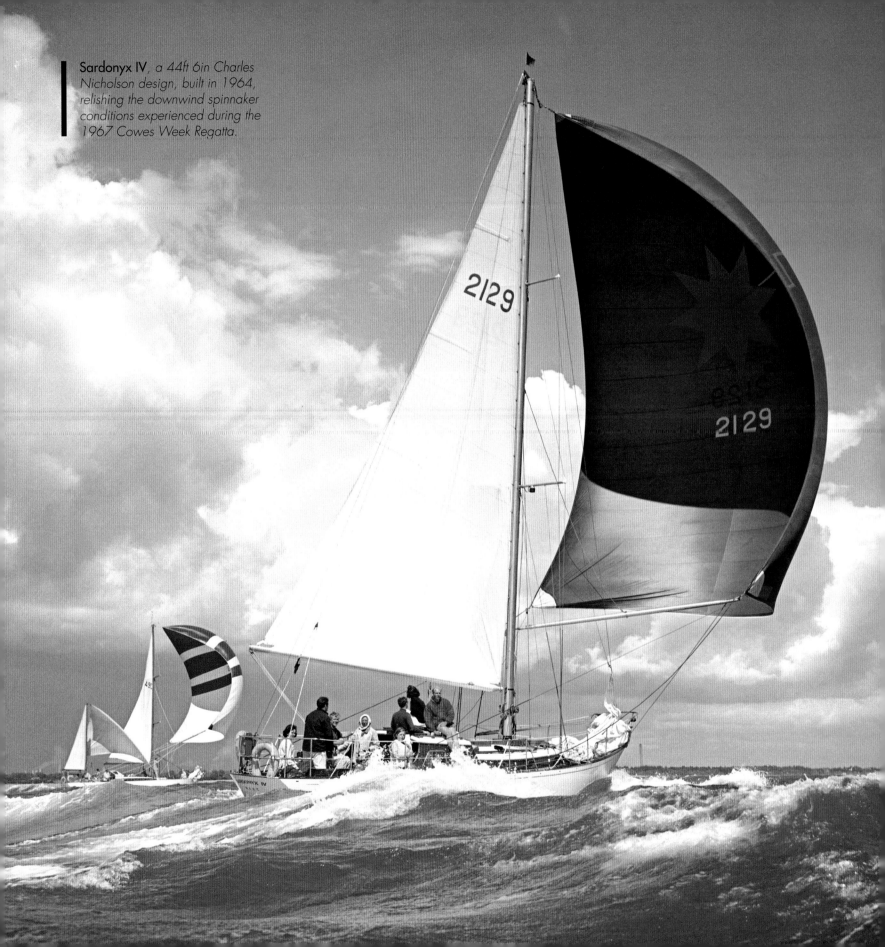

Sardonyx IV, *a 44ft 6in Charles Nicholson design, built in 1964, relishing the downwind spinnaker conditions experienced during the 1967 Cowes Week Regatta.*

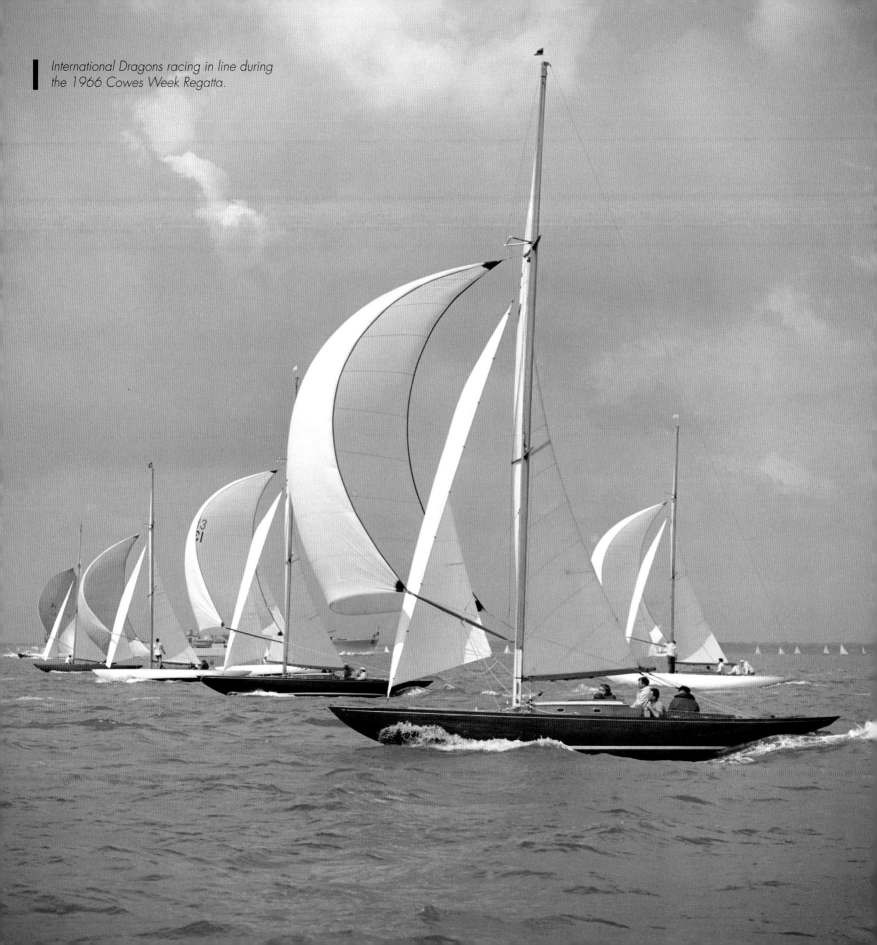

International Dragons racing in line during the 1966 Cowes Week Regatta.

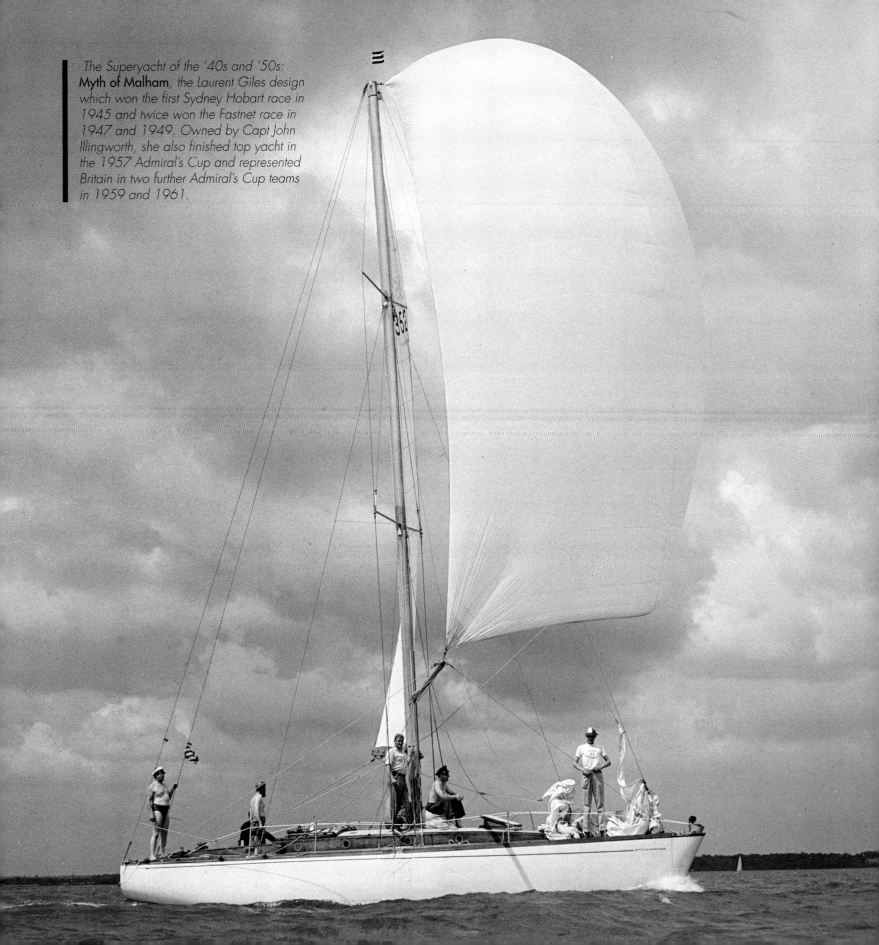

The Superyacht of the '40s and '50s: **Myth of Malham**, the Laurent Giles design which won the first Sydney Hobart race in 1945 and twice won the Fastnet race in 1947 and 1949. Owned by Capt John Illingworth, she also finished top yacht in the 1957 Admiral's Cup and represented Britain in two further Admiral's Cup teams in 1959 and 1961.

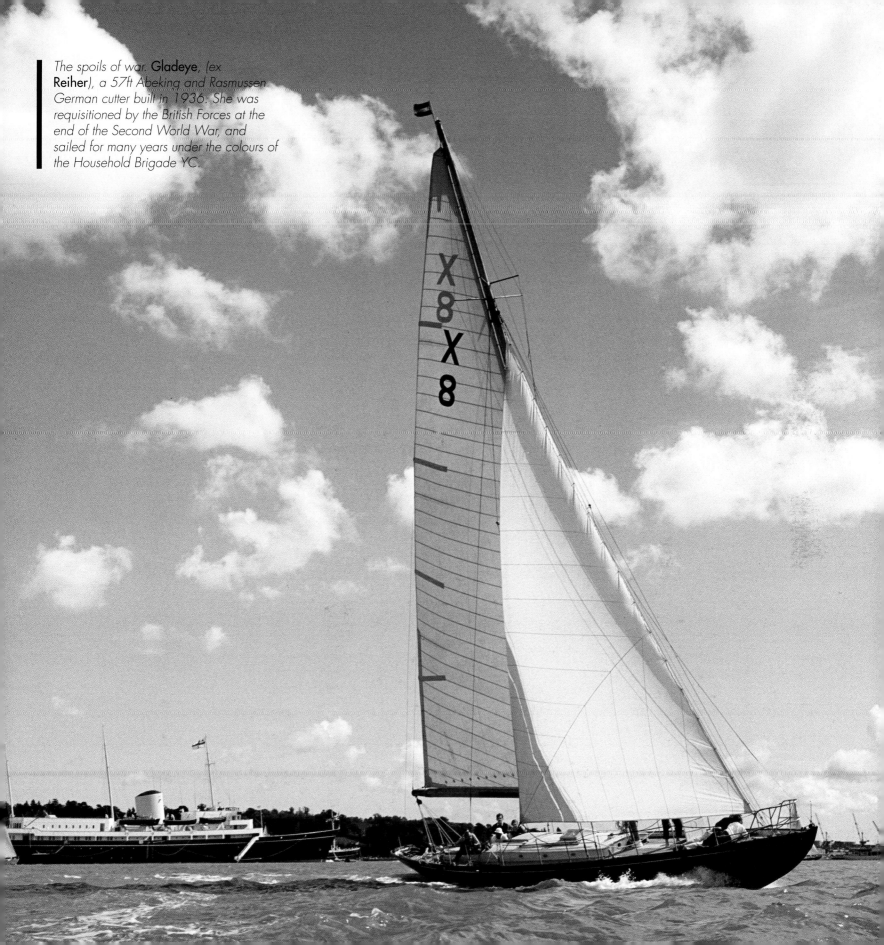

The spoils of war. **Gladeye**, (ex **Reiher**), a 57ft Abeking and Rasmussen German cutter built in 1936. She was requisitioned by the British Forces at the end of the Second World War, and sailed for many years under the colours of the Household Brigade YC.

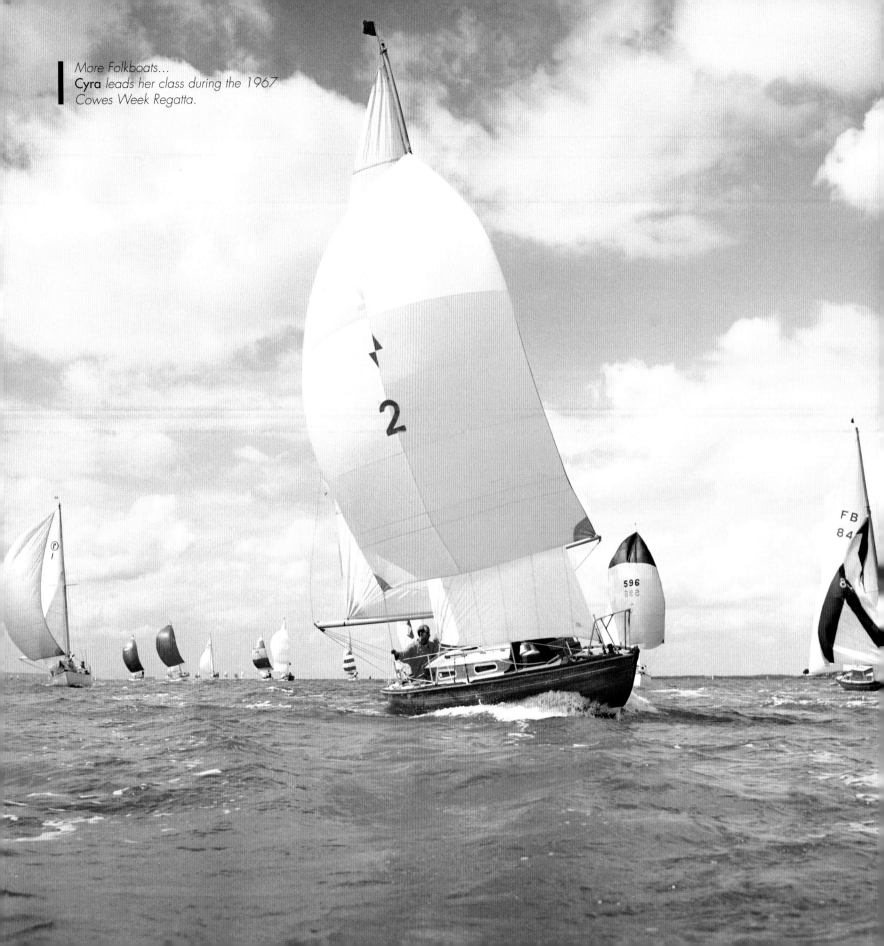

More Folkboats...
Cyra *leads her class during the 1967 Cowes Week Regatta.*

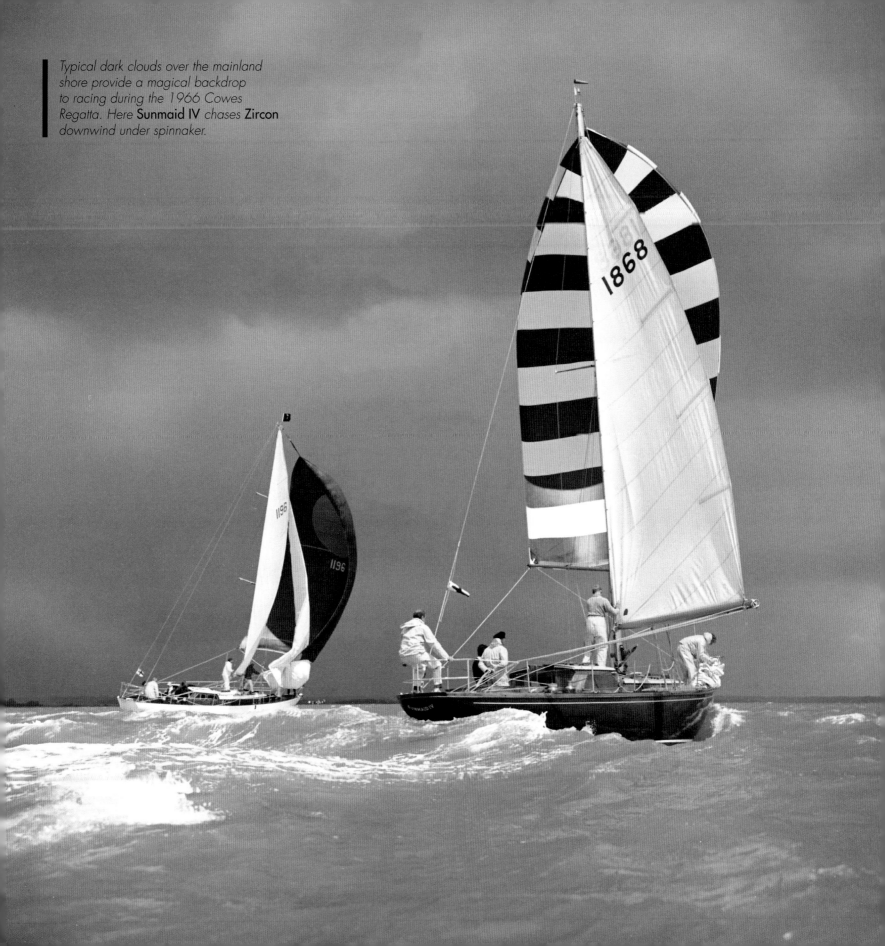

Typical dark clouds over the mainland shore provide a magical backdrop to racing during the 1966 Cowes Regatta. Here **Sunmaid IV** *chases* **Zircon** *downwind under spinnaker.*

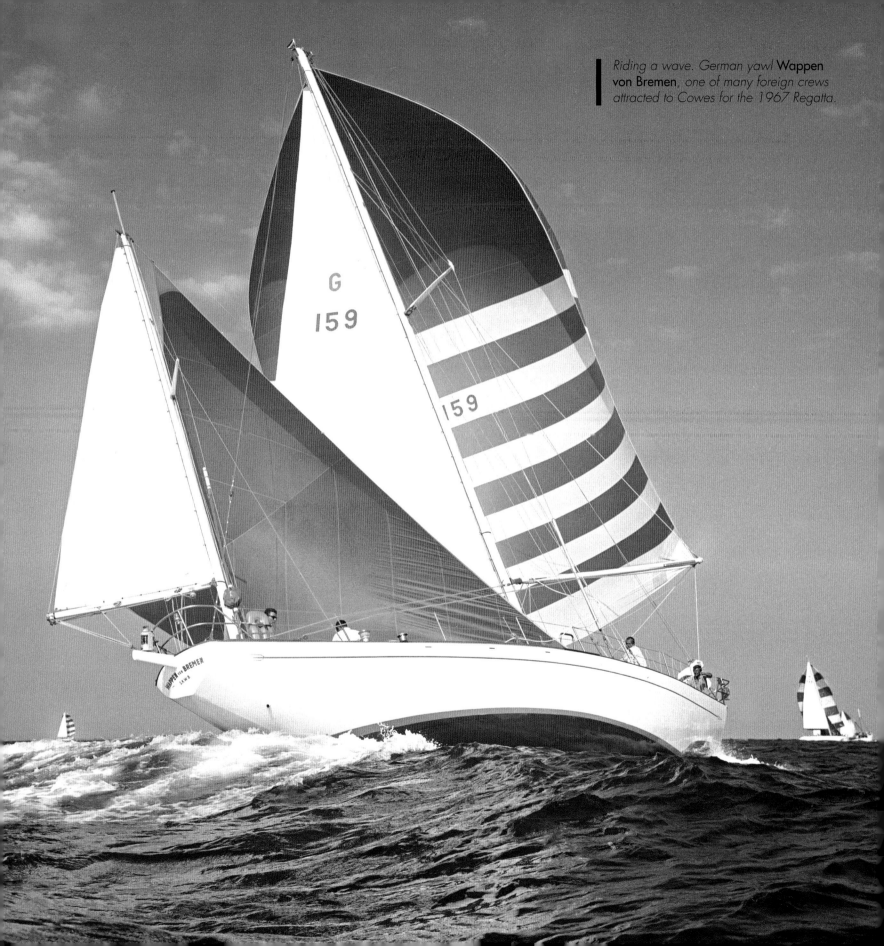

Riding a wave. German yawl **Wappen von Bremen**, *one of many foreign crews attracted to Cowes for the 1967 Regatta.*

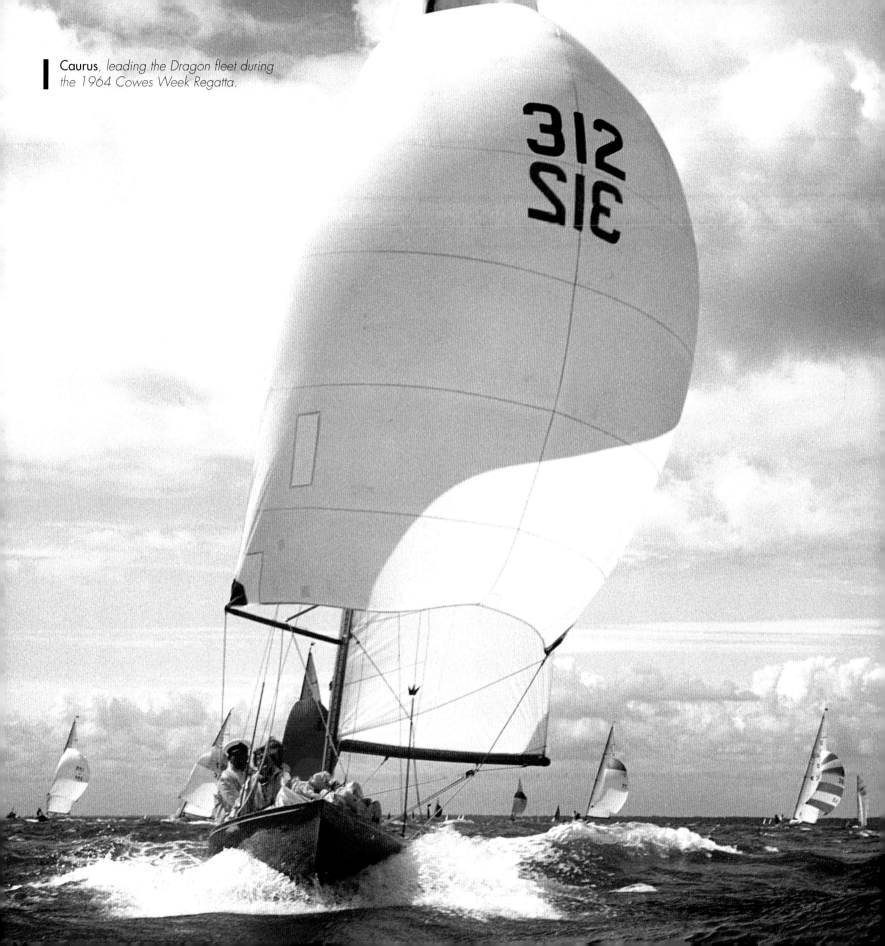

Caurus, leading the Dragon fleet during the 1964 Cowes Week Regatta.

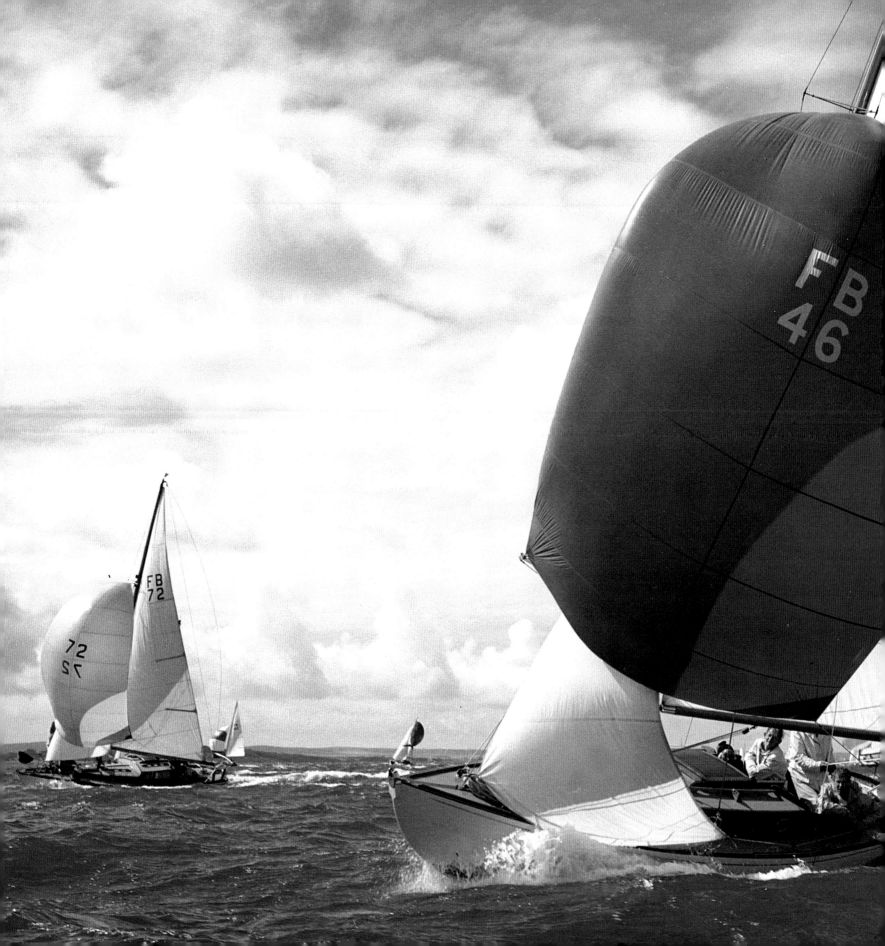

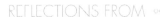

It was in the late seventies that I first met Eileen during a multi-generational family holiday on the French canals. She was the first professional photographer I had met, and she instantly captured my attention – much more than the usual run of my parent's friends, who were bankers, doctors or lawyers.

Photography and sailing combined. The seed of a career idea was sown. Over the following decades, Eileen's enthusiasm, encouragement and interest in my photographic career remained a constant, and I sensed that she enjoyed observing my progress, almost as much as I enjoyed the pursuit of photography.

Eileen's gifted eye and modest nature produced beautiful pictures in an era before sponsorship, when an elegant boat had a hull unblemished by corporate branding. This stunning book provides others with a chance to appreciate her remarkable body of work.

The crew of the Folkboat **Blue Mist** *straining to keep ahead of* **Fickle Baby** *during class racing in the 1964 Cowes Week Regatta.*

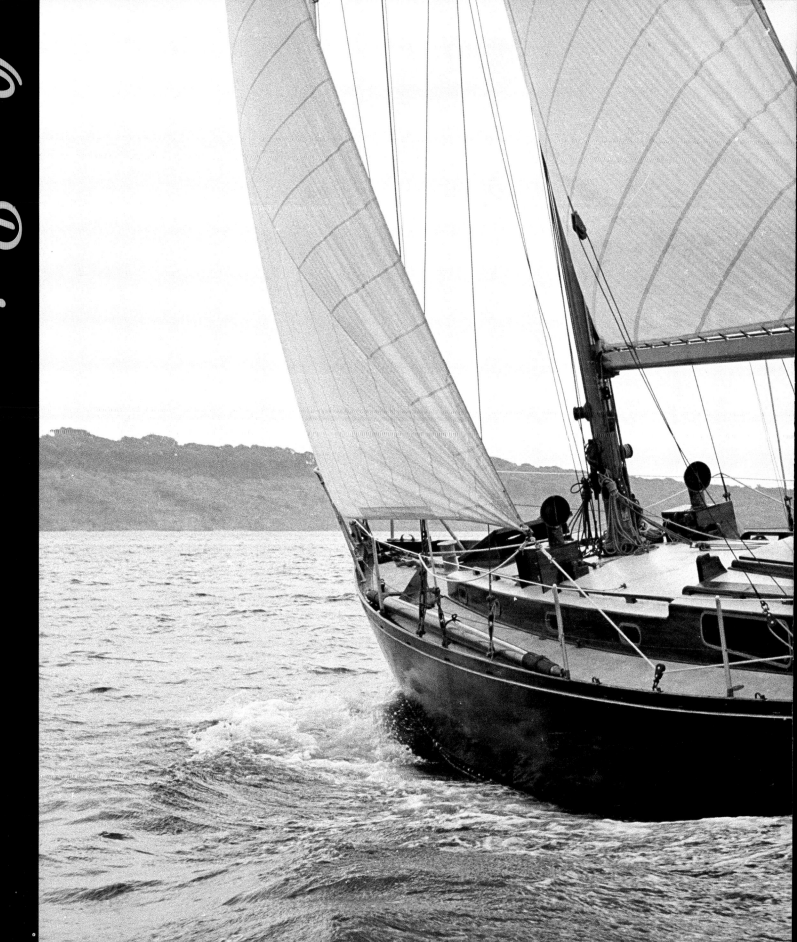

Ocean Racing

A decade into Eileen's career and some of the more adventurous offshore sailors were starting to look at widening horizons beyond weekends in the Solent, occasional trips to France and the biennial Fastnet Race.

One of these was Lt Col HG 'Blondie' Hasler, DSO, OBE from the Royal Marines, who had been decorated during the Second World War for leading the Cockleshell Heroes in 1942 on a daring canoe raid 70 miles up the River Gironde to Bordeaux where they blew up one ship and severely damaged four others. Winston Churchill said that the raid successfully shortened the war by six months, but it was expensive on life. Only two of the twelve Marines survived – Hasler and his co-paddler Bill Sparks.

It was Hasler who first floated the idea of a singlehanded transatlantic race in 1956, and it took four more years to germinate. In 1957, Francis Chichester spotted a notice about the race in the Royal Ocean Racing Club in London, just as he was on his way to hospital to learn that he had contracted cancer, and it was another two years before he felt well enough again to think about the challenge. He wrote to Hasler saying: 'I understand…that you are organising the solo race to New York. This seems to be a most sporting event and I am keen to be a starter.'

The race attracted three more single-minded adventurers in the form of Dr. David Lewis, Val Howells, a gentle giant of a man with a luxuriant beard and strong Welsh tones, together with Frenchman Jean Lacombe. The Royal Western YC of England based at Plymouth organised the start, and the runner and sports journalist Chris Brasher twisted the arm of Lord Astor, then proprietor of *The Observer* newspaper, to sponsor the event, after explaining that crossing the Atlantic in small yachts 'was no more dangerous than riding in the Grand National'.

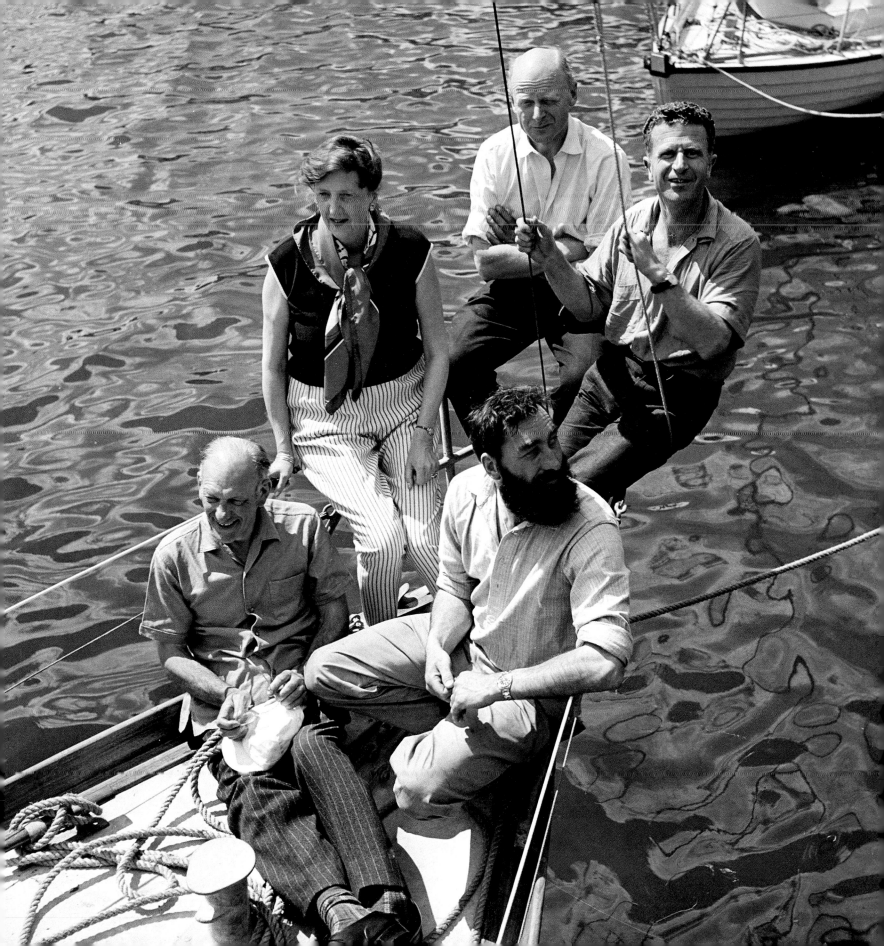

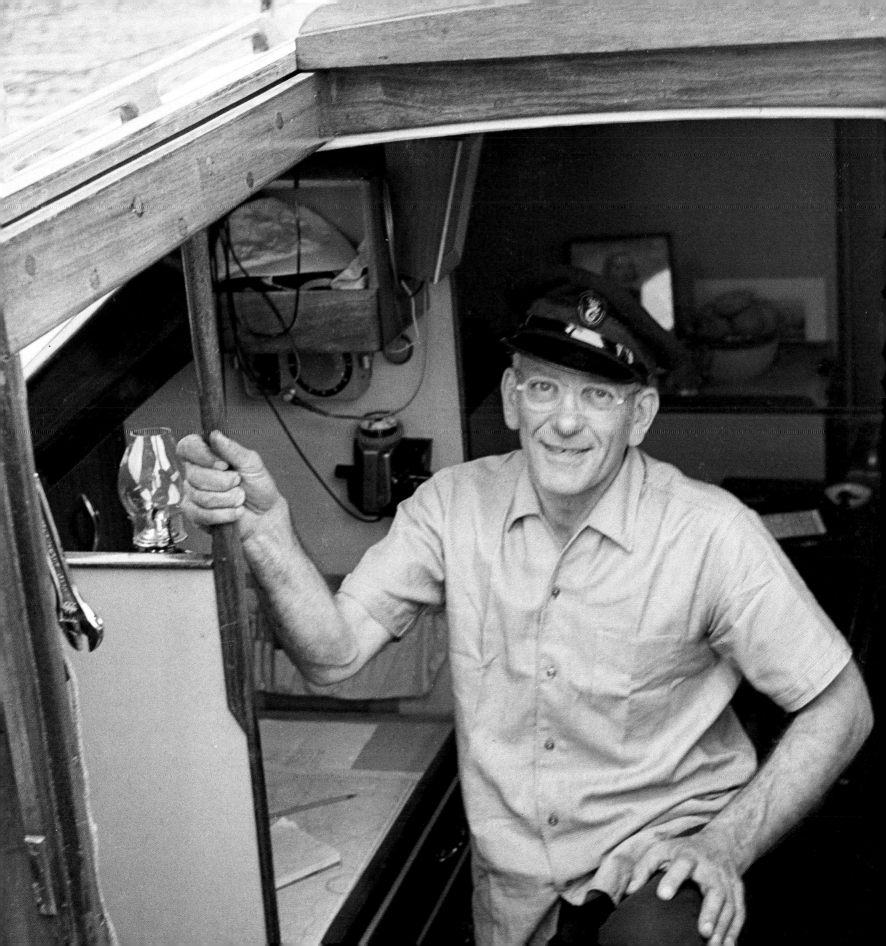

The first OSTAR, as it became known, began from Plymouth on June 11, 1960. Chichester's *Gipsy Moth III*, at 40ft overall, was by far the largest boat. Hasler's junk rigged *Jester* and Howell's *Akka* were both 25ft Folkboats, Lewis had the Laurent Giles designed 25ft *Cardinal Vertue* (which later became the smallest yacht to round Cape Horn) and Lacombe, who set out three days behind the fleet, had the smallest of all – the 21ft 6in *Cap Horn*.

Chichester, who did not suffer the press well, appointed Eileen Ramsay as his official photographer. She became the only camera person he would consider having aboard his *Gipsy Moth* yachts, and any newspapers or magazines wanting pictures had to deal directly with her.

'Chichester was a real charmer. He went everywhere with a bottle or two of champagne and was always having parties. I found him very good company. I was the only photographer he would allow on the boat and he just let me get on with it.' Eileen recalls. She also got on well with the Lady Chichester, who controlled much of her husband's life. 'I had to. She managed all the media,' Eileen laughs now, adding, 'Actually, we became great pals, and I would often help Sheila to provision the yachts before a voyage.'
Eileen not only covered Chichester's preparations on the Beaulieu River, but attended the start, where she became firm friends with all the competitors, who allowed her to photograph them too. This was where her early training as a portrait photographer really came into its own.

Chichester was first to finish in 40 days, followed 8 days later by Hasler's *Jester*. Lewis was third and Val Howells and Jean Lacombe, who both chose to take the trade wind route to the south, took 62 and 74 days respectfully.

It was during the build-up to the second OSTAR four years later that a story emerged (one still repeated today) that the first race had developed around

(continued on page 104)

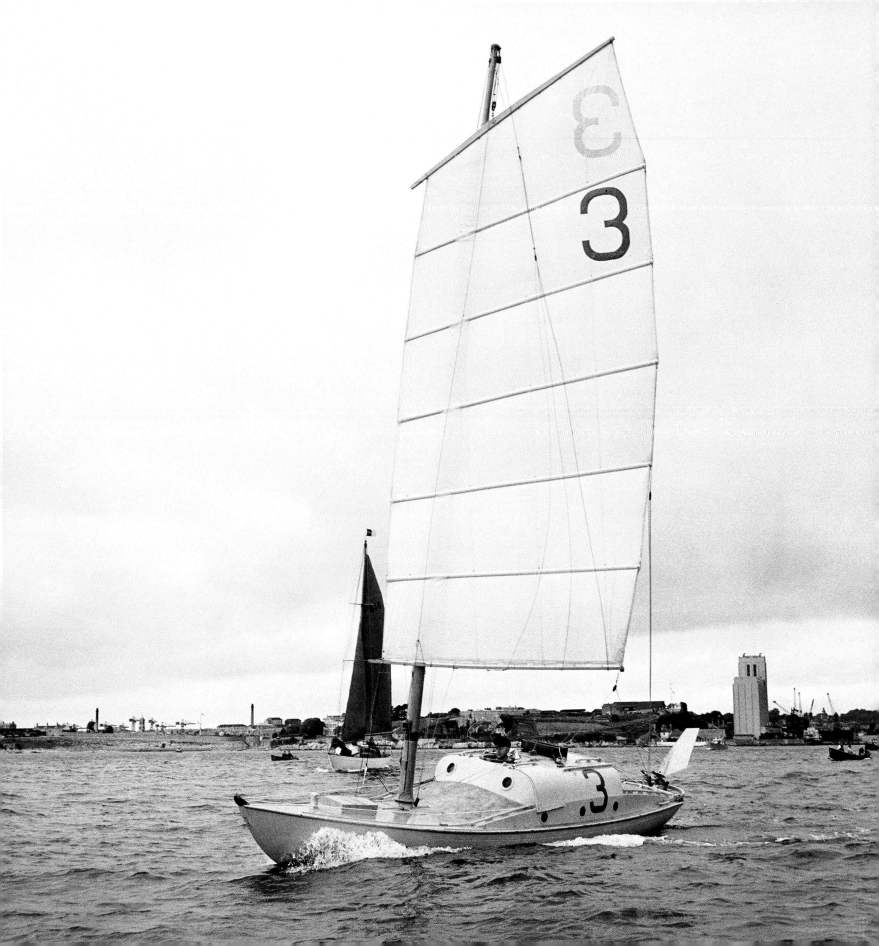

Lt Col H G (Blondie) Hasler, the Father of modern-day singlehanded sailing, pictured with his junk-rigged Folkboat **Jester** at the start of the first OSTAR in 1960. Hasler also competed in the second transatlantic race four years later and finished 5th in the same yacht.

Hasler however, was equally famous for establishing an amphibious assault team within the Royal Marines during the Second World War, now known as the Special Boat Squadron (SBS) and leading his 'Cocklshell Heroes' on an audacious canoe raid 70 miles up the River Gironde to blow up as many ships as possible in the German occupied port of Bordeaux.

The raid was successful, and according to Winston Churchill, it shortened the war by six months, but not without loss. Of Hasler's twelve man team, only two survived – Blondie and his fellow canoist, Bill Sparks.

Hasler, who was awarded a DSO, and an OBE for his war-time exploits, died in 1987.

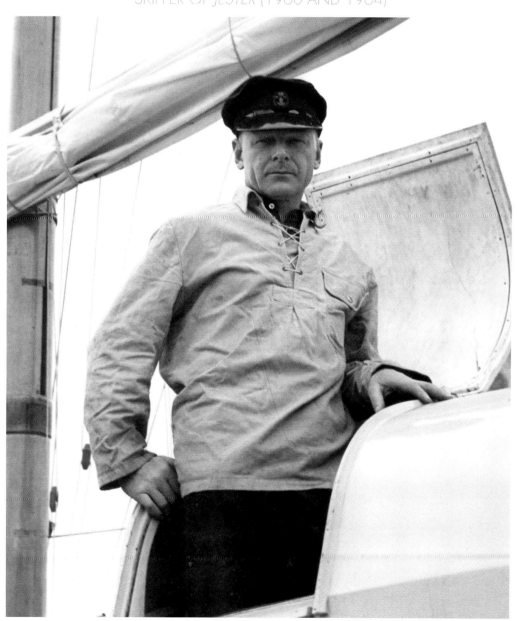

Francis Chichester

SKIPPER OF *GIPSY MOTH I* (1960 AND 1964)

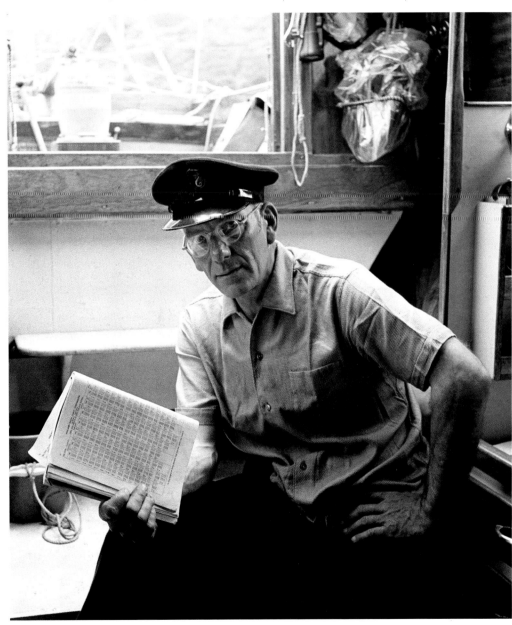

Francis Chichester was an adventurer at heart. In 1929, he flew a De Havilland Gipsy Moth bi-pane solo from Croydon to Australia and went on to become the first to fly the Tasman Sea solo.

He crashed the plane in Japan during the return trip and spent several months in hospital. On returning to England, he became the Chief Navigation Instructor at the Central Flying School during the war.

Chichester's sailing career began in the early '50s with **Gipsy Moth II**. **Gipsy Moth III** was commissioned in 1956 just before he was diagnosed with cancer. His recovery took two years, when he decided to join Hasler's race across the Atlantic, which he won. After finishing second to Tabarly in the following race in 1964, he was awarded a CBE.

In 1966, he set out solo in **Gipsy Moth IV** to beat the best time to Australia and back set by the clipper ship **Cutty Sark**. He received a Knighthood on his return in 1967.

His last major challenge was an attempt to average 200 miles per day during a solo crossing of the Atlantic in his last yacht **Gipsy Moth V**. Chichester died in 1978 shortly after attempting to compete in that year's OSTAR.

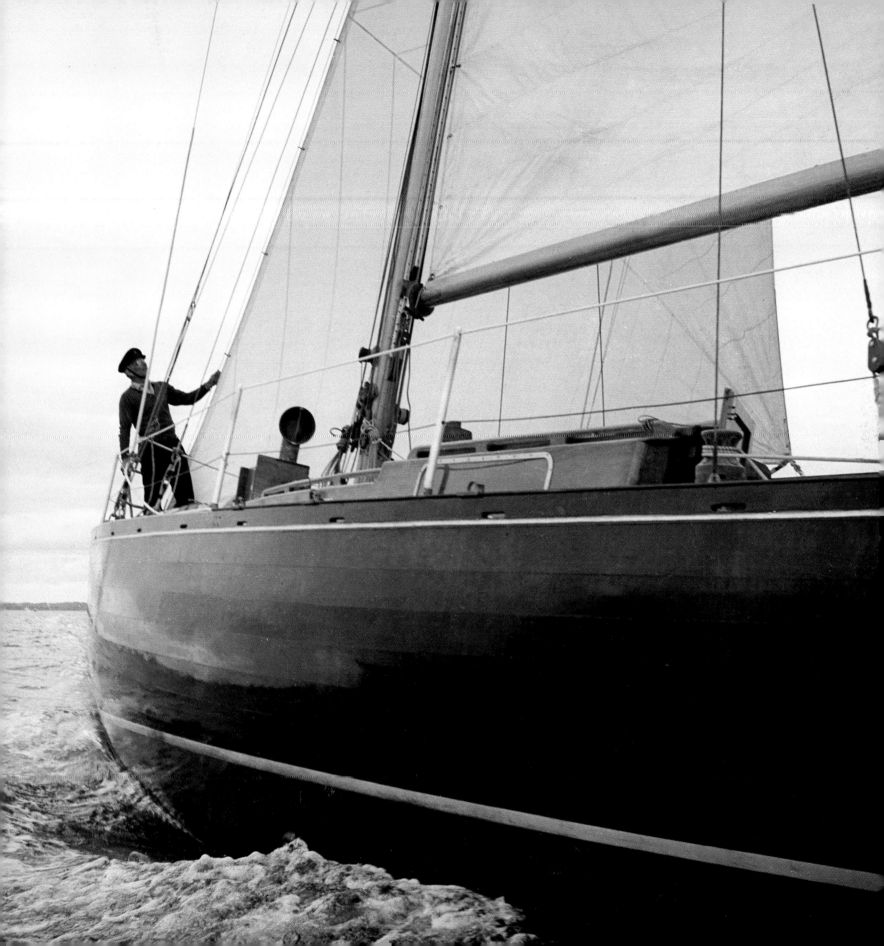

David Lewis

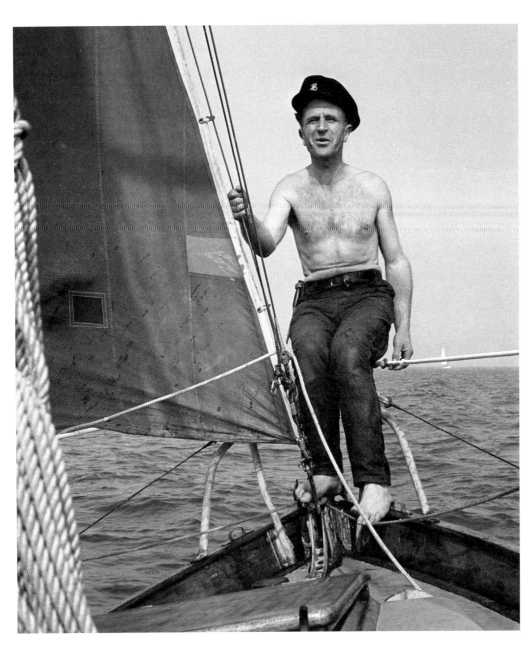

Dr David Lewis was born in the UK but brought up in New Zealand. He returned to England in 1938 to complete his degree and served as a medical officer during the war.

A keen rock climber, canoeist and parachutist, his imagination was fired by Hasler's challenge to sail solo across the Atlantic. Lewis's choice of yacht, the Laurent Giles 25ft **Cardinal Vertue** was a class of yacht more used for coastal and estuary cruising than extended trans-ocean sailing.

Shortly after the start of the 1960 OSTAR, the yacht suffered rig failure forcing Lewis to return for repairs, but he still managed to finish third.

He returned for the 1964 OSTAR with the catamaran **Rehu Moana** in which he later circumnavigated the Globe – the first such passage in a multihull.

He later attempted to circumnavigate Antarctica, but his yacht, **Ice Bird**, capsized and he was lucky to survive.

Lewis was awarded the Distinguished Companion of the New Zealand Order of Merit. He died in 2002.

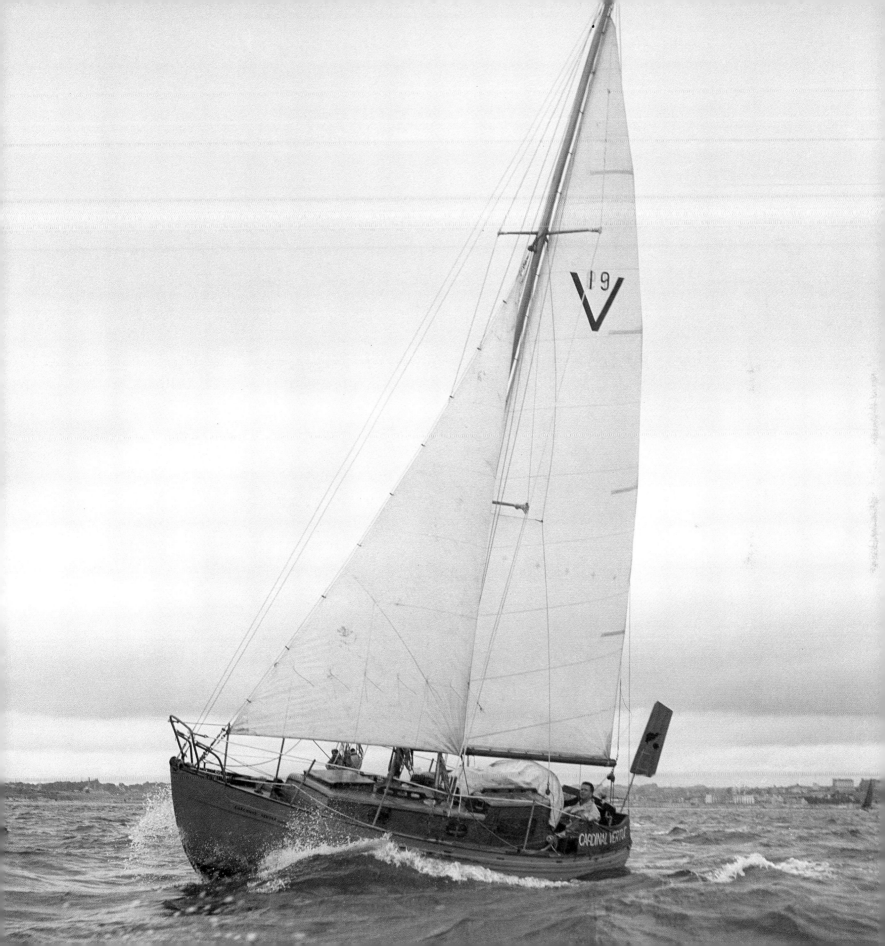

Val Howells

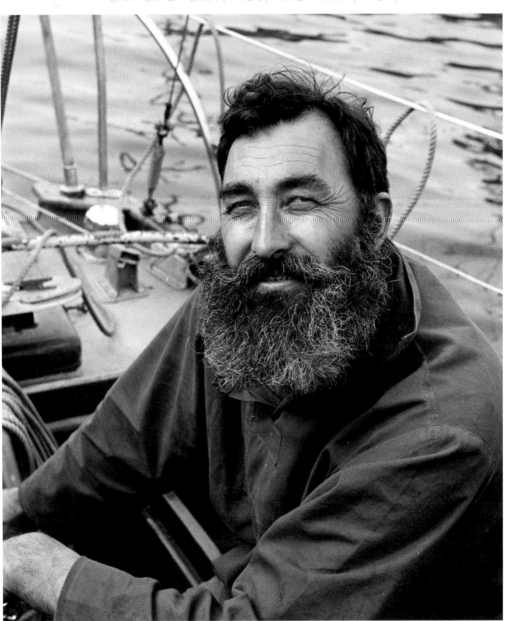

Valentine (Val) Howells is the gentle Welsh giant and the last surviving competitor from the 1960 OSTAR.

He served as a merchant seaman from the age of 17, experienced having his ship blown up during the Normandy landings and later saw service aboard an ammunition ship during the Burma campaign.

On meeting his wife Eira, he settled down to farm the Welsh hills around Narberth near Swansea. Later, he bought a standard 25ft clinker-built Scandinavian Folkboat more used for day and weekend cruising than crossing oceans. He sailed **Eira** singlehanded to northern Spain and back, and was then approached by Blondie Hasler to enter the OSTAR. He finished fourth.

Val Howells returned for the 1964 OSTAR with the novel approach of delivering the 35ft **Akka** to its owner in America and finished thirrd out of 15 starters.

He returned again for the 1976 OSTAR, but was injured in a fall soon after the start and forced to retire from the race. Not to be outdone, he then set out to sail solo around the world and completed the voyage two years later.

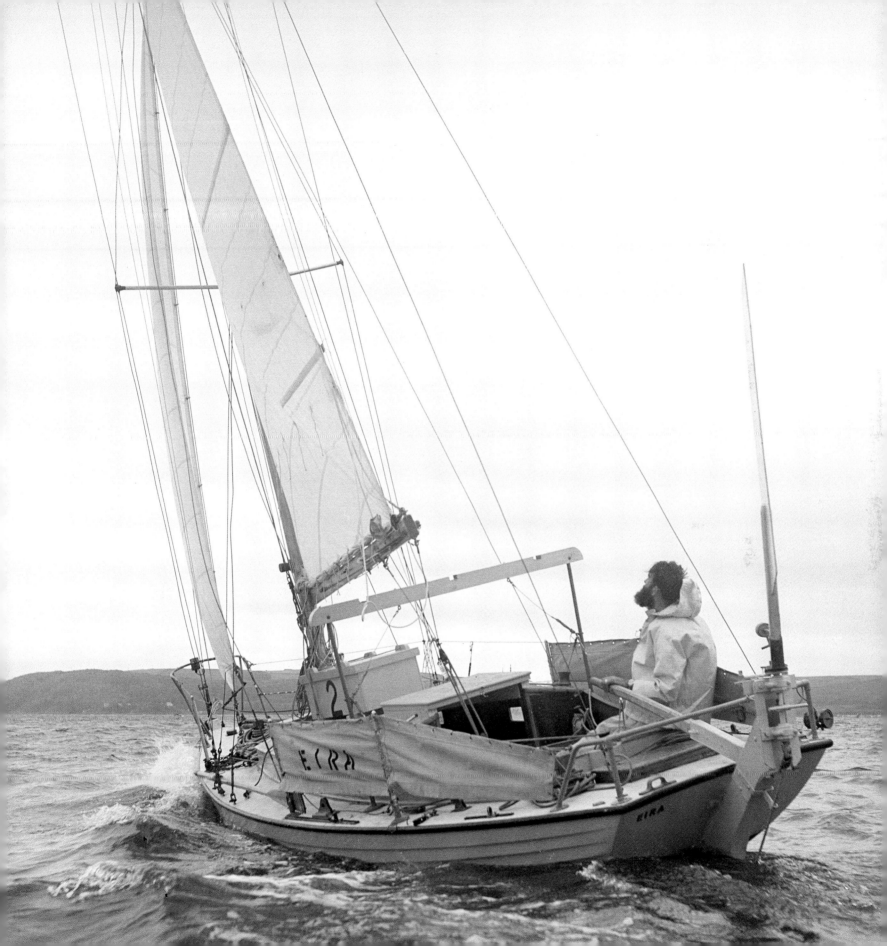

Jean Lacombe

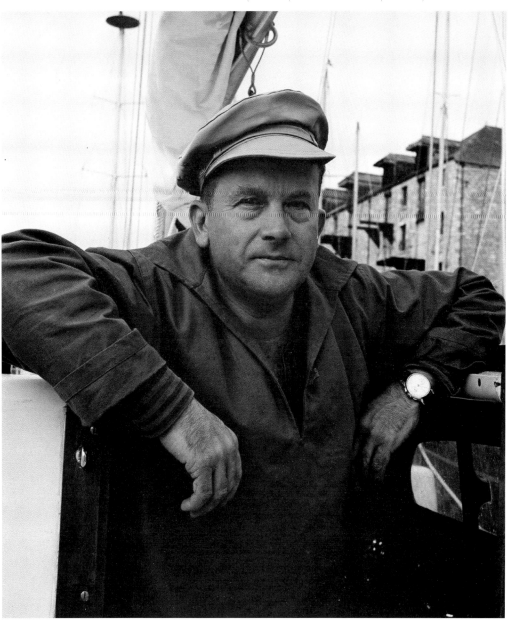

Jean Lacombe, the fifth of these OSTAR pioneers, had already confounded the French speaking world by sailing his self-built 18ft **Hippocampe** solo from Toulon to Puerto Rico in 1955, taking 68 days, He then sailed on to New York to work in a hotel where he read about Hasler's challenge. He scrimped and saved to buy the 21ft wooden sloop **Cap Horn** and set out for Plymouth, arriving on the eve of the start, just in time to take part in a 'last dinner' with his fellow competitors. It took him a further three days to ready his yacht for the return voyage in which he finished fifth, 'To have sailed such a small boat both ways across the Atlantic was a display of guts and determination of which he could be justifiably proud,' says fellow OSTAR sailor Howells.

Lacombe returned for the 1964 race in the 22ft **Golif** and, outsized by the fleet, again finished well out of the frame. He died in 1995.

OPPOSITE
Down to the sea in small ships: four of the five contenders moored in Mill Bay Dock prior to the start of the 1960 OSTAR.

Foreground: **Gipsy Moth III**
Left to right: **Eira**, **Jester** and **Cardinal Vertue**

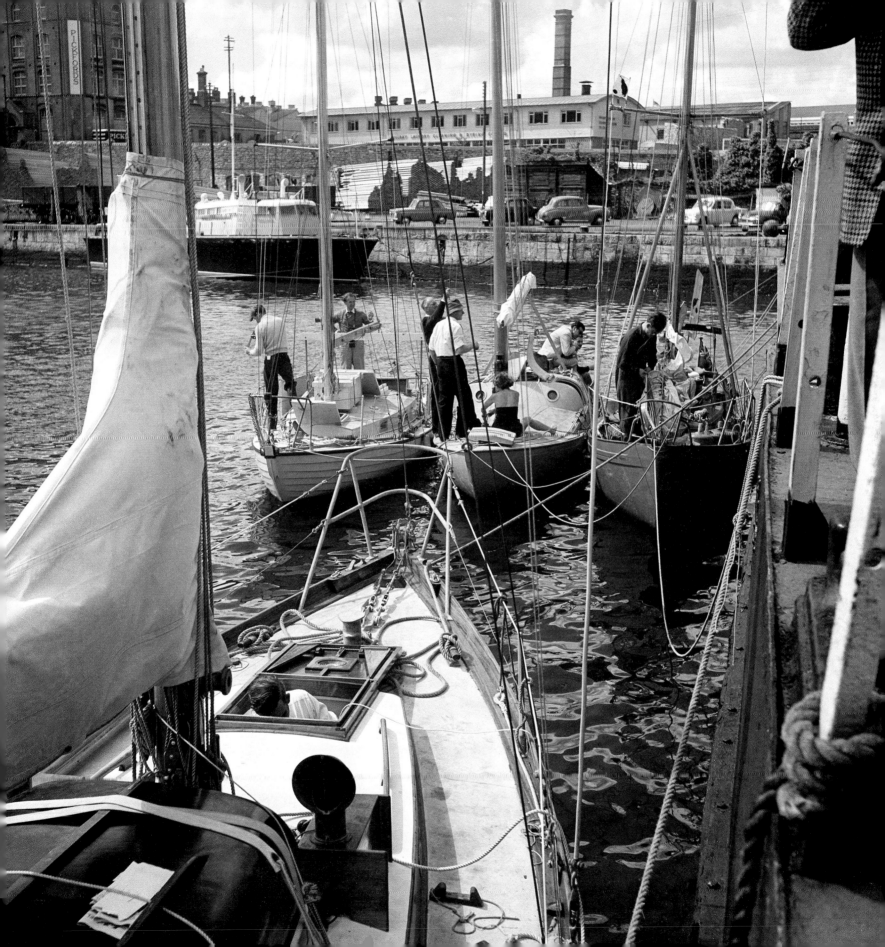

RIGHT
Scene in Mill Bay Dock priot to the start of the 1964 OSTAR when multihulls were included for the first time.

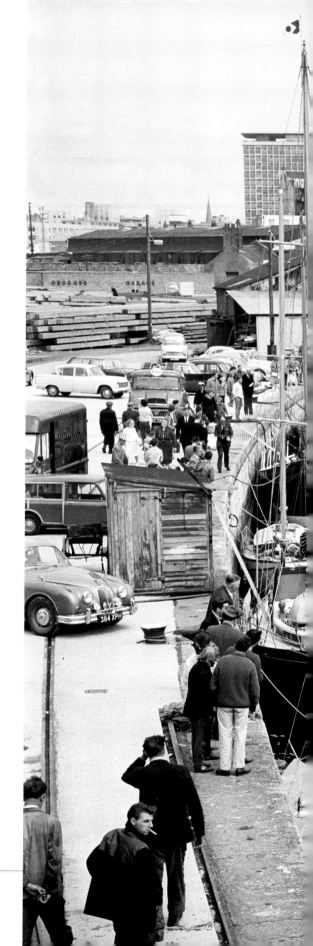

(continued from page 93)

a half crown bet between Chichester and Hasler. However, according to Val Howells, the sole surviving competitor, this was simply a PR stunt dreamed up by Chichester's publicists, to draw fresh interest in the second event. 'If there had been a bet, you would have thought the other competitors would have known about it,' says Howells, five decades on. 'The story was widely quoted at the time, and because it seemed good for the race, we stupidly didn't do anything to correct the misconception. Now, whenever you read the history of the race, even on the Royal Western YC's own web site, the half crown bet is firmly embedded. Yet it is complete fiction.'

Like Howells, Lewis, Hasler and Lacombe, Chichester returned for the second OSTAR in 1964. This time there were 15 entries and the race created world-wide interest with Eric Tabarly from France and his 44ft *Pen Duick II* taking line honours, Australian Bill Howell competing in his catamaran *Rehu Moana*, and the then largely unknown greengrocer from Portsmouth, Alec Rose, with *Lively Lady*.

Tabarly, a shy young French Naval Lieutenant who beat Chichester and returned home to a ticker-tape parade down the Champs-Élysées in Paris and a Legion d'Honour award – France's highest accolade – quickly became an icon within French sailing circles, 'He was a very nice man. He didn't have much to say for himself, but was happy to pose for me on his yacht.' Eileen recalls now.

She was less impressed with Alec Rose. 'At the time, he was viewed as someone trying to ride on the coat tails of Francis Chichester, who by then was planning to sail solo around the world and beat the time set by the *Cutty Sark*. I photographed him onboard *Lively Lady* before the start. He was trying to upstage Chichester's planned solo circumnavigation, but in the end, wasn't ready in time and had set off a year after Chichester.'

(continued on page 114)

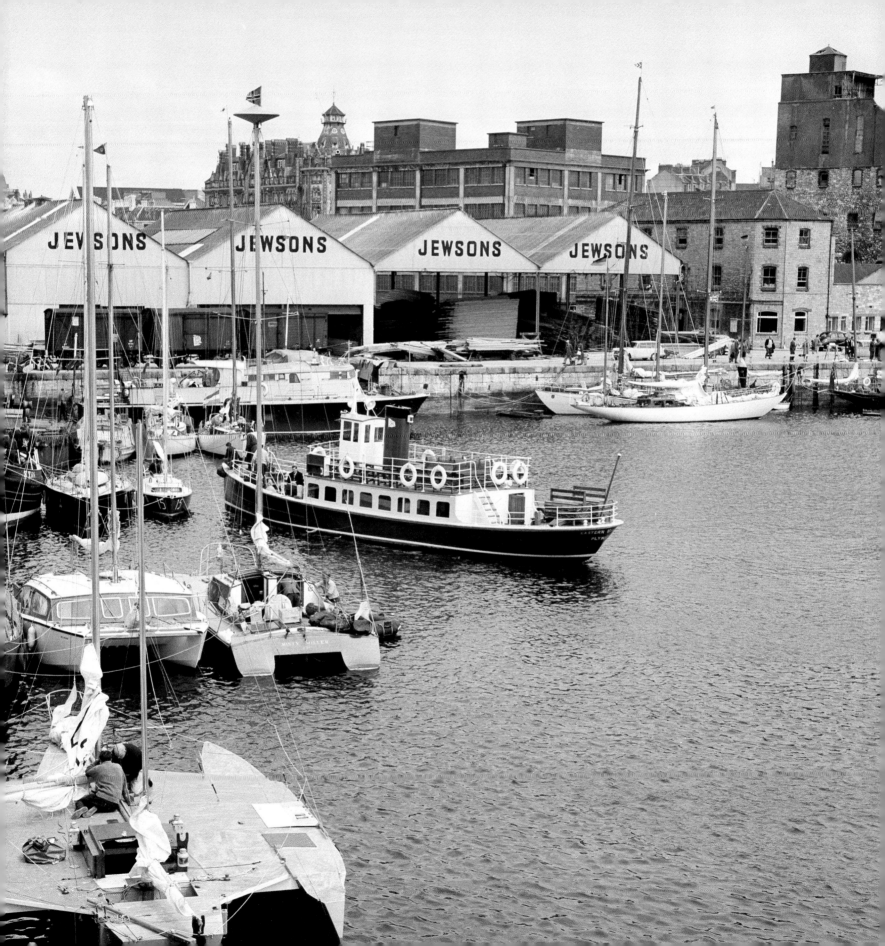

Eric Tabarly

SKIPPER OF *PEN DUICK II* (1964)

Eric Tabarly posing for Eileen's camera aboard his purpose-built 44ft ketch rigged French yacht **Pen Duick II**. Tabarly competed the second OSTAR in 27 days: 2 days and 20 hours ahead of Chichester's second placed **Gipsy Moth III**, and returned to a hero's welcome back in Paris where he was given a tickertape parade up the Champs-Élysées and presented with the Legion d'Honour – the highest award in France – by President De Gaulle.

In 1968, he returned to Plymouth to race his **Pen Duick IV** in that year's OSTAR, but was forced to retire after suffering damage during a collision.

He returned to Plymouth in 1976 with his 73ft monohull **Pen Duick VI** to win the fourth running of the OSTAR event, overcoming hurricane conditions in mid-Atlantic that led to 53 retirements.

In 1980 he set a transatlantic record sailing from West to East from New York to The Lizard, on the multihull **Paul Ricard**, slashing the previous 12 day record set back in 1905 by the 185ft American schooner **Atlantic**, by more than 2 days.

Tabarly drowned in 1998 after being hit by the gaff while sailing his original yacht **Pen Duick** in the Irish Sea.

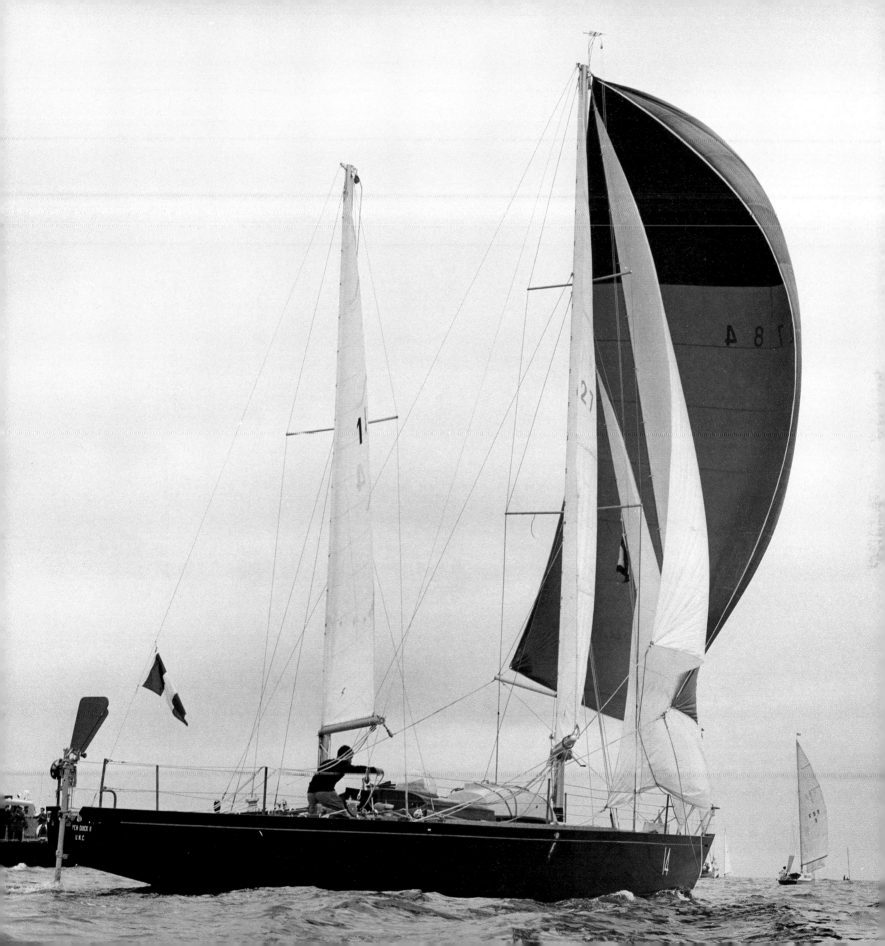

Geoffrey Williams

SKIPPER OF *SIR THOMAS LIPTON* (1964)

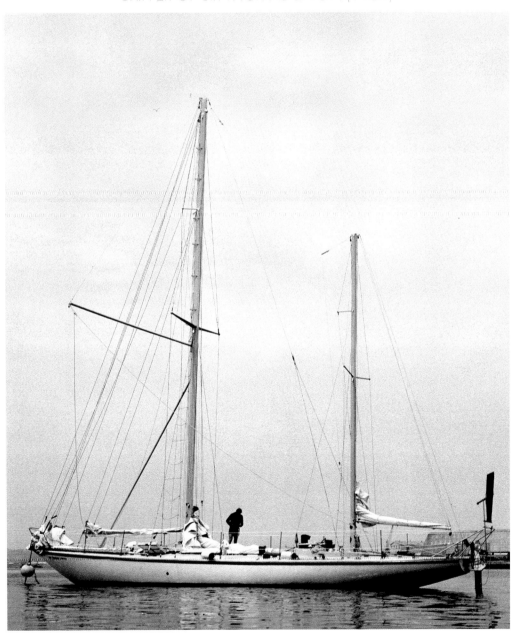

Geoffrey Williams, a 25-year-old school teacher, came to prominence in the 1968 OSTAR event, not just for being supremely fit, but for being well advanced in his preparations. Eileen Ramsay photographed him aboard his 57ft monohull **Sir Thomas Lipton** and remembers his single-minded attitude.

Williams was the first to use computer science to guide him through the Atlantic weather systems, which were particularly bad that year. Williams, who was penalised 12 hours for not presenting his yacht correctly for scrutineering prior to the start, had weather information generated by a main-frame computer ashore which radioed to him on a daily basis, the first such weather-routing of its kind.

The **Sir Thomas Lipton** skipper courted further controversy by taking a 'short-cut' through the Nantucket Shoal, a particularly dangerous route supposedly outlawed by the race organisers. However, due to a printing error, the race instructions required skippers simply to keep south of Nantucket, instead of Nantucket Light.

Williams went on to win the race in record time, 17 hours ahead of second placed Bruce Darling and his 50ft South African yacht **Voortrekker**. Darling refused to protest the winner, despite pleas from the Race Committee to do so, and Williams' clear victory remained unblemished.

Alec Rose

SKIPPER OF *LIVELY LADY* (1964)

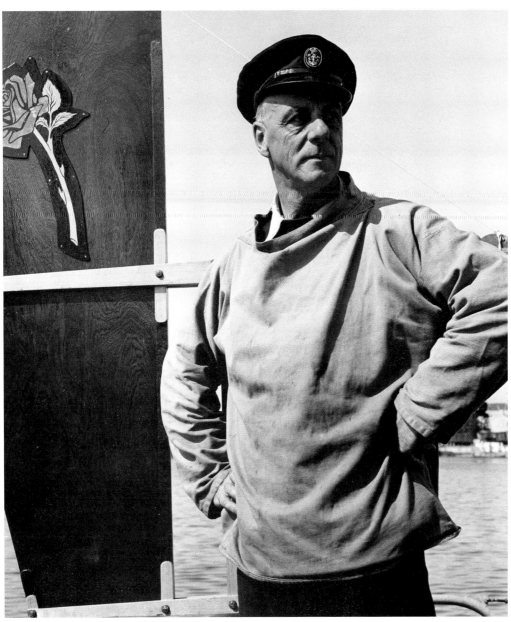

Alec Rose was seen as something of a controversial character, riding the coat tails of Francis Chichester to become first to sail solo around the world.

The Portsmouth based greengrocer entered his 36ft traditional ketch **Lively Lady** in the 1964 OSTAR and finished a credible fourth.

In 1966, Rose had plans to set out from Portsmouth to rival Chichester's planned solo circumnavigation, but **Lively Lady** fell on her side while moored up against the harbour wall. The repairs put his plans back a year, but he eventually completed a one-stop circumnavigation in 1968, returning to Portsmouth in a blaze of publicity after spending 354 days at sea.

Like Chichester, Rose was awarded a knighthood by the Queen soon after his return.

He died in 1991 at the age of 82.

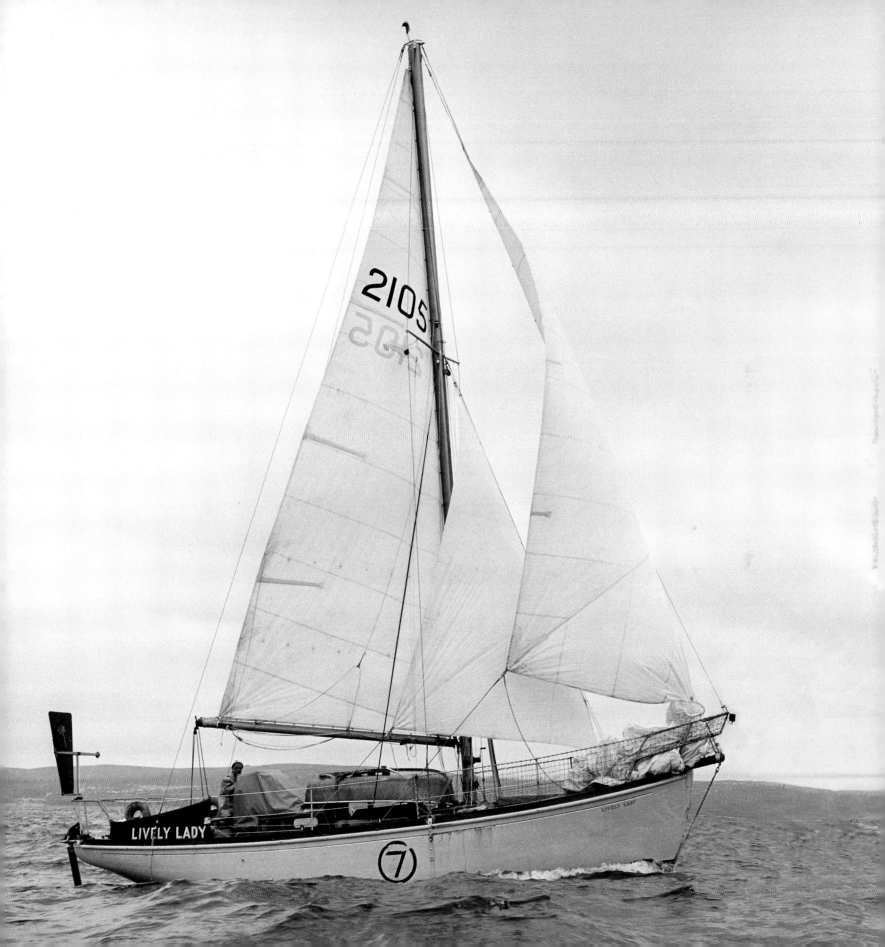

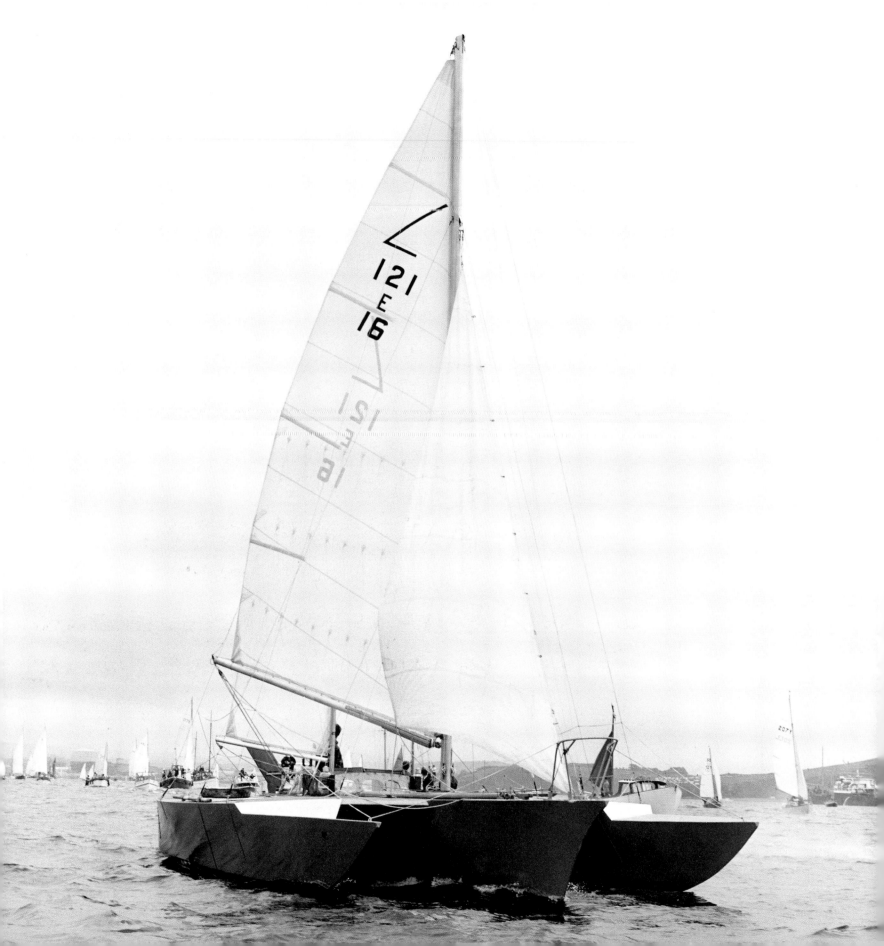

Derek Kelsall was an early multihull pioneer, starting with his 35ft trimaran **Folatre** in the second OSTAR in 1964 when he finished 13th overall.

Two years later, Kelsall designed and built the pioneering 42ft trimaran **Toria** in which he and crewman Martin Minter-Kemp won the first Two–Man Round Britain Race. **Toria** was the first foam sandwich-moulded yacht of note and the first multihull to win a major open offshore race. Her design and construction method set the style for all that followed.

Kelsall went on to become a builder of state-of-the-art composite racing yachts including Geoffery Williams' monohull **Sir Thomas Lipton**, winner of the 1968 OSTAR, and Chay Blyth's 78ft **Great Britain II**, which won line honours in the first Whitbread Round the World Race in 1973. Both were the largest composite–built sailing yachts of the time.

Kelsall also built Blyth's two racing trimarans, **Great Britain III** and **IV**. The latter, crewed by Blyth and Rob James, won the 1978 Two–Man Round Britain Race.

Kelsall emigrated to New Zealand in 1998 and continues to design and build multihulls.

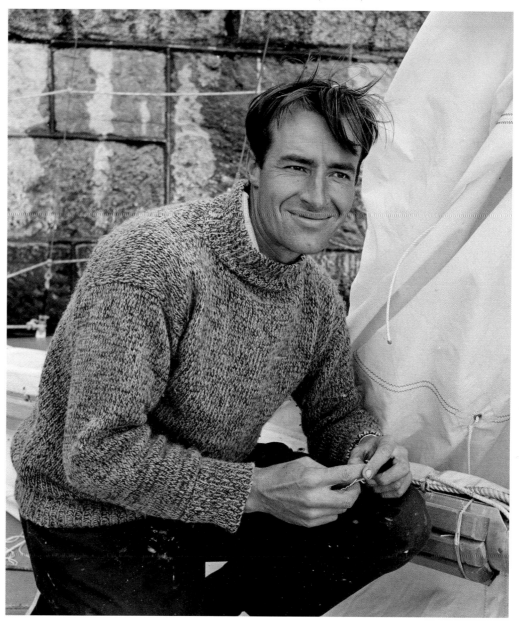

(continued from page 104)

Two years after the second OSTAR, Chichester set off from the same start line at Plymouth aboard the 54ft yawl rigged *Gipsy Moth IV*. Eileen, who had captured the yacht's construction at Camper & Nicholsons yard in Gosport, as well as Chichester's preparations, photographed him, both then and when he returned to a hero's welcome 226 days later.

Chichester was knighted at Greenwich a few weeks later for 'individual achievement and sustained endeavour in the navigation and seamanship of small craft'. For the ceremony, the Queen used the sword that Queen Elizabeth I had used to bequeath the same honour on Sir Francis Drake, the first Englishman to complete a circumnavigation.

The arrangements to get *Gipsy Moth* up to the Thames in preparation for the televised ceremony were quite rushed, and Sheila Chichester turned to Eileen for advice about the correct attire to wear. 'She rang me to ask what she should wear for the ceremony. "I am going to have to climb on and off the boat, and wearing a skirt is not very practical. Do you think it would be OK to wear a trouser suit?" Lady Chichester asked.' 'Absolutely' said Eileen, leading to what royal circles deemed the most shocking fashion faux pas of the decade.

Chichester himself had no great affection for his yacht. He wrote 'Now that I have finished, I don't know what will become of *Gipsy Moth IV*. I only own the stern while my cousin owns two thirds. My part, I would sell any day. It would be better if about a third were sawn off. The boat was too big for me. *Gipsy Moth IV* has no sentimental value for me at all. She is cantankerous and difficult and needs a crew of three – a man to navigate, an elephant to move the tiller and a 3'6" chimpanzee with arms 8' long to get about below and work some of the gear.'

(continued on page 119)

*The scale of the challenge. Chichester set himself the goal of beating the best time set by the famed clipper ship **Cutty Sark** to Australia and back.*

	Cutty Sark	Gipsy Moth IV
Length OA	280ft	53ft 1in
Waterline length	212ft 6in	38ft
Beam	36ft	10ft 6in
Draft	22ft 6in	7ft 9in
Sail area	32,000sq ft	854 sq ft
Displacement	2,100 tons	11½ tons

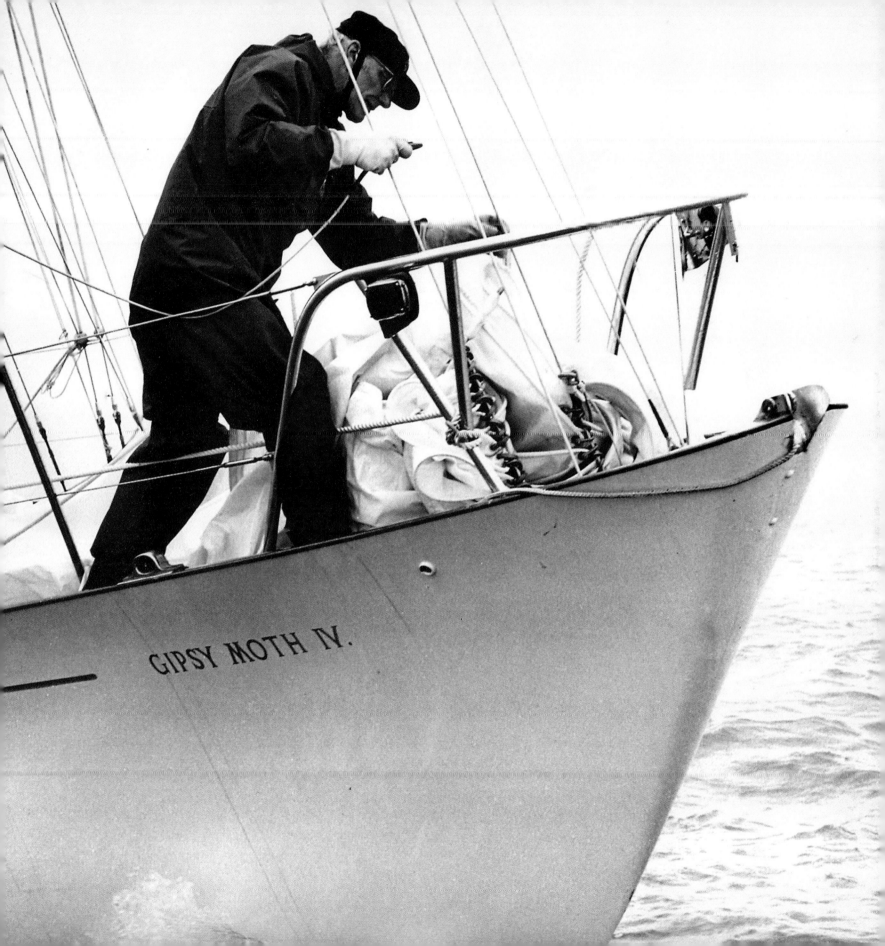

GIPSY MOTH IV.

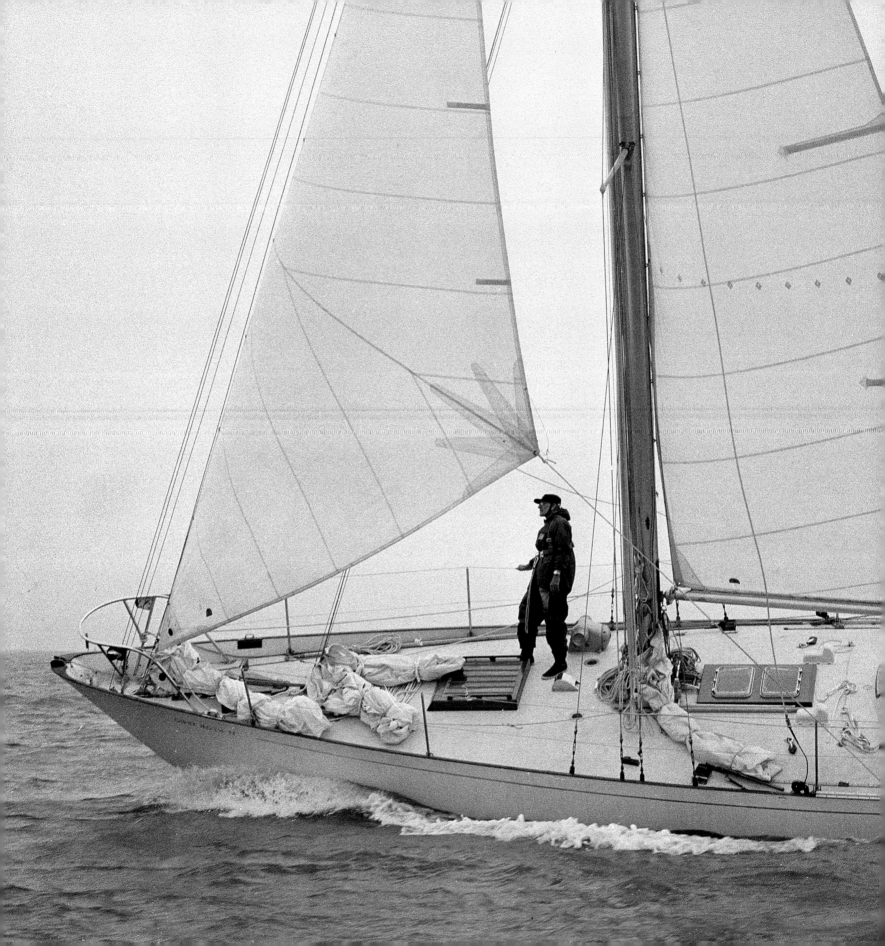

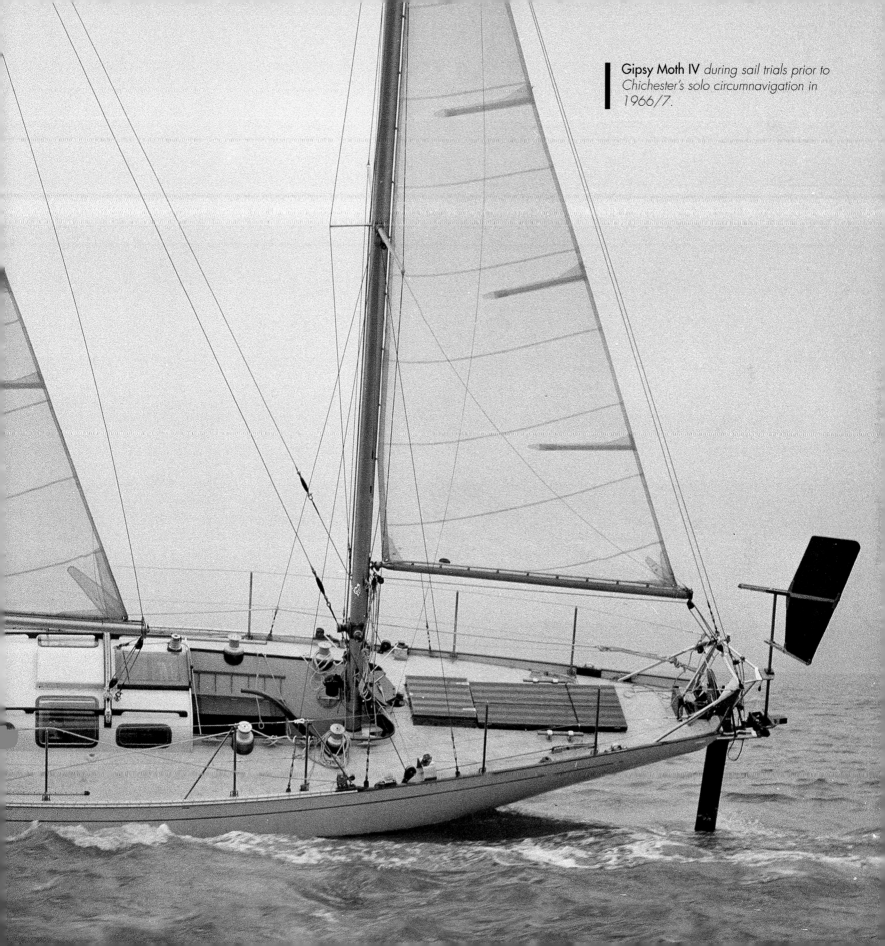

Gipsy Moth IV *during sail trials prior to Chichester's solo circumnavigation in 1966/7.*

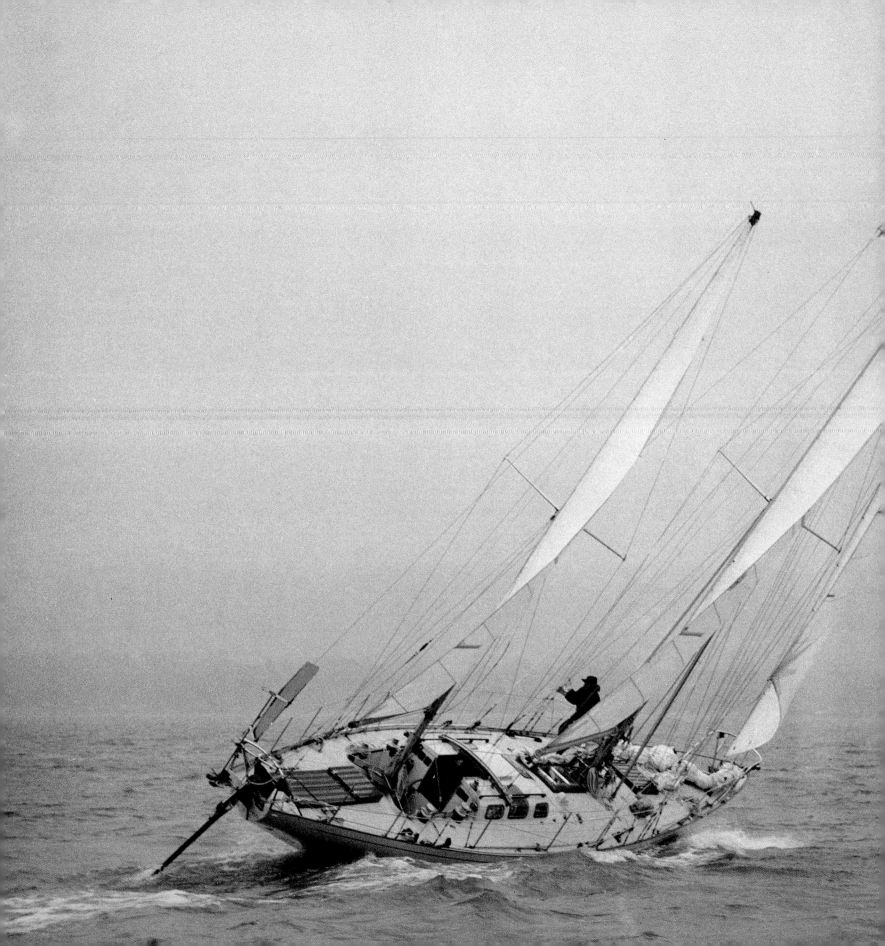

(continued from page 114)

Chichester was never enamoured by his Robert Clark-designed **Gipsy Moth IV**. *He felt she was too tender and did not steer well. On arrival in Sydney, he commissioned Australian designer Warwick Hood to reconfigure the keel and rudder design, but the yacht broached badly soon after heading out into the Pacific.*

Soon after Chichester's knighthood, *Gipsy Moth IV* was put on public display alongside the *Cutty Sark* at Greenwich. In 2003, concern for her deteriorating condition led Paul Gelder, then Editor of *Yachting Monthly* magazine, to launch a public campaign to have the yacht restored and sailed around the world once more to mark the 40th anniversary of Chichester's achievement, and the 100th birthday of the magazine.

The restoration and voyage with young underprivileged youngsters was masterminded by the UK Sailing Academy at Cowes, which bought the yacht from the Maritime Trust for £1 and the cost of a gin and tonic.

The campaign won huge public support and Eileen Ramsay's archive of historic pictures was given a new lease of life. After the voyage, *Gipsy Moth IV* failed economically to provide sailing opportunities for youth, and the UK Sailing Academy was forced to put her up for sail. She sat on brokerage lists for almost a year until an article in the *Sunday Times* newspaper, suggesting that she was likely to be sold to an American collector, stirred Rob Thompson and his business partner Eileen Skinner to put in a bid to keep this iconic yacht in British waters. 'The story really got my gander up. I thought, "we really can't allow this very British icon to leave these shores." I knew all about the story. The yacht and Chichester's achievement happened at the height of the Swinging '60s, a time when I was very impressionable. I spoke to my partner Eileen, who is also a keen sailor, and we agreed to buy her for the national that Sunday afternoon.

Thompson and Skinner have since formed the *Gipsy Moth IV* Trust to keep the yacht as a working museum piece and provide young people with the opportunity to sail in her. And as with the yacht, so Eileen Ramsay's original photo archive of Chichester's circumnavigation is also assured recognition into the future.

Looking back over the five decades that have elapsed since the inception of singlehanded ocean racing, what comes to mind, particularly when recalling the first OSTAR event, is the varying attitudes apparently displayed by those who were taking part, because some people are significantly better than others at disguising their true emotions; displaying an outward calm, when in reality they are close to being overwhelmed by the pressure of events. There are all sorts of things that contribute to this pressure, but one of them is undoubtedly the arrival on the scene of 'Yachting Correspondents'.

Imagine the scene: you have been bustin' your gut, over a period of several years, to get a boat which is hopefully up to the job. In many instances, financial resources have been stretched to their absolute limit. All sorts of personal commitments have been made, and some of them already abandoned. There are family responsibilities, which cannot be brushed aside, but have somehow been manoeuvred to a position where it's just about acceptable to leave the wife and children astern, so for those people left waving on the quayside it may not just be a matter of strolling home and taking the dog for a walk.

And then, in amongst this maelstrom, the ladies and gentlemen from the Press arrive with pencils poised and cameras clicking. Some of them are better at it than others – amongst the correspondents, in those early years, Chris Brasher would have to be placed amongst the very best.

And of the camera crew? Eileen Ramsay, with an engaging style that is best described as unobtrusive but perceptive; the sort of professional who doesn't exert pressure on the subject – to the contrary, someone who somehow fits in with whatever's going on.

The result? Some of the finest marine photographs that form a fascinating record of those long gone events. And coupled with that, her portraits of those taking part are outstanding – a real credit to her art.

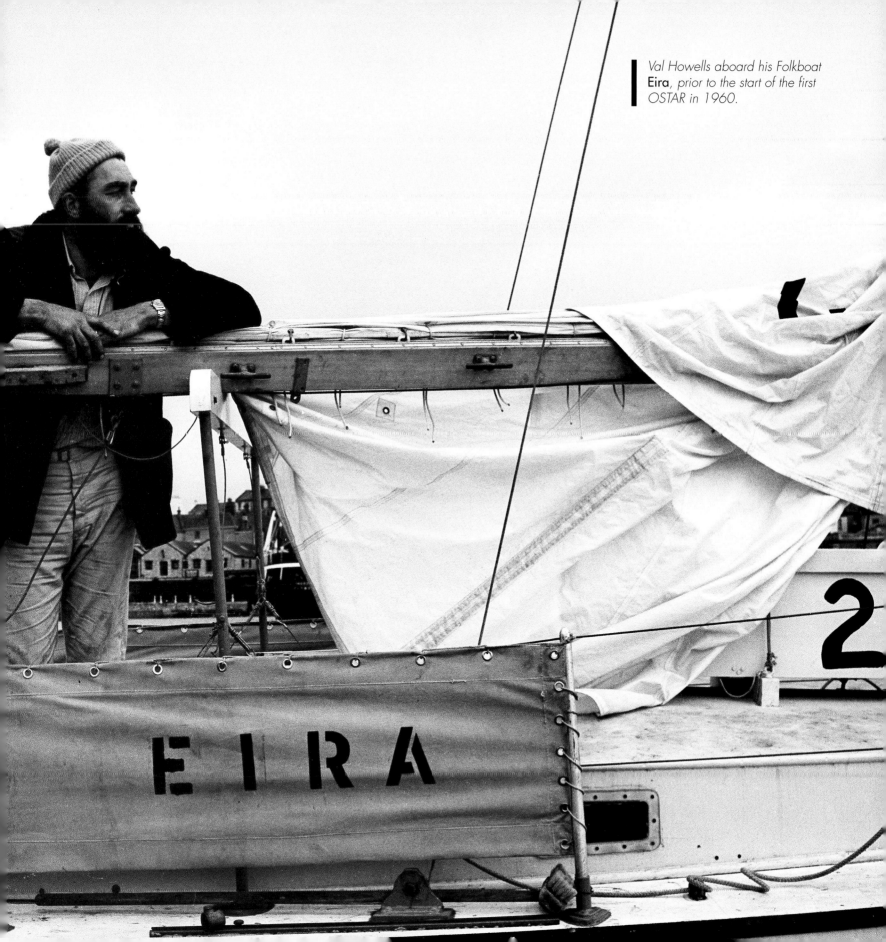

Val Howells aboard his Folkboat
Eira, *prior to the start of the first
OSTAR in 1960.*

Powerboats

Eileen Ramsay's introduction to powerboating came directly from her success with photographing dinghies. Charles Currey, who won a Silver Medal in the Finn singlehander class at the 1956 Olympics in Helsinki, was a founding director of Fairey Marine based at Hamble Point, where he had pioneered the mass – production of wooden Fireflys, Swordfish, Albacores and International 14s using the hot moulding autoclave system developed by Fairey Aviation. Ramsay photographed all their boats, so it was not surprising that she was asked to do the same for a new range of hot-moulded powerboats that Fairey began to build in the late 1950s.

Fairey began by gaining the rights from Ray Hunt, an established American designer, for his deep – V hull concept, which was suited to the cold, choppy British waters. The first boats were not a success, mainly because of the lack of suitable lightweight engines to power them. The marinised road truck had not yet arrived.

Undaunted, Currey and his team worked to refine the design which led to the launch of the 25ft Fairey Huntress deep-V fast cabin cruiser. This proved an immediate success, and in addition to their own line, Fairey produced bare hulls for other companies to complete. One of these was the Christina 25 *Thunderbolt*, driven by former racing driver Tommy Sopwith, which won the inaugural Daily Express Cowes/Torquay Race in 1961, setting an average speed of 24.5mph. Another Fairey-built entry, the less powerful *Diesel Huntsman* driven by Currey, finished third overall and first in class.

Eileen not only took all the brochure photography for these boats, but was there to capture the later successes of these Fairey designs. She did not get seriously involved with covering powerboat racing until 1966 when the Ford Motor Company decided to enter a works team and use the event to prove the rugged reliability of their marinised truck engines in the extended Fairey

(continued on page 130)

PREVIOUS PAGE
Thunderstreak II, *skippered by R L Rodman, an American 28ft Jim Wywne design, taking to the air during the 1967 Daily Express Cowes/Torquay powerboat race. This was a popular event for American and Italian entrants, keen to prove their designs at an international level*

OPPOSITE
Ghost Rider, *winner of the 1966 Daily Express Cowes/Torquay powerboat race. This picture made the front cover of the Radio Times.*

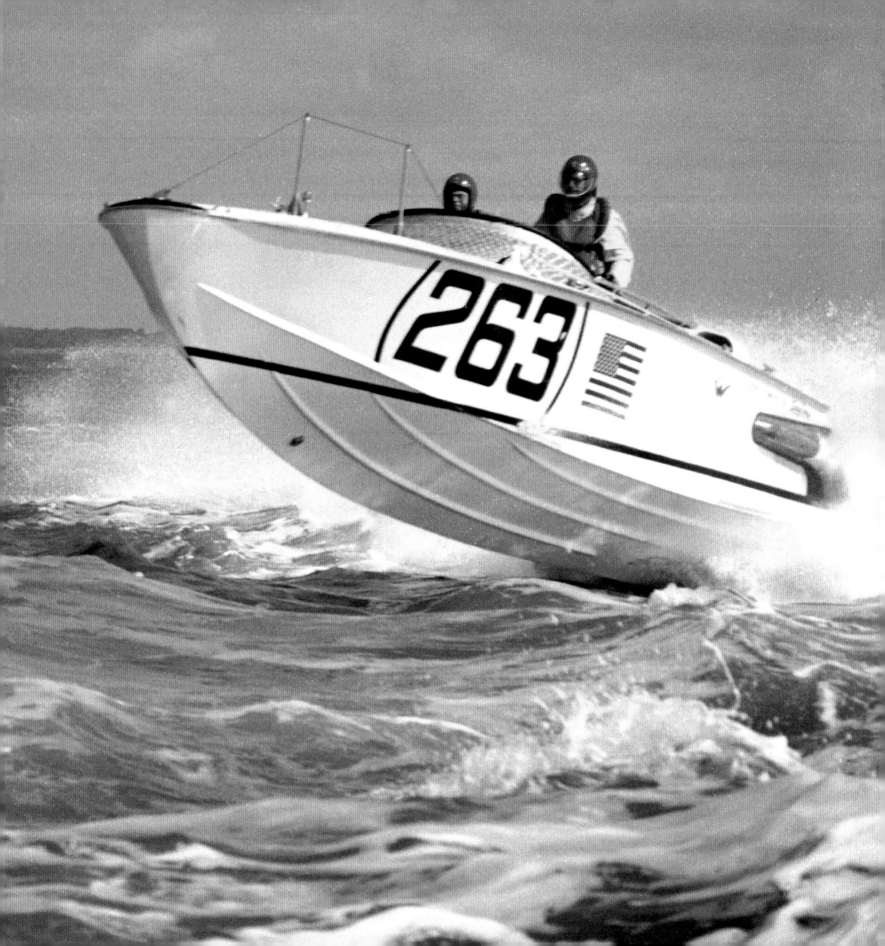

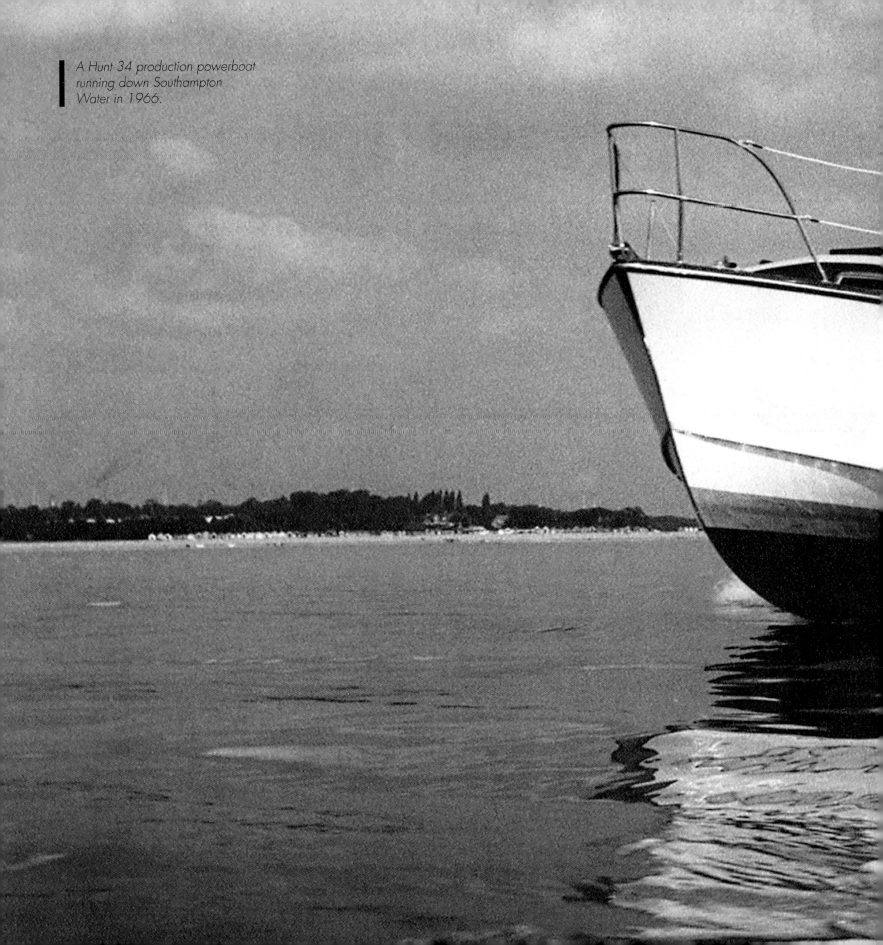

A Hunt 34 production powerboat
running down Southampton
Water in 1966.

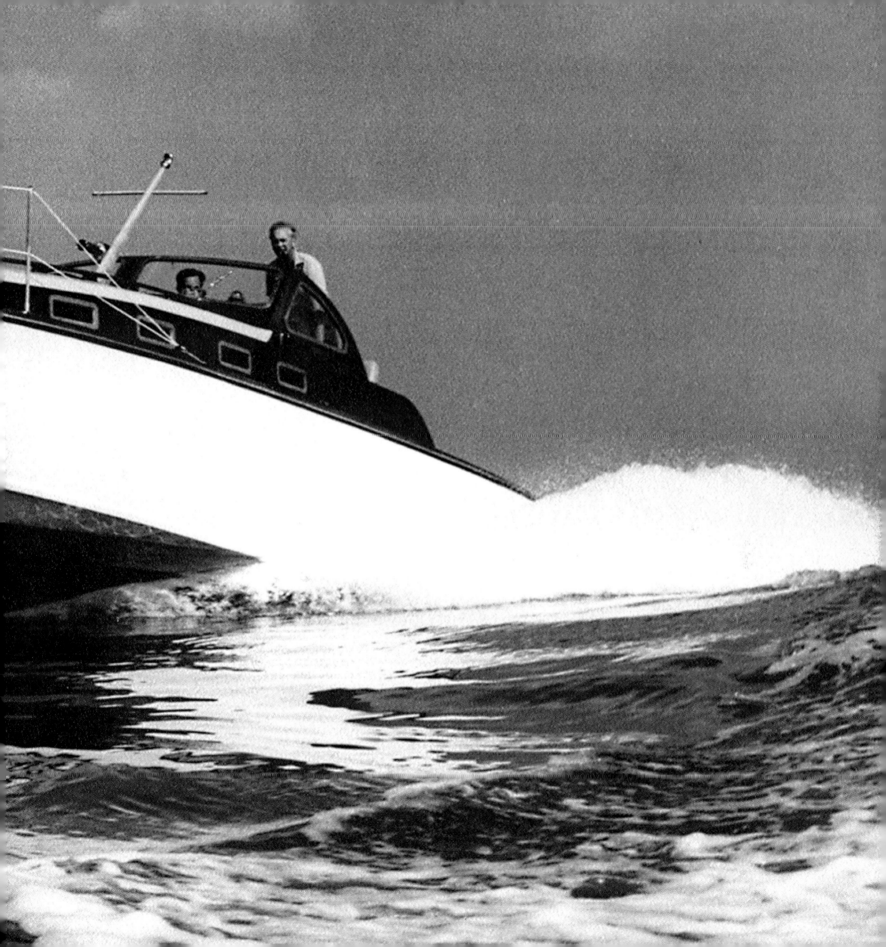

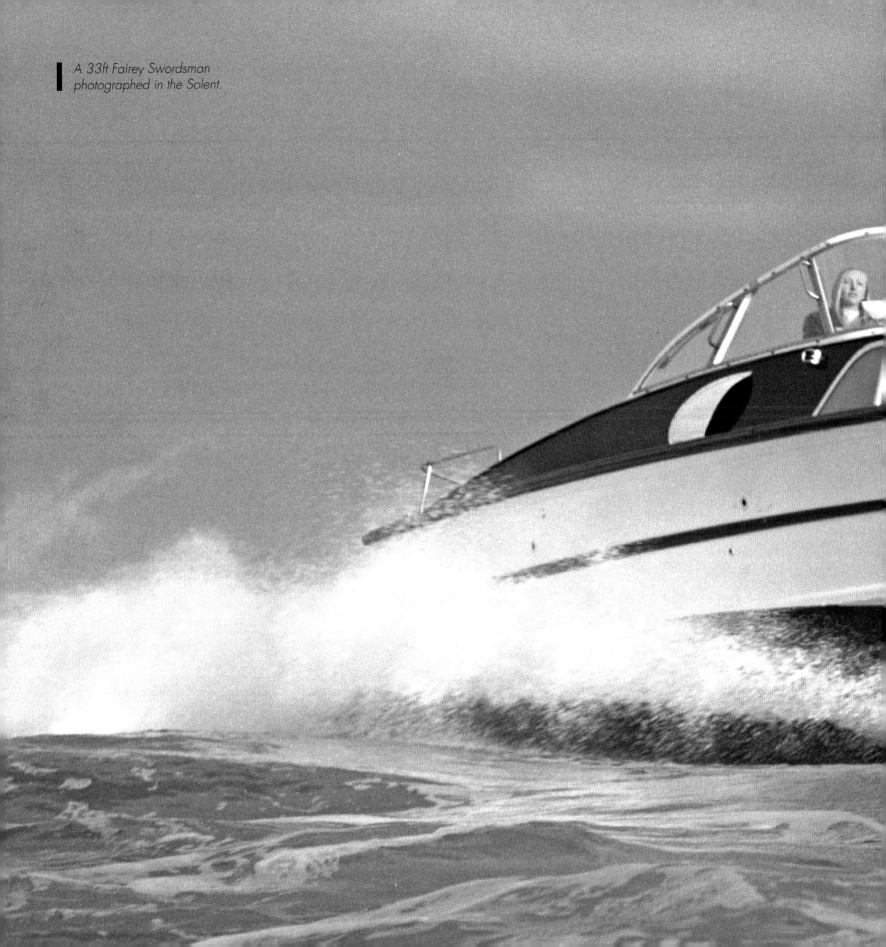

A 33ft Fairey Swordsman photographed in the Solent.

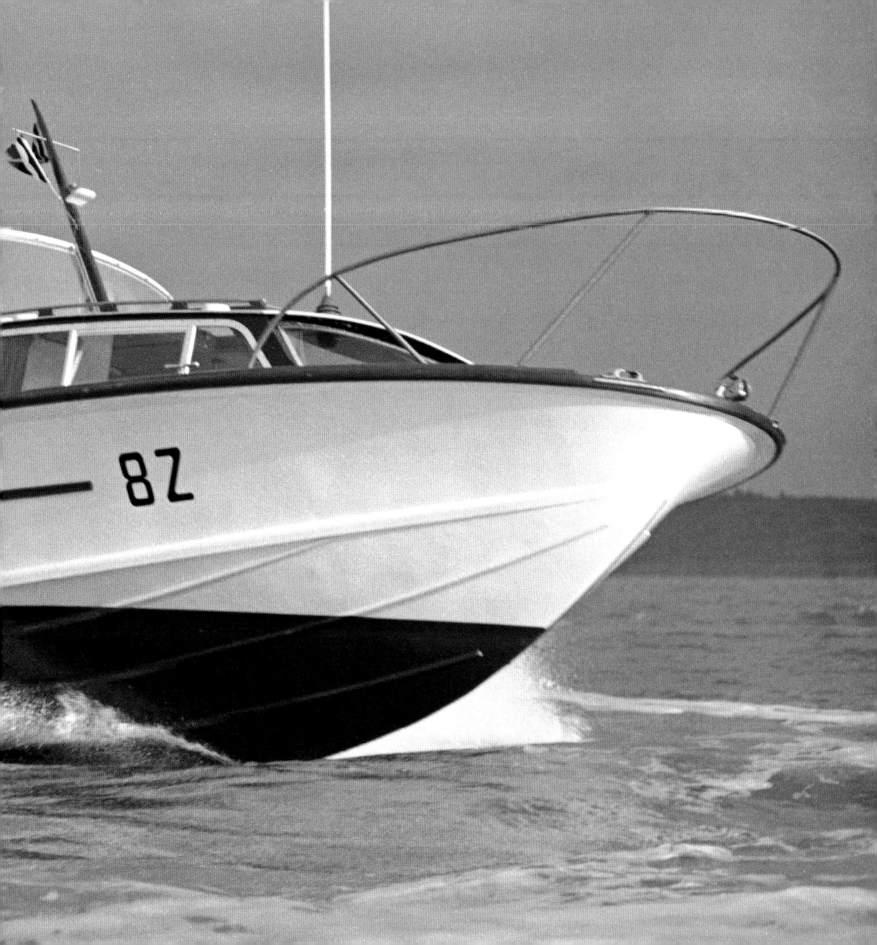

Dum Dum, *a regular production Senior Marine powerboat, taking a beating during the 1967 Daily Express Cowes/Torquay powerboat race.*

(continued from page 124)

range, which by now included the Huntsman 28 and Swordsman 33. Currey was joined on the Fairey Board by Peter Twiss, the former chief test pilot at Fairey Aviation who, back in 1956, had been first to break the sound barrier, setting a speed record of 1,132mph in a Fairey Delta experimental plane, a forerunner to Concord. Between the two, Currey and Twiss helped to win 148 racing awards in Fairey-built boats between 1961 and 1973.

Eileen not only took the brochure photography for these boats, but was there to capture the later successes of the Fairey designs. As the boats flashed past her small *Snapdragon*, she and George shot everything that came within their focus screens. One of these was the infamous *Jackie S*, piloted by the equally infamous insurance fraudster Dr Emil Savundra of Fire Auto and Marine Insurance fame, who was later sentenced to eight years imprisonment for embezzling the premiums of 400,000 motorists. 'That was a boat we did our best to avoid,' Eileen remembers, but the memory has nothing to do with fraud.

Jack Knights, the yachting correspondent for the *Daily Express* hitched a ride aboard *Jackie S* in the 1967 Round the Island Race, a prelude to the Cowes/Torquay event that year, and related the experience in the following issue of *Yachts & Yachting*. Titled The wilful capers of *Jackie S*, he began:

'Never have I had such a hair-raising morning – by 11:45am (when some five-day weekers were still paddling around in bedroom slippers, groping for milk bottles, newspapers and radio knobs) we in *Jackie S* had already had one mechanical breakdown, rammed the Needles Lighthouse, collided with another competitor and completely demolished a spectator craft.'

Jack found that Savundra's 40knot boat, powered by four Jaguar E-type engines, had one fatal flaw to its design – an iron will to turn left when thrown off a wave, whatever was done with the rudders or engines, caused by the lack of counter-rotating props.

Knights continued, 'we were rounding the lighthouse pretty close, not worried apparently by the wreck just offshore. Dr Savundra had *Jackie S* at full bore and was beginning to give her a little port on her rudders (she has three) when – oh, my gosh! – off she went heading straight for the rocks at 43 knots. It seemed a lifetime before Peter cut the throttles and we just sat braced for the crash. We hit the rock and concrete base at about 5 knots. *Jackie S* rose up 3ft or so and this took the shock. I slipped out of my seat belt and scrambled forward as *Jackie* slipped back.'

Miraculously, the boat escaped serious damage, and in no time was back at full speed. Off St Catherine's Point, *Jackie S* was thrown off course once more. 'It happened again. We caught a sea wrong, then the starboard chine forward dug in and round *Jackie* slewed, half buried by flying water and heeling far outwards. Through the murk I was horrified to glimpse over my right shoulder the distinctive and purposeful shape of *Trident's* black and bulbous nose careering towards us. Don Shead must have been lightning quick to cut his throttles. *Trident* merely reared up over our flimsy alloy and nylon deckhouse, mangled a couple of feet of our gunwales, buckled a stanchion and then slipped back free. Don Shead and John Quick shook their fists and were gone!'

Off Yarmouth for a second round, these steerage problems re-emerged. 'Almost clear of the crowd, we came abreast a converted ship's lifeboat about 27ft long and this opportunity was too much temptation for the headstrong *Jackie*. In a flash, she was heading straight for it. Peter cut our throttles quickly but we must have hit at about 20 knots. Aboard *Jackie*, we hardly felt a jolt. Our bows reared up about 15ft. There was a soft crunching – like someone treading on a matchbox, and we came to rest with the lifeboat under our midships section.

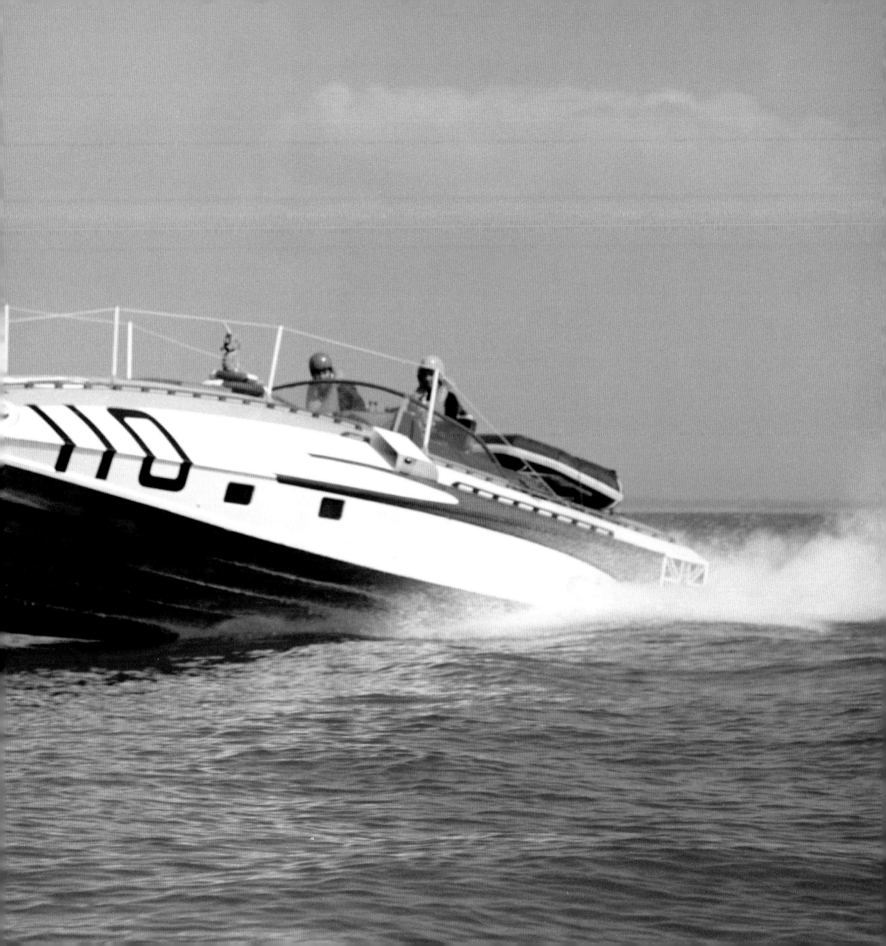

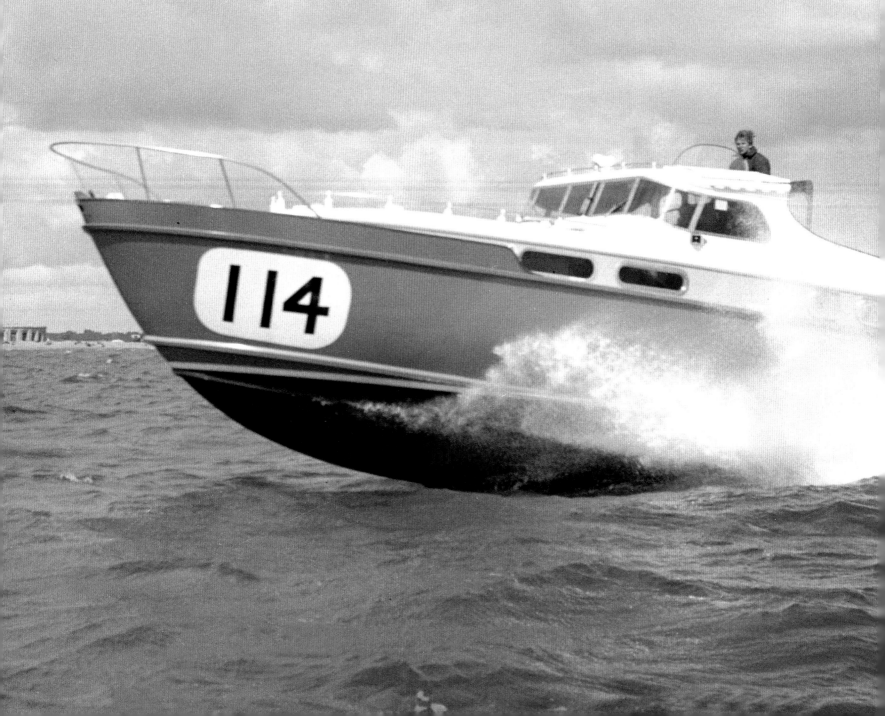

OPPOSITE
Spirit of Ecstasy, *a sturdy 44ft Arthur Hagg design, built by Dorset Lake Engineering. She was so stable that her crew famously cooked a roast enroute from Cowes to Torquay, and were seen from the air having their lunch served by a butler while crossing Lyme Bay.*

BELOW
Trident, *driven by Don Shead, which collided with* **Jackie S** *when the latter broached across her bows.*

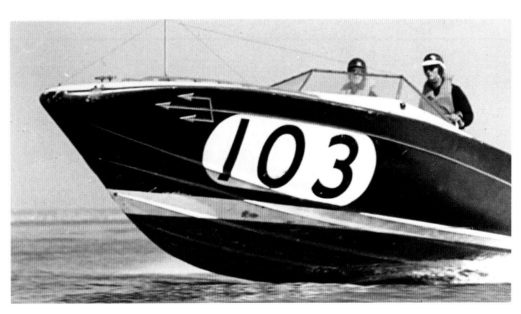

As our deck aft was level with the water, I came to the not unreasonable conclusion that we were sinking, so I launched our rubber dinghy. Peter and Len were helping a woman scramble aboard *Jackie*. Though dazed, she was quite unharmed. Another man was floating in the water a surprising distance away, then a second man came aboard. As the lifeboat sank under us, planks, fragments and red cushions floating around, we settled on to an even keel and a glance in the engine room showed we were not taking water. A launch ranged alongside and the crew of the late lamented lifeboat conversion *Skip Jack* were transferred to it, with nobody the worse for it and only one man wet.'

Undismayed, the irrepressible Dr Savundra, had thoughts to continue in the race, but Knights had had enough. He grabbed his coat, wished the *Jackie S* crew the best of luck…and jumped into the launch alongside the rescued family.

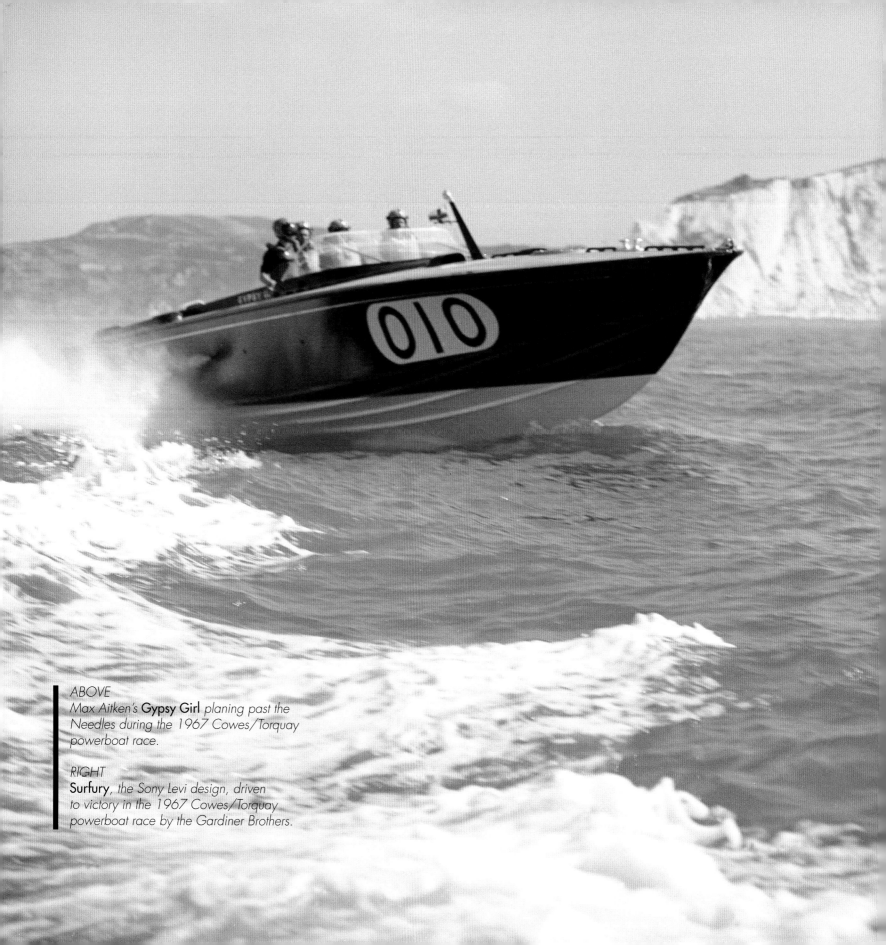

ABOVE
Max Aitken's **Gypsy Girl** *planing past the*
Needles during the 1967 Cowes/Torquay
powerboat race.

RIGHT
Surfury, *the Sony Levi design, driven*
to victory in the 1967 Cowes/Torquay
powerboat race by the Gardiner Brothers.

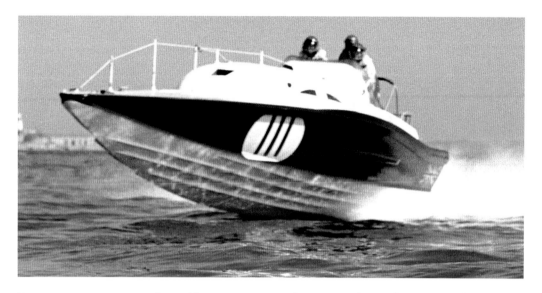

Race security was nothing like it is now, with starting lanes buoyed off and snarling officials in patrol boats shouting abuse at any hapless press or spectator boat that even threatens to break through these invisible lines. The reason of course is the modern day need for 'elf and safety' and our penchant for suing all and sundry even when tripping over the pavement when drunk. The world was a much freer place back in the '60s and Max Aitken, then proprietor of the *Daily Express*, showed up the dangers at one of these rolling race starts. Powerboats then had nothing like the power available to them now. Some would take an age simply to get on the plane, rearing their bows high in the air before finally gaining hump speed, while others simply had to first turn downwind to reach planing speed, before turning on to the race course.

Aitken's *Gypsy Girl*, a 40ft Ray Hunt design powered with twin Cummins diesels, was one of the former. During the run-up to the start of the 1967 Cowes/Torquay race, and with bows high in the air blanking out almost all forward vision, Aitken suddenly caught a glimpse of a spectator boat in front and just had time to turn the wheel hard over. *Gypsy Girl* heeled dramatically to present a fast spinning prop that made a neat row of shark's gill-like cuts right down the topsides of the spectator boat. With other safety boats nearby to assist, Aitken and his crew sped the scene and went on to finish eigth overall and third in class.

The following year, the Cowes/Torquay course was extended to 230 miles in order to qualify for world championship status, and finished back at Cowes, as it has done so on every race since.

(continued on page 141)

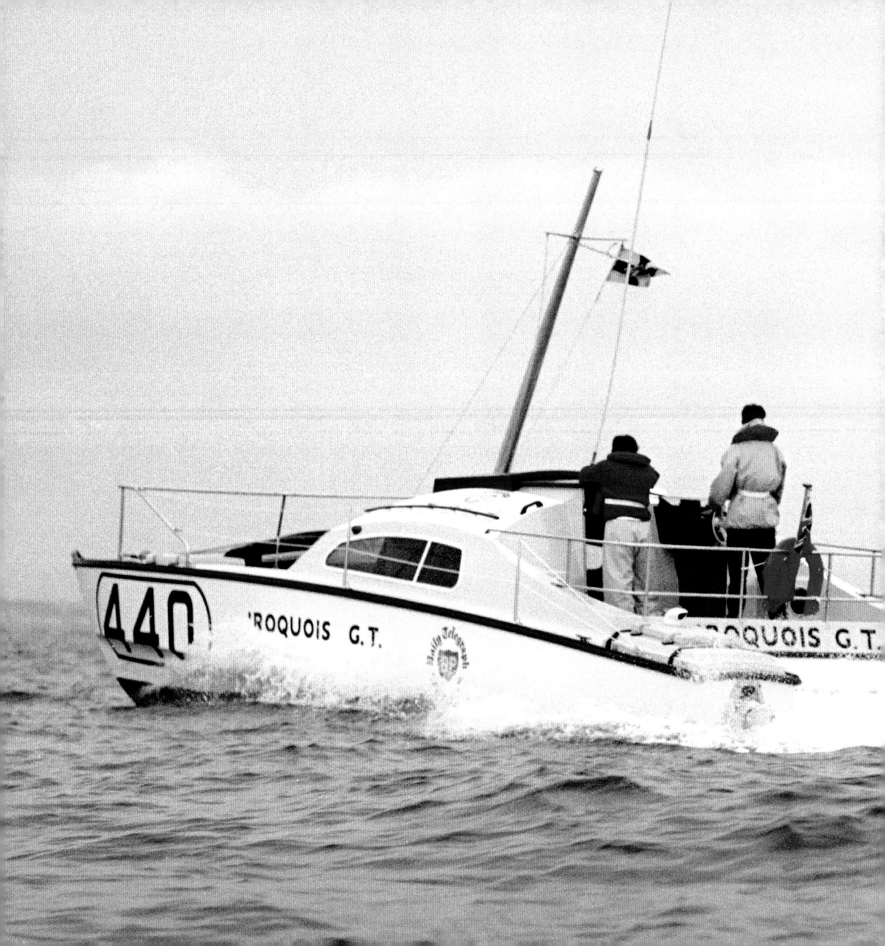

(continued from page 137)

PREVIOUS PAGE
The Round Britain race competitors moored in Cowes for scrutineering prior to the start of the 1967 marathon.

BELOW
Contrasting entries: the twin-engined Iroquois catamaran **Iroquois GT** *converted from her usual sailing mode, chasing a Fairey Huntsman at the start.*

In 1969, Group Captain 'Crab' Searl and John Chitty, Commodore of the British Powerboat Racing Club, came up with the idea of a 1,400-mile dash round Britain, which captured the attention of both the sport and public. Sponsored by *The Daily Telegraph* and BP, it turned into a bruising experience for craft, crew, engines and support teams. Of the 42 starters, which ranged from the prototype Atlantic 21 rigid bottom inflatable *Psychedelic Surfer* to an unarmed Naval patrol boat (of which only 24 managed to complete the course) was a team of four Fairey cruisers driven by Lady Aitken, Peter Iwiss, Derek Morris and John Freeman, entered for the purposes of diesel engine development by Ford Europe.

The race was won by the Don Shead designed *Avenger Too* crewed by 'Flying Finn' rally driver Timo Makinen, with Pascoe Watson and Brian Hendicott, who won the overall prize of £10,000. They were followed home by Tim Powell's all American boat *UFO*. However Fairey, with their standard-powered and built production power cruisers, took the lasting glory. With Derek Morris' *Fairey Fordpower*, third, Peter Twiss in *Fordspeed*, fourth and Lady Aitken's *Seaspray* fifth, these three took the team prize, and it was Eileen's pictures of them that covered the magazines and newspapers.

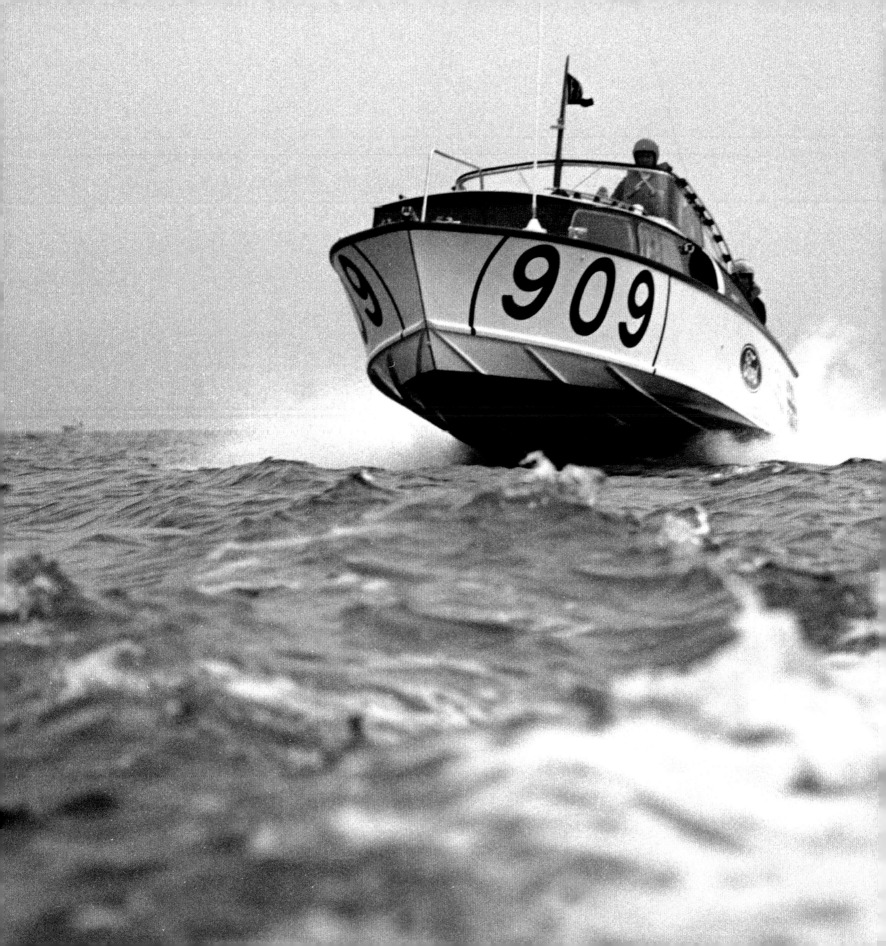

*The 28ft Fairey Huntsman **Fordspeed** driven by Peter Twiss, flying at the start of the 1969 Round Britain Powerboat race.*

Eileen built up an enduring relationship with Fairey Marine and Charles Currey and Peter Twiss in particular, and when her partner George died in a tragic riding accident in 1971, the two Fairey directors rang her to say that they would drive her photo boat at any time. 'That was a wonderful gesture which I very much appreciated,' she recalls.

Instead, she redesigned the coach house within the grounds of her cousin's manor home in nearby Droxford and spent the next three decades enjoying her other passions of gardening and painting flowers with the same enthusiasm and dedication that she applied to her photography.

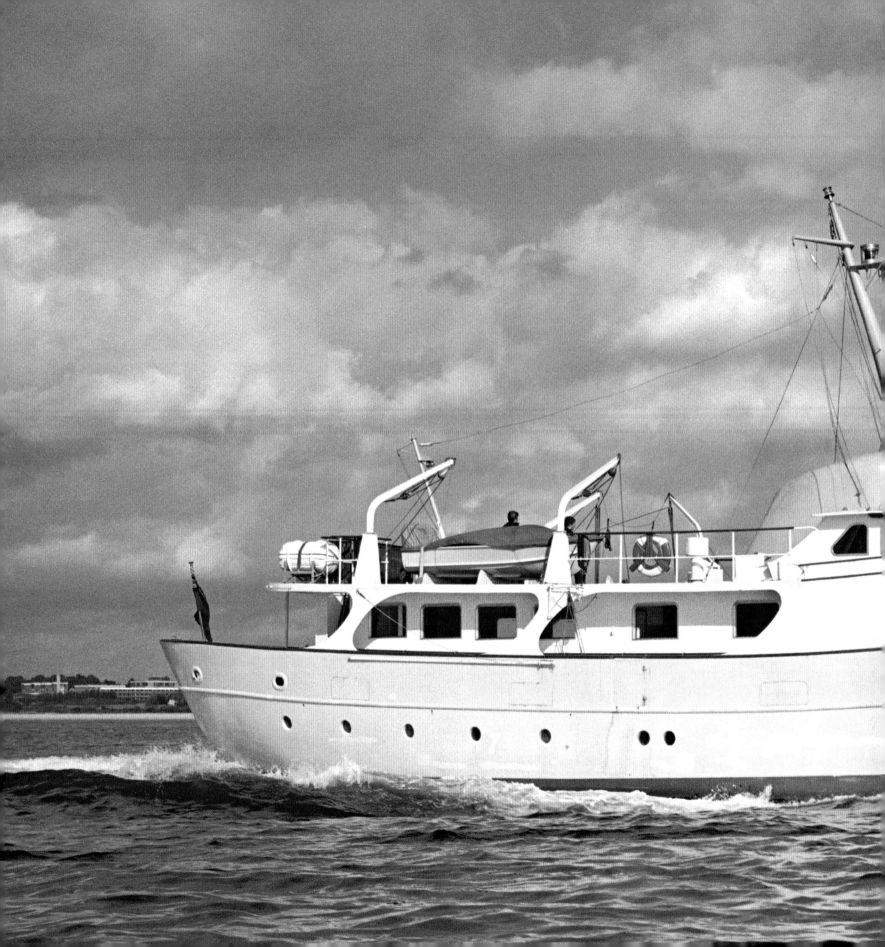

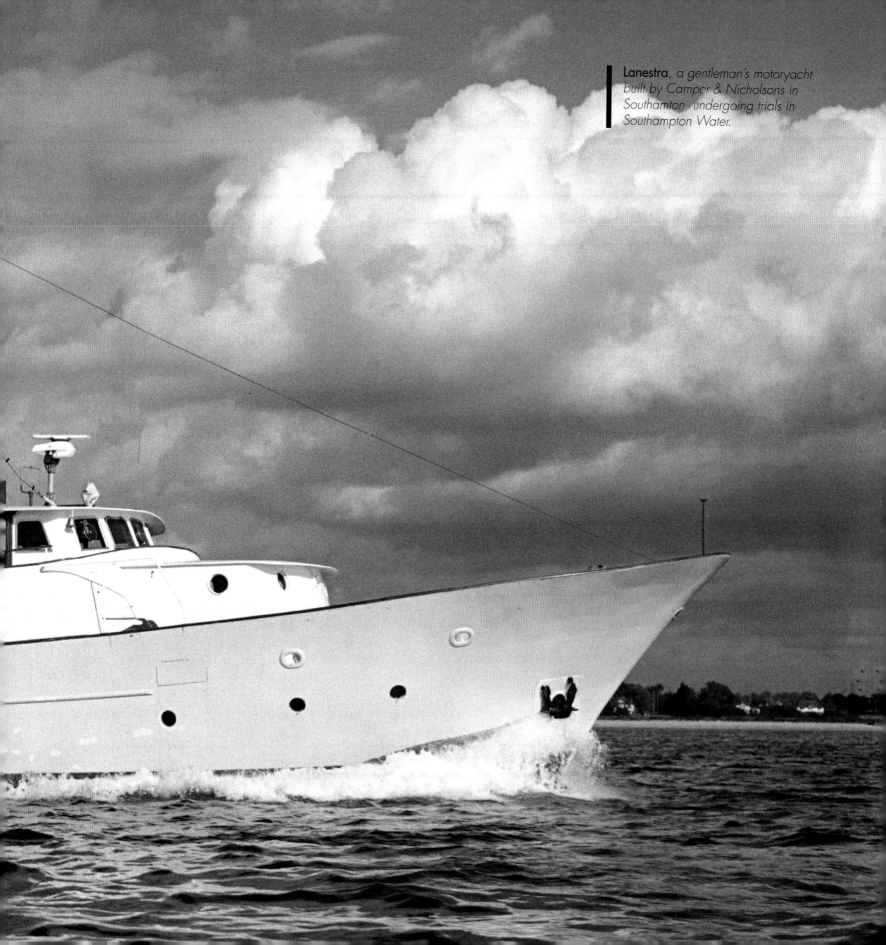

Lanestra, a gentleman's motoryacht built by Camper & Nicholsons in Southamton, undergoing trials in Southampton Water.

The Ramsay Technique

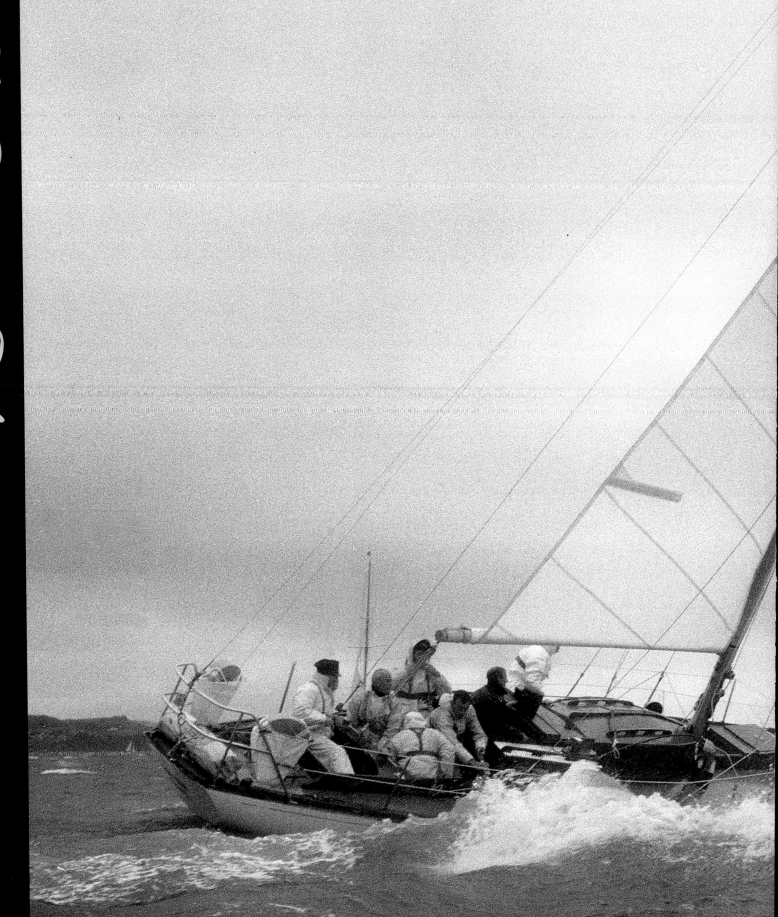

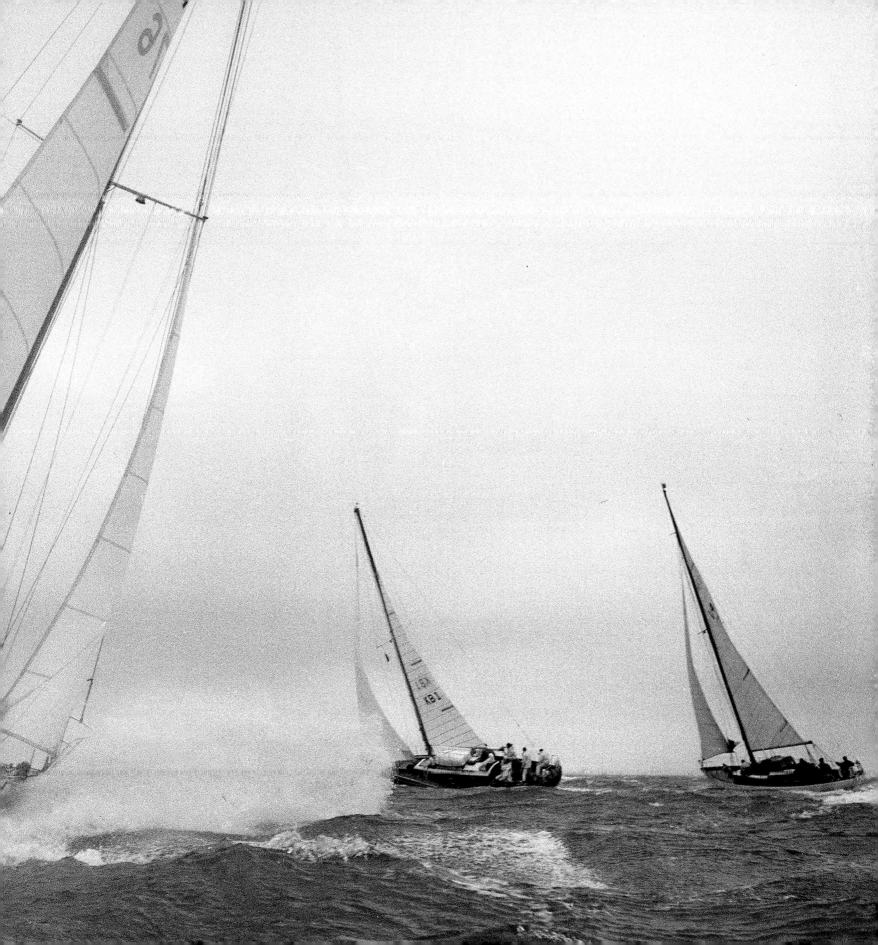

The Ramsay Technique

Eileen describes her work as 'making pictures rather than taking photographs.' 'Frank Beken and later his son Keith, based at Cowes, stood up in the middle of his photo boat taking great pictures of big yachts with a plate camera in his hands and a bulb in his mouth to trigger the shutter. So I developed my own style, taking my pictures as close to the water as possible. I was an impressionist photographer and liked nothing better than to highlight reflections in the water.'

Eileen's preferred camera remained the Rolleiflex twin lens reflex camera, producing 6x6cm medium format negatives but she also had a Linhof plate camera. Bending low over the gunwale of her launch, Eileen's style was expensive on cameras. 'I used to get through at least one camera a year, and we would have to thoroughly clean the salt from them after each outing,' she recalls.

These low-level pictures became Eileen's signature and others soon began to copy her approach. 'I was photographing the Thames A Raters during one Bourne End Week at Upper Thames YC and had cleared an area of the river bank to kneel down and take my pictures as the boats sailed by. I became so involved in my work that it took quite some time before I looked up to find other photographers mimicking my style further down the river bank.'

The Rolleiflex, with its overhead screen, was essential for taking pictures at water level, especially on calm days when her low-level technique turned an otherwise boring image into a vibrant array of reflections. With each roll of 120 film limited to just twelve exposures, she learned to frame each picture yet work quickly by using two cameras, with George either reloading one or taking pictures himself as Eileen changed the roll in her own camera. 'We learned to work as a team, especially when covering big regattas when a hundred dinghies could plane past in a matter of minutes.'

PREVIOUS PAGE
1963 Fastnet Race: **Cumbrae Isle***, C A Parker's 40ft Macmillan designed sloop from Scotland, making most of the stiff conditions after the start from Cowes.*

OPPOSITE
Eileen in action aboard **Snapdragon***.*

'The highest shutter speed of the Rolleiflex was 1/500th of a second but this, in conjunction with very fast films, enabled us to get good, sharp negatives even in dull weather.'

After testing various films, she worked almost exclusively with Kodak Tri-X Pan Professional 400 ISO black and white film processed in Microdol-X, a very fine-grain developer, which allowed her 2¼" square negatives to be enlarged without any appreciable grain being noticeable in the print.

A lens hood was another essential part of her equipment, used to protect the lens from direct light, especially when photographing into the sun, when Eileen could often obtain attractive silhouette type pictures with dark sparkling seas. Except on very bright days at sea, when overcorrection would result, she used either yellow or green filters. She found the yellow filter was particularly good with black and white film in penetrating the haze so often present near the water, while green produced a more dramatic type of bold contrast.

A soft wash chamois leather was always to hand to wipe away any spray on the lens, but however carefully Eileen and George tried to protect their cameras, these Rolleis had to be replaced each season or if they were lucky, sent away for a complete overhaul to de-salt them.

Eileen was among the first to embrace colour photography afloat, and her work did most to persuade publishers who were reluctant to change or spend money 'needlessly', to gear up for colour front covers. Ramsay pictures were the first to be used on the covers of *Yachting Monthly*, *Yachting World* and *Yachts & Yachting*, and soon she was not only developing her own C-41 colour negative films, but also those of Beken of Cowes.

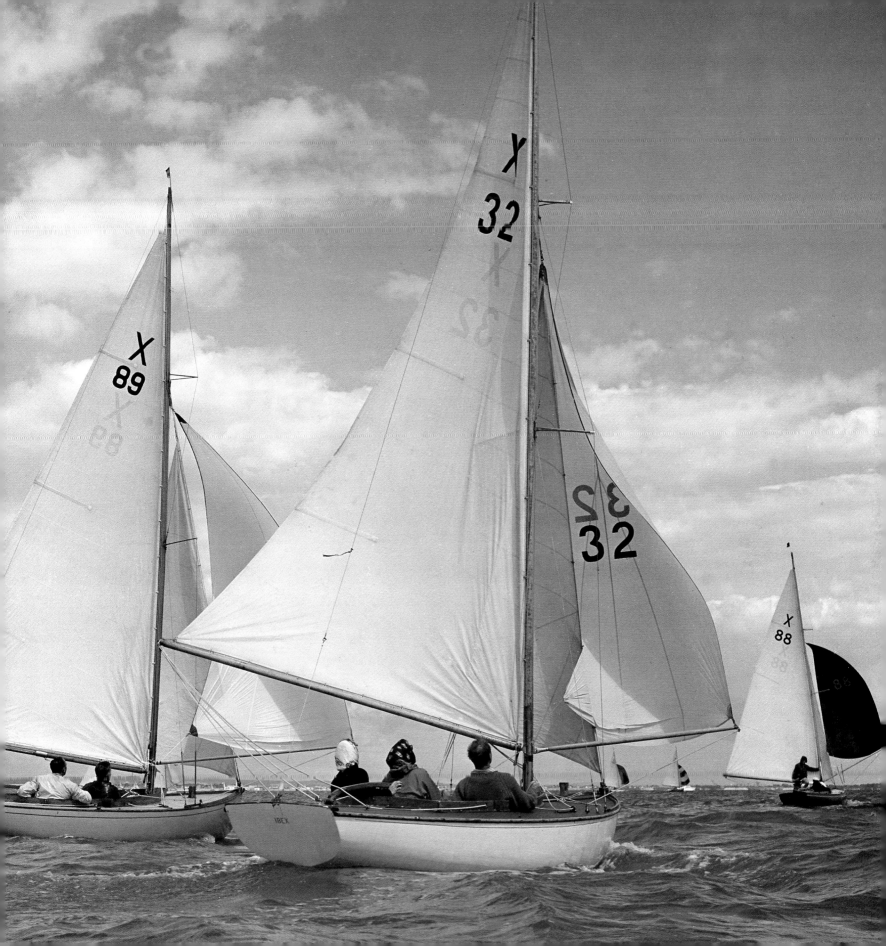

During her coverage of International 14 races, she met environmentalist Peter Scott and in later years spent a week or two each year with a companion 'house sitting' at his lakeside home at Slimbridge and used this time to photograph the wildfowl. This interest in wildlife has continued. Eileen hung up her cameras for the last time in 1971, following George's death. She then moved to Droxford and her passion turned to gardening and painting flowers. Her latest watercolours were exhibited at the Droxford art exhibition in 2010.

RIGHT
Denis Doyle's 47ft Irish Admiral's Cup yacht **Moonduster** *designed by Robert Clark at full stretch under spinnaker during the 1967 Cowes Week Regatta.*

BELOW LEFT
Eileen Ramsay's two Rolleiflex cameras.

BELOW
George Spiers – Eileen's partner with their Linhof plate camera.

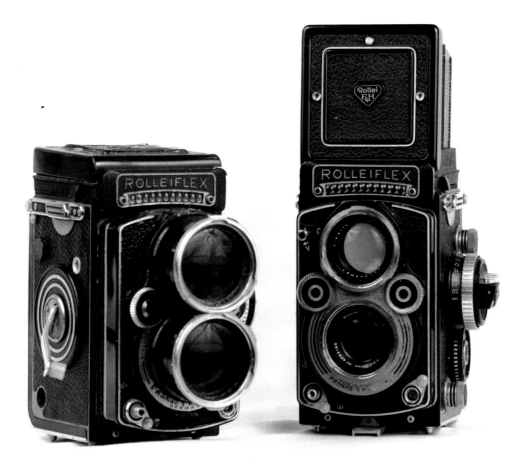

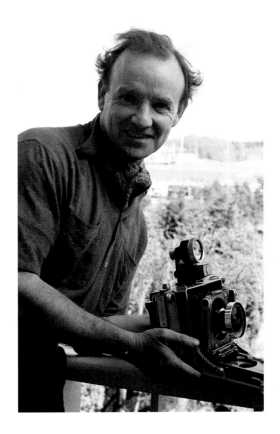

Patrick Blake

When I was a lad my Grandmother bought me a box camera for my birthday, and at about the same time my parents purchased an old GP14 racing dinghy. I then became obsessed by the sport of sailing and the art of photography – passions I still have to this day!

One of my main influences was the super photography of Eileen Ramsay. She caught the spirit of the moment – and they were moments we could all imagine. These were not the impossibly spectacular yachts that Beken shot, but a Merlin planing down the Hamble River or a calm day on the Thames. Her photos were of boats we could aspire to, made exciting by her fabulous technique.

Later, when I studied photography, I tried to emulate her style and realised how hard it was. She always had an interesting viewpoint, usually very low, and captured the highlight detail of the sails, clouds and waves – exactly the things you notice when you are out on the water but that are so hard to photograph, especially in black and white which, I think, was her best work. Eileen's portraits are an inspiration too. Look at Sir Francis Chichester through the companionway of *Gipsy Moth* or John Oakley from above with just water in the background.

When I came to meet her – much later in life – she certainly didn't disappoint. Now in her 90s, she has given up photography and is painting, using all her skills of composition and lighting and so much more – she is my inspiration.

OPPOSITE
*David Dyer and Peter Ward planing up the Hamble River in their Proctor Mk 9 Merlin Rocket **Suspense**, when leading the 1960 Fossil Bowl race.*

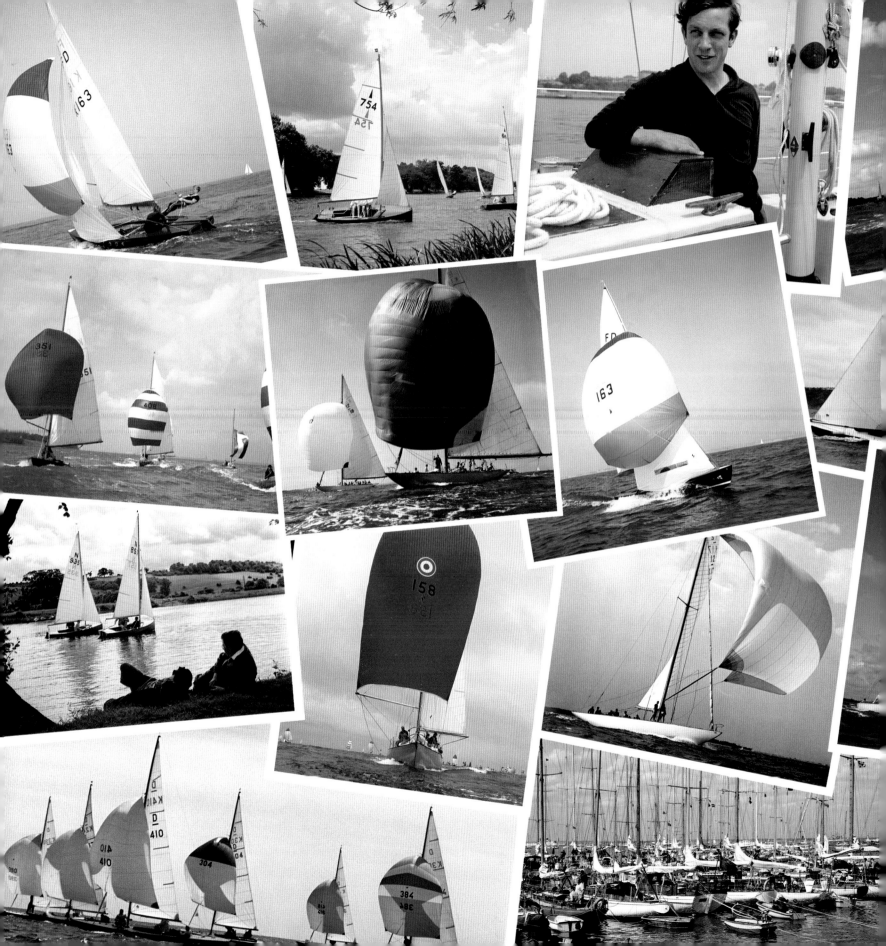

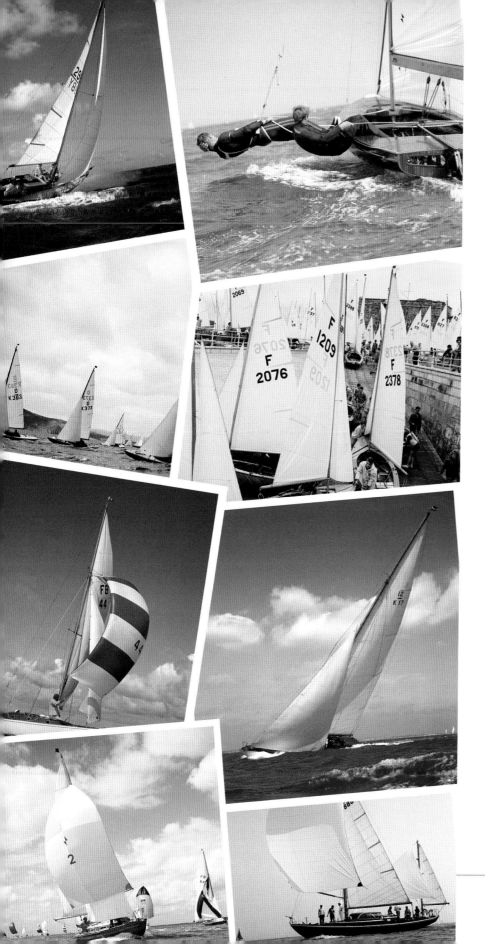

ppl Ltd

The specialist photo source

The work of Eileen Ramsay, the queen of yachting photography from the 1950s to early 1970s, has been saved for posterity. Having kept her 50,000 strong sailing archive intact, Eileen called in PPL Photo Agency to digitise the pictures and manage the Library.

Barry Pickthall, at PPL, says, 'It was very important to save Eileen Ramsay's archive. As well as photographing dinghies and yachts for more than two decades, she was a specialist portrait photographer, and her early pictures of our sailing pioneers have great significance when recording Britain's sailing history.'

Her pictures are once more available for reproduction in the media and as fine art prints, and can be viewed within PPL's s specialist 'Pictures of Yesteryear' online archive at www.pplmedia.com.

PPL also holds the official archives of Sir Francis Chichester, Sir Robin Knox-Johnston and Sir Chay Blyth, together with a comprehensive collection of pictures and fine art illustrations covering all forms of sailing, dating back to the mid 1850s when the 100 Guineas Cup and the race around the Isle of Wight led to the start of the America's Cup.

Index

Acknowledgements

Our grateful thanks go to everyone who has so generously given time and energy to helping produce this tribute to a life's work. The first round of applause must go to Eileen Ramsay herself who, at 97, can remember every photograph she has taken, the story behind each picture, and in just about every case, the year it was taken!

It was the perseverance of Eileen's family friend Katie Southgate and photographer Patrick Blake that first got us involved with Eileen's remarkable archive of pictures. Like the 'Queen of Yachting Photography' herself, they wanted to see this wonderful collection of photographs saved for posterity, and came to PPL with two estate-car loads of precious negatives, and more than 140 albums of prints. Could we catalogue, digitise and make them available to view on the world-wide-web?

That task fell to Lee Martin who has devoted a year to producing a searchable online database listing some 30,000 images, and scanning several thousand of Eileen's better known images. It has been a monumental task to which he is rightly proud to have played a prime role in saving the Ramsay Archive.

Many others have rallied round to help identify images, provide background information, proof pages or contribute a passage: Ken Beken and Peter Mumford from Beken of Cowes, Ray Bulman, Peter Cook, Gordon Currey, Donald and Cherry Forbes, Val Howells, Olympic Silver medallist Keith Musto, Cliff Norbury, Mark Pepper, Olympic Gold medallists Rodney Pattisson and Iain MacDonald-Smith, and Nick Ward whose father, Stanley, often drove Eileen's launch *Snapdragon*.

Grateful thanks must also go to PPL's principal designer Kayleigh Reynolds and to PPL's picture research team of Andrew Wetherall and Lee Martin. Without all your unstinting support, Eileen Ramsay's photographic archive would still be languishing in an outside scullery. This book is for all to enjoy the fruits of your labour!

Barry Pickthall
Chichester, 2012